WOMEN
in

LONG ISLAND'S
PAST

WOMEN

in

LONG ISLAND'S

PAST

A History of Eminent Ladies and Everyday Lives

NATALIE A. NAYLOR

Charleston London

THE
History
PRESS

Published by The History Press
Charleston, SC 29403
www.historypress.net

Cover lighthouse image courtesy of the Library of Congress.

First published 2012

Manufactured in the United States

ISBN 978.1.60949.499.5

Library of Congress CIP data applied for.

Notice: The information in this book is true and complete to the best of our knowledge. It is offered without guarantee on the part of the author or The History Press. The author and The History Press disclaim all liability in connection with the use of this book.

CONTENTS

ACKNOWLEDGEMENTS

Many people have assisted this publication. Commissioning Editor Whitney Tarella at The History Press encouraged me to write this book, read chapters as I completed them and provided helpful comments and encouragement throughout. Cathy Ball, local history librarian at the Smithtown Library, read all the chapters, suggested additional women to include and supplied information about them and others. Terry Walton, wordsmith *extraordinaire*, also read all the chapters and provided innumerable useful suggestions. Southampton College Professor Emeritus John Strong and Hofstra Museum director Beth Levinthal each shared their expertise by reviewing a chapter. Others who helped with specific information are acknowledged in the notes. Project Editor Ryan Finn and others at The History Press provided their professional expertise to turn my manuscript into this book. I am grateful to each of you.

Those who assisted securing photographs and images include: Linda Barreira, Rock Hall Museum; Carole Berglie, Literary Estate of May Swenson; Julia Blum, Cradle of Aviation Museum; Clare Clark, Cold Spring Harbor Laboratory Archives; Mary Cummings, Southampton Historical Museum; Larry Feliu, manager, Northrop Grumman History Center; George Fisher, Nassau County Museum Services, Photo Archives Center; Amy Folk, Oysterponds Historical Society; Barbara A. Guzowski, Hofstra University Archives; Helen Harrison, Pollock-Krasner House & Study Center; Cheryl Klimaszewski, Bryn Mawr College; MaryLaura Lamont, William Floyd Estate, National Park Service; Robert B. MacKay, Society

for the Preservation of Long Island Antiquities (SPLIA); Karen Martin, Huntington Historical Society; Nicole Menchaise, Oyster Bay Historical Society and Raynham Hall Museum; Karen Mouzakes, Yaphank Historical Society; Anne Nauman, Fullerton/Nauman Archives; photographer Mark Patiky; Gina Piastuck, East Hampton Library; Joshua Ruff, Long Island Museum of American Art, History & Carriages; S. Joan Ryan, St. Joseph's College; William Titus and Lisa Chalif, Heckscher Museum of Art; Amy Verone, Sagamore Hill, National Park Service; Debbie Wells, Roslyn Landmark Society; and Christa Zaros, Long Island Museum of American Art, History & Carriages. Student aides in Hofstra University's Faculty Support Center assisted by scanning images. My thanks and appreciation to all.

INTRODUCTION

Women have been part of Long Island's past for thousands of years, but they are almost invisible in the records and histories of the last four hundred years. Half of the population, they have played essential roles in the island's history and made significant contributions. Some have achieved national fame, others have been regionally important and many are women whose names did not make it even into this book, but each is part of Long Island's history.

Geographic Long Island is nearly 120 miles in length and includes today's boroughs of Brooklyn and Queens, which have been part of New York City since 1899. In popular usage today and for much of the twentieth century, "Long Island" refers only to Nassau and Suffolk Counties, which are the focus in this book.

The population of geographical Long Island in 1700 was probably less than 9,000 people. In 1790, the population of Suffolk County and the towns in present-day Nassau totaled about 21,000, which had increased to just under 57,000 by 1850. In the twentieth century, Long Island's population grew from 133,000 in 1900 to more than 1 million in the early 1950s and more than 2.7 million in 2000.[1] Not surprisingly, for many of these years, this sparsely populated provincial hinterland produced few national figures, male or female. The lives of most local women did not extend beyond their own home, church and community until well into the 1800s. Opportunities for women to achieve on a wider stage were limited.

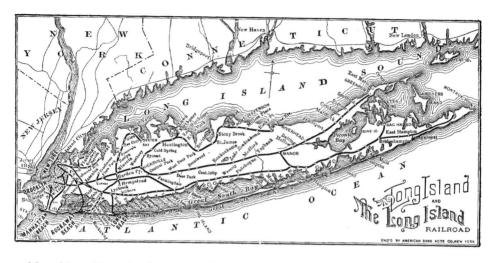

Map of Long Island showing communities and railroad lines. Reprinted from Long Island Railroad's *Summer Homes on Long Island*, 1895. *Courtesy Nassau County Museum Collection, Long Island Studies Institute, Hofstra University.*

Beginning in the late 1830s, railroad lines facilitated transportation on the island, furnishing better access to Brooklyn and Manhattan and enabling city residents to enjoy Long Island's seaside resorts. Technological improvements in printing in the same period gave wider access to newspapers, magazines and books—broadening women's access to a wider world and opening opportunities for some to earn income by writing. Women achieved the vote in 1917 in New York State. The twentieth century greatly expanded their opportunities on Long Island and in the wider world.

When I began to research women in Long Island's past, I identified nationally eminent women who appeared in the four volumes of *Notable American Women* (*NAW*), the standard biographical dictionary. For inclusion in that scholarly reference work, "the criterion was distinction in their own right of more than local significance."[2] I initially located more than 150 women with connections to Long Island, which I narrowed to about 50 who had lived or worked on Long Island, including Brooklyn and Queens, during their years of achievement. My article "Long Island's Notable Women" appeared in the *Long Island Forum* in 1984.[3] In subsequent years, I wrote other articles that focused on women, and I have drawn on them for this book.

All thirty of the eminent Nassau and Suffolk women who appear in the (now) five volumes of *NAW* with prominent connections to Long Island are profiled in this book. A few women were only born or grew up on Long Island, but most lived on the island during a significant period of their adult

years. Some of the women summered on Long Island or had country homes here; a few commuted to work in New York City. Long Island women who achieved national recognition by inclusion in *Notable American Women* are identified by their *NAW* entry in the endnotes.

Innumerable other women have been locally or regionally important, and some of these women appear in these pages. Following the example of *NAW*, I have included only those who are no longer living. Selection of such women was difficult due to space limitations. I have sought to provide some variety in types of endeavor and chosen women for whom information is readily available. I have also tried to encompass what many more typical but unheralded and anonymous women experienced in their everyday lives, even though their names may not be in the historical record. Some appear in chapters on fields in which women achieved national fame and others in chapters covering specific years or periods. Readers who wish to learn more about individual women or topics can pursue Internet resources or the books and articles cited in the endnotes.

Throughout most of our history, married women have been publicly identified by the name of their husband (e.g., Mrs. Thomas Powell). I have chosen to give priority to the woman's own first name, though I also provide her husband's name.

The Long Island Studies Institute of Hofstra University organized the Long Island Women conference in 1996. The two-day conference had a broad array of presentations, many of which were published in the conference volume *Long Island Women: Activists and Innovators* (*LIW*). As I wrote in its introduction, the conference and book represented "a significant beginning in documenting and recovering the history of Long Island women."[4] I have drawn on many of its chapters for this book. Additional important sources include other books published under the auspices of the Long Island Studies Institute, histories of Long Island by Newsday, numerous local community histories and articles in the *Long Island Historical Journal* and other journals—all cited in the endnotes.

Women in Long Island's Past gives a general overview, but it is necessarily brief and incomplete. This book combines topical and chronological approaches. Since it is difficult to provide historical perspective on the recent past, I have not attempted to bring the story of Long Island's women to the most recent decades, although the epilogue suggests some of the themes.

This book builds on the work of many others, men and women, past and present, who have written on Long Island history. I hope it will not only enhance understanding of Long Island's past but also encourage others to seek out the roles of women as they write local histories.

Chapter 1

THE FIRST LONG ISLANDERS

Thousands of years before the first European explorers and settlers reached Long Island, the Native Americans inhabited the land they called Seawanhacky, "Island of Shells." The earliest written accounts, however, date only from the early 1600s. Wyandanch and Tackapousha were seventeenth-century Algonquian men whose names are familiar today, but Indian women have been almost invisible in most historical accounts. Yet Henry Hudson and other explorers were met by women as well as men. On September 5, 1609, Robert Juet recorded in his logbook for the *Halve Maen* (*Half Moon*) that some of the native women "came to us with Hempe."[1] Tackapousha became an influential sachem partly through his extensive kinship ties, many with his wife's relatives.

The early years of European settlement were difficult ones for the native Algonquians. Having no natural immunity to smallpox, tuberculosis, measles and other diseases brought by the Europeans, many Indians—women and children as well as men—died in the first decades of contact. The Indians could not tolerate the liquor that the Europeans introduced, and many became alcoholics. Excessive drinking disproportionately affected men, but it was also a problem for women.

In the mid-1640s, a series of conflicts now known as Kieft's War wreaked havoc on Long Island. Captain John Underhill and his troops burned at least two Indian villages, including Fort Neck at present-day Massapequa. These conflicts killed more than one thousand Indian men, women and children.

In an account published in 1670, settler Daniel Denton attributed the decline of the natives to God's will: "There is now but few [Indians] upon the Island, and these few no ways hurtful but rather serviceable to the English, and it is to be admired, how strangely they have decreased by the Hand of God." Denton remembered six Indian towns in the 1640s when his family came to Hempstead, but only two remained, for "where the English came to settle, a Divine Hand makes way for them, by removing and cutting off the Indians, either by wars one with the other, or by some raging mortal disease."[2] Denton ignored the many hundreds of Indians killed by the Europeans and overstated those killed by other Indians, for intertribal battles did not take heavy tolls of life. Moreover, when the Indians fought, they usually spared women and children, capturing them to adopt into their tribe.

When in 1653 the Niantics came across Long Island Sound and captured a number of Montaukett women, including Wyandanch's daughter, Quashawam, colonist Lion Gardiner assisted in having her returned. In appreciation for this and other aid over the years, Wyandanch gave Gardiner ten square miles of land in Smithtown and Setauket in a deed that was also signed by Wyandanch's wife and which explicitly mentioned the ransom of his daughter. (Gardiner would later convey this land to Richard "Bull" Smith, for whom today's Smithtown is named.)

WOMEN AND THE LAND

Denton in his 1670 account reported "their wives being the husbandmen to till the land, and plant their corn," while the men hunted and fished. Family ties to male sachems, as well as their special relationship with the land, enabled some women to become "sunksquaws," or female sachems in Long Island Algonquian communities.[3] The English in East Hampton in 1655 proclaimed Wyandanch the "chief sachem of Long Island" to simplify conducting land treaties and other relations with the Indians rather than deal with different sachems. When Wyandanch died, his wife, Wichitaubet, inherited the position with her young son. Quashawam, daughter of Wyandanch, in turn inherited her position as sunksquaw in 1664 after the death of her widowed mother and only brother. The English recognized her as "chief Sachem" over the Shinnecocks and Montauketts in 1664, and her name is on five legal documents in English records of 1664–66 relating to land in Jamaica and Montauk, as well as other locations. Colonial

records identify several other women as sunksquaws, including Shinnecock Weany, the unnamed wife of Massetewse, Montaukett Askickotantup and an unnamed Montaukett sunksquaw. Unkechaug sunksquaws at Poospatuck in the nineteenth century included Caroline Hannibal, Elizabeth Job and Martha Hill Maynes.[4]

Other Indian women sometimes took part in land transactions, though they were not sunksquaws. This involvement reflected the women's relationship with the land that they tilled and harvested. The English often ignored the women, however, based on their own view of property ownership. Under English common law, only widows or single women could own property; when women married, their husbands took control of any property the women had previously owned. Many women are identified not by name in treaties but as the "wife," "widow" or "daughter" of a male leader. Indian women may have played greater roles than records suggest, as the gender is not always obvious from their names.

Historian John Strong has documented forty legal transactions involving Algonquian women in the colonial period. Most are land sales or leases, some concern testimony on boundaries and others are sales of whaling rights. Lion Gardiner secured his now famous island in a 1639 treaty with Aswan and her husband, Yovawan. Unkechaug women were involved in land transactions with the Floyd family in 1730, 1789 and 1791. In a 1793 lease, eleven Shinnecock women (and five men) attested that they were "the True and Lawful Heirs to said Land." Only one of the parcels was jointly owned by a man and woman; the woman presumably was the man's wife or daughter.[5] By this date, both women and men had adopted English names (e.g., Sarah Titus, Abigail Solomon, Prudence Cuffee, Peg Jordan and Elizabeth Manaman). Admittedly, the number of transactions that recorded only male Indians was considerably larger.

SERVITUDE, SLAVERY AND WOMEN'S WORK

Indian women sometimes appear in other colonial records. Indentured servitude was not uncommon in the colonial period for Indians as well as poor whites. When Hope, an Indian servant in the home of Edward Howell in Southampton, became pregnant by a white servant in the household in 1644, the town intervened, forcing the couple to confess in court, and publicly whipped them. Their child was indentured to Howell to the age

of thirty. In 1694, a Montaukett couple bound out their daughter, Marget, to David Osborn for seven years. The parents received three pounds, and Marget received room and board and three pounds at the end of her term. Unlike the typical indenture for whites, there was no provision to teach her to read or write or a skill, though she probably did learn "housewifery" by assisting in domestic tasks in the Osborn home.[6]

Some Indians were enslaved on Long Island. Indian slavery was abolished in New York in 1679, but the law was not always enforced. An Indian girl, Beck, probably captured in an Indian war against encroaching New England colonists, was purchased by James Loper of East Hampton in 1677. Sarah, the eight-year-old daughter of a free Indian, Dorcas, was sold to James Parker of Southampton in the 1690s. After two more sales, she was taken to Madeira, where she successfully petitioned the English consul for her freedom.[7]

Throughout the colonial period and into the nineteenth century, Indian women retained many traditional roles. They processed hides for clothing and shelter. They not only had primary responsibility for planting and tending crops, but they also gathered berries, roots and ground nuts and processed, prepared and preserved food. Some had special skills with herbs for medicinal purposes and were healers (medicine women or female shamans) who also conducted religious rituals. Women were involved in making wampum and were often the traders with the Europeans.[8] And, of course, as in all societies, the native women bore children, had primary responsibility for raising them and transmitted their native culture to the next generation.

Female elders were well respected in the Algonquian culture. Some became legendary. Dorothea (Dolly) Cuffee was one such Unkechaug matriarch. She married William Cooper in 1806 when they both were servants in a white household in Mastic. William went to sea, first on a merchant ship and later in the U.S. Navy. After he was killed in a battle between the USS *Constitution* and a British ship in 1813, Dolly received a small pension. In 1828, she married Adam Brewster, who drowned the following year while fishing. Her third marriage was to Obadiah Cuffee in 1835; he worked for Nicoll Floyd. Dolly also worked for the Floyds, performing domestic work—taking care of children, sewing, washing, cooking and cleaning. The Cuffees had their own small cabin on the Poospatuck Reservation. Dolly kept a garden where she grew vegetables and raised chicken and geese. She and her husband were active in the Poospatuck Church. Obadiah died in 1847, and Dolly struggled during widowhood, successfully increasing money from a trust and securing a veterans' bounty warrant she was able to sell. She moved in with her son a few years before she died in the late 1860s.[9]

Transmitters of Traditional Culture

When Thomas Jefferson came to Long Island in 1791 to record the Algonquian language, William Floyd, Long Island's signer of the Declaration of Independence, took him to the Unkechaugs living at Poospatuck near Floyd's Mastic home. The only ones who could still speak the native language were a few elderly women. Jefferson wrote the Unkechaug words phonetically, and the women provided the English translations. Today, only a few pages of Jefferson's project survive.[10]

A number of women have preserved the history and lore of the Indians in their published writings. Lydia A. Jocelyn was the co-author with Nathan J. Cuffee of *Lords of the Soil: A Romance of Indian Life Among the Early English Settlers* (1905). As the title implies, it is a historical novel, though when it was reprinted in 1974, the dust jacket proclaimed that it was "packed with historic fact and Indian lore." Cuffee was a blind Montaukett and Jocelyn the widow of a white missionary to the Dakota Sioux. Presumably Cuffee provided information on the Montauketts, while Jocelyn turned it into a novel. Olivia Ward Bush-Banks (1869–1944) had both African and Indian (Shinnecock and Montaukett) heritage. Some of her poems and particularly her 1920 play *Indian Trails; or, Trail of the Montauk* deal explicitly with her Indian heritage; she was the tribal historian for the Montauketts before 1916.

In 1950, Lois Marie Hunter (born 1903) wrote *The Shinnecock Indians,* which had several reprintings. The title page indicates that Hunter was a "Descendant of Sachem Nowedonah and the [Shinnecock] Rev. Paul Cuffee." She ironically titled a chapter on Shinnecock women "Only a Squaw." Hunter described some of the women's traditional medicinal remedies and their work as domestics, and she briefly sketched the lives of Rebecca Bunn Kellis (1838–1936) and Mary Emma Bunn (died in 1937). Juanita Langhorn Mayo wrote a brief *History of Poosepatuck Reservation,* published in 1958. Anthropologist Gaynell Stone has edited several scholarly volumes in the Suffolk County Archaeological Association's series, including books on the Shinnecocks and Montauketts, as well as native forts.[11]

For thousands of Long Island children, their introduction to Indian life and lore was at the Indian Village at Jones Beach State Park. Rosebud Yellow Robe (1907–1992), a Lakota (Sioux) from South Dakota, was initially hired in 1930 to teach archery at Jones Beach. Within a few years, she was telling stories and legends of Sioux and Eastern Woodland tribes, directing Indian games and teaching Indian handicrafts—including

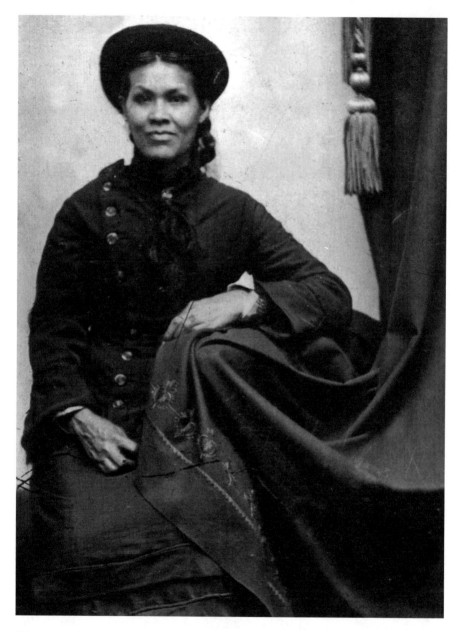

Shinnecock Cora Eleazar, here in 1902, was an informal social worker on the reservation. Except for special celebrations, Indian women have worn clothes similar to other women for more than two centuries. *Courtesy of the East Hampton Library, Long Island Collection.*

beadwork and basketry at the Plains Indian Village on the beach that featured three tipis and rotating exhibits of artifacts. Rosebud lived in Forest Hills, Queens, and worked at Jones Beach for two decades (1930–50), though her activities there were curtailed during World War II when she worked at Sperry Gyroscope Company.[12]

Protecting Tribal Land

Women played important roles in the struggles over the years to protect tribal land. Seven women were the majority on an 1859 petition to the Albany legislature signed by twelve Shinnecocks. They protested that a petition with names of twenty-one male Shinnecocks to surrender their 1703 thousand-year lease to the Shinnecock Hills included forgeries, names of minors, deceased men and non-Shinnecocks. Their protest was ignored.[13]

Women continued to be involved in efforts to protect their land in the twentieth century. Three of the seven Montauketts in a photograph of leaders who fought to retain their lands in 1909–18 are women. Emma Maynes Brackett (1899–1993) defended Poospatuck land rights in 1935 in an attempt to abrogate a 1700 deed. Shinnecock Community Group, formed in 1952 to fight the Cove Realty Company's effort to take reservation land, had an equal number of Shinnecock women and men. Harriett Crippen Brown Gumbs has documented her leadership role in the Shinnecocks' successful legal challenge; the U.S. Supreme Court dismissed Cove Realty's appeal.[14]

A recent threat to tribal land was thwarted in 1996–97. When Doreen Dennis-Arrindell heard a bulldozer near her home on the Shinnecock Reservation, she sat down in front of the bulldozer and, a week later, in front of a truck. This prevented William Pell IV from clearing Shinnecock land that he claimed to have purchased. Two women Shinnecock

Rebecca Bunn Kellis was Montaukett and Shinnecock. "Aunt Becky" lived in a cottage on the Shinnecock Reservation in her later years. *Courtesy of the East Hampton Library, Long Island Collection.*

lawyers, Marguerite Smith and Roberta Hunter, worked with the Suffolk County district attorney's office when the case went to court, and the Shinnecocks secured a favorable decision. The judge ruled that "most, if not all" of the site Pell had tried to clear was Shinnecock land.[15]

WOMEN ON THE SHINNECOCK AND POOSPATUCK RESERVATIONS

Two Indian reservations on eastern Long Island have been recognized by New York State for more than two centuries. At Shinnecock in Southampton, 363 people lived on the eight-hundred-acre reservation as of the 2010 census; Poospatuck in Mastic (fifty-two acres) is home to about 300 Unkechaugs. Women are in the majority on both reservations. The Shinnecocks achieved federal recognition in 2011. In addition, some Montauketts and Matinecocks survive in scattered enclaves, and in recent years they have become more active, as John Strong recounted in his book *"We Are Still Here!" The Algonquian Peoples of Long Island Today* (1998).

In 1792, the New York legislature imposed a trusteeship government on the Shinnecocks. Patterned on a then-prevailing practice in the white community, it provided for only male trustees and male voting, though women previously had full participation in Shinnecock governance. Beginning in the late 1960s, individual Shinnecock women raised the issue of their exclusion from voting. The Shinnecock Women's Group began to raise the issue again in the 1980s, and in 1992, members convinced the male Shinnecocks to allow women to vote in tribal meetings and, in 1993, in trustee elections.[16]

Women have long been active in the churches on the Shinnecock and Poospatuck Reservations. In 1986, a Shinnecock, Holly Haile Davis, was the first Native American woman ordained as a minister by the Presbyterian Church (USA). Food is central to the June Meeting, a traditional celebration on the reservations—hence women are key. They are also involved in the more publicly visible annual powwow on the Shinnecock Reservation under the Shinnecock Presbyterian Church and tribal trustees. The powwow was revived in the twentieth century and has been held during the Labor Day weekend every year since 1946.

Women have been prominent in other organizations on the reservation as well, often in leadership positions, including the Shinnecock Nation American Cultural Coalition, the Shinnecock Senior Citizens Nutrition Program,

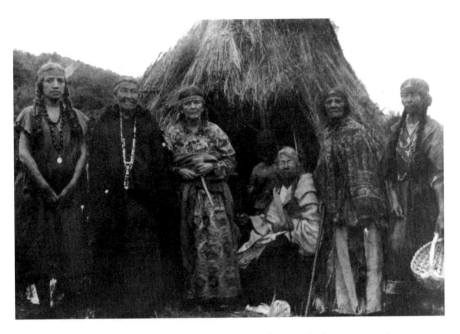

Women on the Shinnecock Reservation in 1915 in Indian regalia for a pageant (a predecessor of the powwow). All are Shinnecocks except as indicated. *From left*: Adeline Cuffee Cogsbill, Mary Emma Bunn, Rose Kellis Williams, Anna Bunn Kellis, Mary Augustus Cuffee (Montaukett), Adela Bunn Santoya (Matinecock, Unkechaug and Shinnecock). *Courtesy East Hampton Library, Long Island Collection.*

Shinnecock and Poospatuck Title V Education Projects, Shinnecock Youth Council, Shinnecock Indian Health Center, Unkechaug Culture Class and the Shinnecock Nation Museum and Cultural Center. The photographs in John Strong's *"We Are Still Here!"* confirm the extensive involvement of women in reservation activities.

The Shinnecock Nation Cultural Center and Museum on Montauk Highway in Southampton houses murals and photographs of Shinnecock women. This and other Long Island museums—particularly the Southold Indian Museum, Suffolk County Historical Society Museum in Riverhead and Garvies Point Museum in Glen Cove—display Indian artifacts, including some created by women such as clay pots, splint baskets and scrubs (brushes made from white oak to clean pots). Men also made baskets and scrubs; lacking signatures, it is impossible to know now whether men or women made the artifacts displayed.

The role of women among the first Long Islanders has a long history. Over the years, they have served as sunksquaws, shamans, traders, transmitters

of Algonquian culture and respected elders in the tribes. Wives and mothers, the women have also been agricultural specialists, protectors of tribal land rights and sustainers of the traditional culture. In the twenty-first century, they are among the leaders in their community as mothers, wives, teachers, lawyers, nurses, entrepreneurs, community and social activists and honored elders.

Chapter 2

COLONIAL LONG ISLAND

Beginning in the mid-1620s, the Dutch established New Amsterdam at the southern tip of Manhattan. Within a few years, some had crossed the East River to western Long Island for farming and eventual settlement. On the East End, groups of New England families sailed across Long Island Sound in 1640 to settle Southold and Southampton—each today still dispute which was New York's first English settlement. Although the Dutch and the English both claimed all of Long Island, the Dutch effectively possessed the western portion and, within a few decades, had five Dutch towns in what today is Brooklyn. English settlements in the seventeenth century also included East Hampton, Brookhaven (Setauket), Huntington and Oyster Bay. The Dutch permitted English families to settle in their territory, particularly in what later became Queens County—including Newtown (now Elmhurst), Jamaica, Flushing and Hempstead.

At the negotiations for the Treaty of Hartford in 1650, the Dutch and English agreed to settle their overlapping claims via a line drawn at the western edge of Oyster Bay, a few miles west of today's Nassau-Suffolk line. The English never ratified that treaty, however, and in 1664, King Charles II gave his brother, James, the duke of York, land from the west shore of the Connecticut River to the north shore of Delaware Bay—including Long Island and the Hudson River Valley. Soon, with cannons from an English warship facing the New Amsterdam settlement, the Dutch governor, Pieter Stuyvesant, reluctantly surrendered New Netherland to England, which renamed it New York.

This political change had important implications for women, since women had greater equality under Dutch than English law. In New Netherland, married women could own property, operate businesses and engage in trade in their own name. Under English law, when man and wife married, they became one, and the woman lost her legal identity; she could not even control property that she had brought to the marriage. Moreover, English inheritance practices generally favored sons, particularly eldest sons through primogeniture.

SEVENTEENTH-CENTURY SETTLERS

Lady Deborah Moody established the first English settlement on western Long Island. Born Deborah Dunch in London circa 1586 to a prominent and wealthy family, she married Henry Moody in 1606. He was soon knighted, and she became Lady Deborah. She was widowed in 1629, and a decade later, when she was in her mid-fifties, she sailed to Massachusetts to settle in Saugus (now Lynn) with a grant of four hundred acres of land. She joined a church in Salem where she knew the minister. Lady Deborah's religious views soon brought her into conflict with church authorities, however, and by 1642, they were admonishing her for her Anabaptist beliefs (she rejected infant baptism). She left the Massachusetts Bay Colony and was excommunicated.

Lady Deborah went first to Providence, then to New Haven and finally to New Netherland in company with friends and sympathizers. Governor Willem Kieft allowed her to settle in Dutch territory in southwestern Long Island. Soon after arrival, an Indian attack occurred, and Lady Deborah considered returning to New England, but she likely would not have been welcomed back. Massachusetts authorities said that "she is a dangerous woman," doubtless referring to her religious views. She returned to Gravesend in 1645 and received a patent from Kieft for the settlement that guaranteed freedom of worship and self-government. Lady Deborah was the chief patentee and managed the settlement, which stood north of today's Coney Island. She laid out the town in four squares—an early example of town planning. In 1657, members of the Society of Friends (Quakers) held meetings in her home. It is uncertain if she became a Quaker, but Gravesend did become a center of Quakerism on Long Island. The "Grand Dame of Gravesend" died circa 1659. A memorial to her may be seen in Lady Moody

Square in Gravesend. Lady Deborah was unique in heading a settlement and was a bold woman worth remembering in Long Island history.[1]

Colonial records usually include only names of men among the original settlers, but Long Island towns were settled by families. Women signified permanence—a settlement. A trading post, lumbering camp or fishing outpost might have only men, but with women—despite their invisibility in the written record—came a commitment to stay. Histories of the Bethpage Purchase in 1695, for example, refer to Thomas Powell and his fifteen children. He surely did not have all those children by himself, yet most accounts barely mention his two wives (after his wife Elizabeth died, he married Abigail) or refer to them only as "Mrs. Thomas Powell." Multiply Elizabeth and Abigail Powell's thirty years of childbearing by the experience of hundreds of other colonial women, and it yields the population growth that developed and nurtured the island.

In the colonial period, women's sphere was the home and not the public arena. Official records, newspapers and historical accounts overwhelmingly report on the activities of men. Most women's lives, well into the twentieth century, centered on home, family, church and children—the domestic

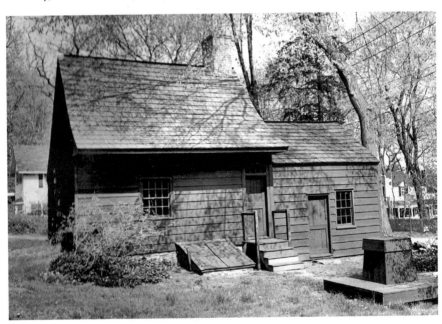

The Van Nostrand–Starkins House, 221 Main Street, Roslyn, dates from circa 1680. Twice enlarged in the eighteenth century, the historic property is restored to circa 1830. Photograph by Ray Jacobs. *Courtesy Roslyn Landmark Society.*

sphere. Historian Laurel Thatcher Ulrich in *Good Wives: Image and Reality in the Lives of Women in Northern New England, 1650–1750* (1982) provided rich evidence of women's activities in these decades. Domestic production of clothing involved raising flax and sheep, processing fibers or wool, spinning, weaving and sewing. Women also tended vegetables, fruit, herbs and animals. They preserved, prepared and cooked food on the hearth. Making and keeping the fire burning for cooking was a never-ending task. Cast-iron cooking pots and flat irons require heavy lifting, and laundering was a tedious task.

Today, our historic house museums interpret domestic life during this colonial period, including the Old House in Cutchogue (circa 1649), the Pieter Claesen Wyckof House in Flatbush (circa 1652), the Halsey House in Southampton (circa 1660), the Van Nostrand-Starkins House in Roslyn (1680), the Schenck House at Old Bethpage Village Restoration (1730) and the Conklin farmhouse in Huntington (1750).

ACCUSATIONS OF WITCHES

In the seventeenth century, many people believed in the supernatural and witches. A generation before the infamous Salem witch trials, two Long Island women were indicted for witchcraft. In 1657, sixteen-year-old Elizabeth Howell, sick and delirious with fever after childbirth, accused Elizabeth Garlick of East Hampton of being a witch. Howell, daughter of the prominent Mary and Lion Gardiner, died, and accusations of Garlick being a witch multiplied. Goodwife (or "Goody") Davis was the source of many of the charges. In his account of this case, historian T.H. Breen points out that East Hampton had a history of "slander and defamation," for which men typically went to court. These cases were among the few times that women enter the public records. Breen described the witchcraft accusations as a gender-specific "defense against insults." Women accused other women in a "contest over social status."[2]

Three justices indicted Elizabeth Garlick after hearings in East Hampton, with depositions from both men and women. The East Hampton judges sent the case to Hartford, which had jurisdiction in capital crimes. The penalty for a person convicted of being a witch (and it was almost always a woman) was death by hanging. The male judges did not find Elizabeth Garlick guilty of witchcraft but required her husband to post a bond to ensure his wife's

good behavior; she also had to report periodically to the court, either in East Hampton or Connecticut.[3]

In 1664, Ralph and Mary Hall of Setauket were accused of witchcraft regarding the deaths of George Wood and his infant son. This case was tried in New York City. The husband was exonerated, but the jury had "some suspicions by the evidence" regarding Mary Hall, though "nothing considerable of value to take away her life." Ralph Hall was bound for his wife's appearance at court and for her good behavior.[4]

In these two cases of Long Island's witchcraft accusations, the women were not found guilty, but neither were they completely exonerated. Each was released only after her husband posted bond for her good behavior.

QUAKERS

In Massachusetts, Quakers were also being persecuted and even hanged in those years. Mary Dyer and her husband were banished from Massachusetts in 1638 for their religious beliefs. Dyer had joined the Religious Society of Friends (Quakers) after hearing its founder, George Fox, preach in England. Returning to America, she protested Quaker persecution in Boston and was permanently banished. Dyer preached on Long Island, including at Shelter Island, before returning twice to Boston, defying the ban. She refused to repent and was hanged in 1660. Soon after, Mary Wright, an eighteen-year-old Quaker from Oyster Bay, went to Boston to protest Dyer's hanging. Wright was arrested and imprisoned but spared a death sentence (the law on executing Quakers had been revoked), yet she did not escape punishment. She was stripped naked to the waist, publicly whipped, tied to the back of a cart and driven out of the colony.

Soon, Mary Wright's younger sister, Hannah, went to Boston to demand an end to Quaker persecution. She was spared punishment because she was only thirteen, but her sister Lydia later traveled to Boston and was arrested. At the court trial in 1677, Lydia's testimony demonstrated her quick wit and tart tongue; she was also banished and tied to a cart but was not whipped. These remarkable Wright sisters from Oyster Bay stood up for their beliefs in their public protests in Boston.[5]

The Wrights were not the only Friends on Long Island. The island was a center of Quakerism and antedated William Penn's settlement

This Matinecock Quaker Meetinghouse was built in 1725; photograph by Harvey Weber, 1984. After a fire in 1985, the meetinghouse was carefully reconstructed. *Courtesy Collection of the Huntington Historical Society, Long Island, NY.*

in Pennsylvania by more than a generation. Quakers were the fourth-largest religious group in the American colonies. By the late 1600s, there were more Friends meetings in Queens County (which included towns in present-day Nassau County) than Presbyterian, Dutch Reformed or Anglican (later Episcopal) churches. Quakers were numerous in colonial Long Island and exerted influence disproportionate to their numbers into the early 1800s. They practiced greater equality for women centuries before most other religious groups—women Quaker ministers and missionaries came to Long Island, and women ministers from Long Island traveled to preach and exhort. Hannah and Lydia Wright became "public Friends," preaching in Maryland and the Caribbean.[6] Friends meetinghouses survive today in Westbury, Flushing, Jericho, Bethpage, Matinecock and Manhasset. Shelter Island has a monument to Quaker martyrs, including Mary Dyer.

Slavery

African Americans have been on Long Island almost as long as Europeans. In the first decades of New Netherland, some of the Dutch farmers brought their enslaved labor across the East River to today's Brooklyn. At the East End, Nathaniel Sylvester brought slaves from Barbados to his provisioning plantation on Shelter Island in the 1650s. Slavery was widespread, with 40 percent of Long Island households having one or more slaves in the late 1600s. Wealthy farmers might have six to twenty slaves. In 1706, New York enacted a law providing that any child born of a slave woman would be a slave, regardless of the status or color of the father. Blacks were 15 percent of the total population in Suffolk by 1723 and 20 percent in Queens and Kings Counties; virtually all were enslaved, and 44 percent were female. African American women were involved primarily in domestic work in the household, but they might also work in the fields.[7]

Slaves could be hired out, sold or bequeathed to the next generation. As historian Lynda Day has pointed out, "succeeding generations of slave-owning families could capitalize on the natural increase of valuable slave property," as women bore and reared children. However, "succeeding generations of African American slaves had to struggle to retain even their familial ties and the culture and values normally passed down within them."[8]

Quaker Alice Crabb, the mother of the Wright sisters, is remembered for the first recorded manumission of a slave on Long Island. She freed Tom Gall in her 1685 will. The Oyster Bay freeholders gave him several acres of land in 1697, by which time he was married.

Mary Cooper's Life from 1768 to 1973

We are fortunate to have five years of a diary of an Oyster Bay farm woman in the last years of the colonial period. Mary Cooper wrote primarily of domestic affairs, the weather and going to "meeting" (church). Most entries are brief: the weather is warm or cold, rainy or windy; she and her daughter, Esther, walked the three miles to "town" (Oyster Bay) or sometimes she rode horseback or took a carriage; and she went to purchase sugar, molasses, salt or flannel. Diary entries mention going to church on Sundays and sometimes during the week. Most often, Mary attended the New Light Baptist services but sometimes the Anglican church or a Friends meeting. She wrote often of

the minister and his sermon text. Religion was important in her life, as it was in the lives of most women at that time.

Although the Coopers had at least one household slave, Mary was often exhausted from preparing and preserving food; cleaning the house; washing dishes and clothes; producing thread, soap and candles; providing for visitors; and performing other household tasks. Cooper lived on Cove Neck in Oyster Bay. Born in 1714, Mary Wright married Joseph Cooper at fourteen and had six children. Two died in infancy and two in childhood, and the two daughters who survived to adulthood each died before their parents. Early death was a fact of life in colonial America, but Mary experienced more than her share.

Her relationship with her husband, Joseph, apparently did not bring her great joy, though she hardly mentions him in the diary. She wrote in 1769, "This day is forty years since I left my father's house and come here, and here have I seen little else but hard labour and sorrow, crosses of every kind. I think in every respect the state of my affairs is more than forty times worse than when I came here first, except that I am nearer the desired heaven. A fine clear cool day. I am un well."[9]

Mary Cooper's house, circa 1770. The house survives in private ownership, though it has been extensively remodeled. Drawing by John Collins, 1981. *Courtesy Oyster Bay Historical Society.*

Cooper wrote the surviving pages of her diary in her fifties. She had been estranged from her older daughter, who had eloped and died in 1752 but left Mary a granddaughter, who visited frequently, as did Mary's sister. Esther, Mary's surviving daughter, born in 1744, had separated from her husband and lived with the Coopers during the diary years. Esther suffered from depression, and Mary often recorded her bouts of crying. She would die in her thirties, several months before Mary herself died in 1778.

In addition to the family relationships, Mary's diary provides insight into housewifery and home life in the colonial period. The Coopers had four slaves in all, including at least one female. Visits from relatives, friends, tradesmen and even strangers are frequent, and Mary had to feed them—some even stayed overnight. It was rare when she could write, "no body here. I am alone." More often, she was "sore distressed." Though she did have assistance with household tasks from her daughter and the house slave, one January evening she wrote, "O, I am tired almost to death waiting on visitors. My feet ache as if the bones was laid bare. Not one day's rest have I had this week. I have no time to take care of my clothes or even to think my [own] thoughts." She frequently wrote that she was "un well," but more often that she was exhausted: "I am tired almost to death, dirty and distressed."[10]

Mary's days were full—the normal cooking, baking, ironing, cleaning and washing, but also combing wool, preparing flax, spinning, sewing, making candles, salting beef, making sausage, preserving quinces, boiling soap, gathering berries and drying apples, cherries and pears. She doubtless grew vegetables and herbs, milked the cows and made butter and cheese as well. The Coopers had horses, hogs, cows, sheep and honeybees, and they raised wheat, hay, potatoes and corn. Mary refers to peaches, strawberries, cherries, blackberries and pumpkins. One entry, perhaps by her husband since the handwriting is different, records selling gammons (smoked hams), butter, cheese, hog fat, cider, potatoes, calves and wheat.

Although Mary Cooper wrote the extant pages of her diary in the years when Revolutionary fervor was developing, she did not mention political events. Visitors may have brought news from Boston and New York, but the only schisms she mentioned are in the local church. Her life, as for most other colonial women, was lived primarily within the domestic sphere and within a few miles of her home.

The experiences of Lady Deborah Moody, women accused of witchcraft and the Wright sisters were unusual, but they tell us much about their times. Quaker women had greater opportunities than most women, and enslaved

women had less. Mary Cooper's diary gives us glimpses of the everyday lives of women on rural Long Island, with seemingly endless work and life centered on the household, domesticity and religion—family and farm, children and church. All of these women contributed to the success of colonial settlements and to Long Island's steady growth. By the eve of the Revolution, the population of the island, from Brooklyn to Montauk, was twenty-eight thousand.[11]

Chapter 3

THE REVOLUTIONARY SCHISM AND THE OCCUPATION OF LONG ISLAND

In the mid-1760s—as the colonial period was moving into the Revolutionary era—the English Parliament enacted taxes on the American colonists in the Stamp Act and the Townshend Acts.[1] The colonists' economic boycotts organized in response would have been ineffective without the women who refused to purchase tea, cloth and other goods imported from Britain. Women found substitutes for tea. "Daughters of liberty" took out spinning wheels and wove homespun. A Boston newspaper in 1769 reported, "Three young Ladies at Huntington on Long Island, namely Ermina, Leticia and Sabrina, having met together, agreed to try their Dexterity at the Spinning-wheel; accordingly the next morning they sit themselves down, and like the Virtuous Woman, put their Hands to the spindle and held the Distaff; at Evening they had 26 Skeins of good Linen Yarn each Skein, containing 4 ounces, all [of] which were the effects of that Day's Work only."[2]

By 1771, Suffolk County had the largest population (13,100) of Long Island's counties. Most of its people were Whigs, or Patriots, in the mid-1770s. The majority of Kings County's 3,600 residents were Tories, or Loyalists. Queens, which had nearly 11,000 people and included present-day Nassau County, was divided. In fact, Patriots in northern Hempstead seceded in September 1775—a split confirmed by the state after the Revolution with the division of the town into North Hempstead and South Hempstead (now the town of Hempstead). But the divisions in the Queens population were not equal. Recent estimates are that a majority of men in Queens County, 60 percent, were neutral or apolitical, with

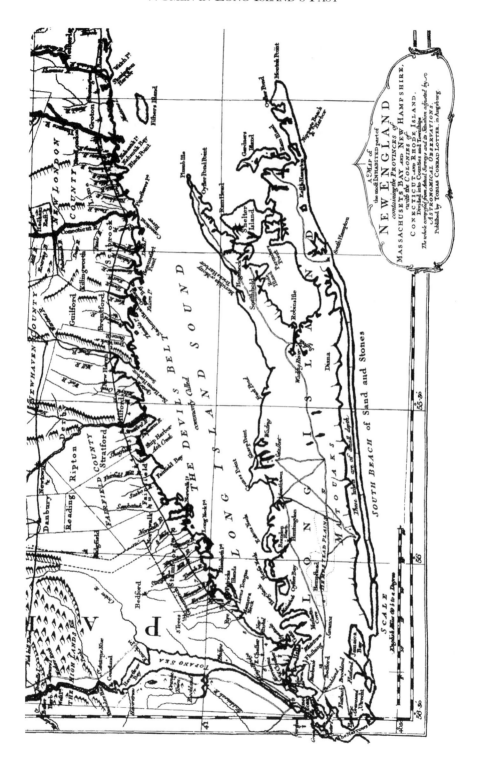

Above: Drawing of Rock Hall, built circa 1767. The Hewlett family donated Rock Hall to the Town of Hempstead in 1948; it was opened as a historic house museum in 1953. *Courtesy Rock Hall Museum.*

Opposite: Detail from a 1776 map showing Long Island. "Matouaks" (on the South Side) was an Indian name for Long Island. *Courtesy Nassau County Museum Collection, Long Island Studies Institute, Hofstra University.*

27 percent Loyalist and only 12 percent Patriot, when they could declare their position in 1775.[3] These divided loyalties alienated neighbors and split some families—mothers and sons, sisters and brothers—making the Revolution on Long Island a civil war.

Women coped with these divided loyalties in varying ways. Before the outbreak of full-fledged war, the New Jersey Patriot militia came to Long Island in January 1775 to disarm the "disaffected" and arrested several prominent Loyalists, including Dr. Samuel Martin. Samuel's father, Josiah, was in his mid-seventies and in poor health, leaving the household of three generations at Rock Hall in today's Lawrence in the hands of women. Patriot soldiers occupied the Martin home, which included Josiah's wife, Mary, his daughters, Betsey, Alice and Rachel, and Betsey's three daughters, ages six months to thirteen years. Betsey's husband had been the royal governor of North Carolina, but the family had to flee, and he remained on a British ship for safety. After returning to Rock Hall, he wrote that the

women had been "exposed to the most mortifying insults of the ruling mob" and suffered the "mortification of being obliged to entertain all the ragamuffins" who quartered in their house.[4] The women's experience at Rock Hall was not an isolated incident.

THE BATTLE OF LONG ISLAND AND FAMILIES OF LONG ISLAND'S SIGNERS

At the Battle of Long Island, late August 1776 in Brooklyn, the Patriots were greatly outnumbered and soundly defeated. It could have been the end of the war, but the British failed to follow up on their victory, and then rain, wind and a heavy fog enabled General Washington to evacuate his surviving troops to Manhattan. This was Long Island's one major battle, other than isolated skirmishes and some cross-Sound raids from Connecticut. The British paroled captured Patriot officers to homes in Brooklyn, and women had responsibility for sheltering and feeding the prisoners and nursing wounded soldiers. It was the British occupation that most affected Long Island women during the Revolutionary years.

The "Old Mastic House" at the William Floyd Estate, 2011. Floyd family descendants donated the property to the federal government in 1976. *Courtesy National Park Service, William Floyd Estate Archival Collection.*

Three of New York's four signers of the Declaration of Independence had ties to Long Island, and the families of two were directly affected by the occupation. Francis Lewis had a country home in Whitestone, Queens. When British troops swept over the island in September 1776, one of their first targets was Lewis's retirement home. He was not there, but they wrecked the house and took his wife, Elizabeth, prisoner. She was kept several months in a room "without a bed or a change of clothing" and was given little food. Eventually, General Washington had two prominent Tory women in Philadelphia kidnapped and "threatened them with the same treatment as Mrs. Lewis unless she was released." Elizabeth Lewis was able to return to her husband, but not to Long Island. She "was broken in health, both mentally and physically" and died in 1779, a casualty of the war.[5]

A second signer, William Floyd, lived in Mastic in Suffolk County. His wife, Hannah, and their children left for Connecticut in September 1776 after the Battle of Long Island. The British occupied his house for a time during the war, and local Tories took their livestock, furniture, bedding and farming implements. Hannah died five years later in Connecticut at the age of forty-one. While with her father in Philadelphia in 1783, his sixteen-year-old daughter, Catherine, became engaged to James Madison. However, she soon broke the engagement and, two years later, married a younger man.[6]

OCCUPATION OF LONG ISLAND

After the Battle of Long Island, the New York Convention recommended that Long Islanders send their women, children and slaves, together with grain and livestock, to safety in Connecticut. These "refugees of Long Island" were an estimated five thousand—more than 15 percent of the island's prewar population. Most refugees were from Suffolk County, where perhaps 30 percent of the population became refugees in Connecticut.[7] They took only what they could carry, and most owned no land or homes there.

Other women stayed on Long Island, and since many men were away in the military, they assumed more responsibility for the outdoor work on farms. They had always been in charge inside the house and tended the kitchen garden with its herbs and vegetables, as well as chickens and dairying. But when wartime disrupted regular routines, women found ways to cope. This experience of independence and greater responsibility during the war may have had lasting effects on family life.

Some Long Island women became camp followers—joining their husbands serving in the military. These "Women of the Army" provided medical and other services and received rations. The Associated Loyalists at Lloyd's Neck, for example, allocated half rations for women and one-quarter for children. Some Connecticut Loyalists moved to Long Island during the war, and their situation was also difficult.[8]

Many families who stayed on Long Island during the war lost their physicians, who were away in the military. In their absence, women provided nursing and medical care. In Huntington, Elizabeth Williams Potter had often assisted her husband, Dr. Gilbert Potter. While he was serving in the Patriot army, she attended the sick in Huntington, both civilians and British soldiers.

"Whaleboat warfare" involved guerrilla raids across Long Island Sound from Connecticut in the small boats used for chasing whales. British forts and hay stores were often the targets, but women sometimes became victims in these attacks. In 1779, Loyalist judge Thomas Jones was kidnapped from his home at Fort Neck in today's Massapequa, to be exchanged for Patriot militia general Gold Selleck Silliman. As her husband later wrote, the Patriots "robbed Mrs. Jones of her wearing apparel and took that of two young ladies in the house," excepting only "the clothes upon their backs." The men sold the clothes and divided the proceeds.[9] As is obvious, whaleboat warfare could degenerate into plundering and stealing. Local residents and British soldiers sometimes also looted, masquerading as Patriot raiders.

Some women—as well as soldiers and civilian men—were killed or injured in the guerrilla raids. After Major Benjamin Tallmadge's successful 1780 raid on Fort St. George in Mastic, a newspaper reported that "a poor woman was also fired on at another house and barbarously wounded through both breasts."[10]

At least one woman, Anna (called Nancy) Strong, was probably involved in the famous Culper Spy Ring. Oral tradition holds that she signaled the Patriots coming from Connecticut to where it was safe for the boats to land using a prearranged code of handkerchiefs and petticoats on her clothesline. Although documented evidence for the celebrated clothesline is lacking and the story may have been embellished over the years, it is part of Long Island's popular folklore.[11]

During the Revolution, most Quakers tried to remain neutral because of their pacifist views. Consequently, each side accused them of aiding the other. Quakers had also pioneered antislavery efforts. In 1771, one in six Long Islanders was African American—17 percent of the population—and almost all were enslaved. Queens County had the largest number (2,236),

but Kings had the highest percentage (32 percent) and Suffolk the lowest (11 percent). Slightly fewer than half were female. By 1776, Long Island Quakers could not be in good standing if they had not freed their slaves.[12]

Both the British and Americans offered freedom to enslaved blacks who enlisted, and some doubtless used the disruptions of wartime to gain their personal liberty by running away. The records of this period have little information on Long Island's African American women (and none at all for Native American women). At the Loyalist evacuation in late 1783, one advertisement sought return of a runaway female slave from Jamaica. Seventeen black women from Queens County were among the evacuees from New York to Nova Scotia at war's end. Most were likely enslaved and accompanied white Loyalist families.

Domestic Resistance

Local historian Edna Yeager (1906–1979) has provided the most extensive account of "Long Island's Unsung Revolutionary War Heroines" in her writings in the 1970s. Certain of her vignettes may be romanticized, but they hold elements of truth. Many describe incidents of "domestic resistance"—the most famous of which occurred in East Hampton. Mrs. Joseph Osborn was cooking a berry pudding; in other accounts, it is Indian pudding made from cornmeal and molasses. Attracted by the aroma, some nearby soldiers came and demanded the pudding. Fannie Elkins told the story in verse in the nineteenth century. Her poem concludes: "Oh, no you're not she made reply / Then seized the boiling pot / Ran with it through the open door, / And threw it, blazing hot. / Pudding and all, adown the hill, / And left it in the sand. / Amid the curses, loud and deep / Of all the hungry band." The account may be folklore and embellished, but there is a Pudding Hill Street in East Hampton.[13]

Southold historian Augustus Griffin (1767–1866) also recorded incidents from the Revolution, mainly on the North Fork. British soldiers returning from a raid to Connecticut in 1781 landed at Orient Point where Betsey Vail's husband, Jeremiah, operated a tavern. The Vails saw the soldiers approaching the house. They had two large barrels of applejack (hard cider) in the cellar. Betsey did not want drunken soldiers wrecking her home, so she went down, knocked out the stoppers and tipped the barrels over to empty them. After tying up Mr. Vail, the soldiers unsuccessfully searched everywhere

for "something to drink." When they went to the cellar, they discovered that Betsey had successfully thwarted them. "The ground had drank the liquor, and was still sober." They confronted Mrs. Vail and "demanded her reasons for depriving them of refreshments. She very deliberately replied: 'You are the enemies of my country; I have nothing for you; you have no business here; threats nor oaths don't alarm me. If I have done wrong, I am responsible to my husband, not to you. You will not eat or drink in this house, if I can prevent it.' She expected violence; but they left the house very soon after, muttering curses for her devotion and fortitude."[14]

IMPACT OF THE OCCUPATION

The British occupation was most difficult for residents during the winter months, when there was usually no fighting and soldiers were everywhere on the island. One estimate is that at the peak of occupation, one in six residents on Long Island was a British or Hessian soldier. Some were quartered in private homes, including today's Raynham Hall in Oyster Bay. Sarah (Sally) Townsend was eighteen years old when Colonel John Simcoe selected the Townsend house for his headquarters in 1778. Young officers in the Townsend home flirted with Sally and her sisters, who enjoyed the masculine company. One soldier scratched on a still-extant windowpane, "the adorable Miss Sally Townsend." Colonel Simcoe sent Sally a valentine in 1779 that read, in part, "To you my heart I must resign; / O choose me for your Valentine!" Her supposed involvement in the capture of Major John Andre and the Culper Spy Ring (her brother, Robert, was "Culper Junior") is impossible to document, though it is part of Long Island folklore.[15]

The overall impact of British occupation was multifaceted. Whether quartered in a house, barns or elsewhere on private property throughout Long Island, soldiers did sometimes bring with them smallpox or other diseases. Household routines were disrupted. Homeowners were to be compensated by American officials for paroled Patriot prisoners and by the British for their troops, but usually women received only receipts of dubious worth, depreciating Continental currency or IOUs from the British. These often went uncollected, even at the end of hostilities, when the British were to settle accounts.

The soldiers' presence also brought the fear and reality of rape and venereal disease. It is impossible to estimate numbers because rapes were

A recent view of the Townsend home, Raynham Hall, which is now a historic house museum. *Courtesy Friends of Raynham Hall.*

sometimes not reported, but investigations by the Continental Congress suggest that they occurred "on a large scale." Historian John Staudt reported, "British soldiers attacked pregnant women, the elderly, and girls as young as thirteen years old, and sometimes gang raped their victims over the course of several days."[16]

Some Long Island women married British soldiers; a number of such weddings are documented. But some young ladies were foiled, like "Miss H.," whose family opposed her marriage to a soldier in a Scots Highlander regiment. Just before the British were to leave, she dressed as a soldier, hoping to leave with their troops, but her father came, found her and took her home.

The British occupation of Long Island meant martial law, but not protection for most Long Islanders. British forces also often commandeered food, which meant less food and fewer resources for the families—and it was the women who coped with the shortages. Women and children suffered along with the local men when British soldiers "plundered, pillaged, and terrorized the civilian population."[17] They denuded the woods and fences for firewood and desecrated Presbyterian churches and Quaker meetinghouses. Anglican churches were usually spared, but even Loyalists were not immune. Many Long Islanders endured abuse from the occupying troops.

Local historian Silas Wood, writing in 1824, summarized the impact of the occupation:

> *The officers seized and occupied the best rooms in the houses of the inhabitants. They compelled them to furnish blankets and fuel for the soldiers, and hay and grain for their horses. They impressed their horses and wagons for the use of the army. They took away their cattle, sheep, hogs, and poultry, and seized without ceremony, and without any compensation, or for such only as they chose to make, for their own use, whatever they desired to gratify their wants or wishes.*[18]

These British occupation incidents are mere samplings from a harsh time. As historian Joseph Tiedemann concluded, the British lost the political struggle, and Long Islanders who had been neutral, apolitical or even Loyalist at first became Patriots after British misconduct against civilians—which was exacerbated by officers profiteering at the expense of Long Islanders.[19]

In 1780, as the war shifted to the southern colonies, the British withdrew most of their troops from the East End. And refugees began to return to Long Island, almost all to find their property in shambles. Fields were overgrown and orchards trampled. It is arguable that Long Island suffered more than anywhere—certainly longer, with the occupation lasting seven years and three months.

Long Island's soldiers as well as other Patriots and Loyalists named in the history books had wives, mothers and daughters affected by the Revolution. Whether on the island during the fighting and occupation, as refugees in Connecticut or camp followers with the troops, few Long Island women escaped suffering during the war years. Many became widows, and some were victims themselves. Others had their household goods stolen and homes and property destroyed, or they resisted British demands at great cost. Many Loyalist women left Long Island at the end of the war and became exiles in England or Canada. The experiences of all these women, whether Patriot or Loyalist, may not be as romantic as Sally Townsend's valentine from Colonel Simcoe at Raynham Hall, but Long Island women endured the battles, raids and the calculated humiliations of seemingly interminable occupation, and they survived the ordeal. After the Revolution, women resumed their lives and again embraced domestic concerns. They rebuilt families, homes, churches and communities, enabling the island to do its share in creating the new nation.

Chapter 4

EXPANDING THE DOMESTIC SPHERE
IN THE NINETEENTH CENTURY

Most women on Long Island and throughout the nation espoused the separate sphere of women and the cult of domesticity. Historian Barbara Welter, analyzing prescriptive literature in the decades before the Civil War, identified this "Cult of True Womanhood," with its "four cardinal virtues—piety, purity, submissiveness and domesticity." Women were expected to be religious or pious, as well as morally virtuous and chaste until marriage. They were to be passive and submissive to their husbands. A woman's place was in the home, the domestic sphere, as wife and mother. Her important responsibilities included rearing and educating children, housewifery, nursing and needlework.[1]

Long Island remained primarily agricultural after the Revolution and in the nineteenth century. Most Long Islanders were farming, with many also harvesting the surrounding waters for shellfish and fin fish. Men participated in town meetings and incorporated villages in the developing commercial centers—Jamaica in 1814, Brooklyn in 1816, Greenport in 1838, Astoria in 1839, Sag Harbor in 1846 and Hempstead in 1853. Taverns, general stores and mills dotted the countryside. Long Island histories typically recount President George Washington's 1790 tour of the island; the whaling industry; turnpikes and railroads; academies, schools and churches; men serving in the Civil War; lighthouses and lifesaving; shipbuilding and shipwrecks; and famous Long Islanders, including artist William Sidney Mount, poet Walt Whitman and the founder of Garden City, A.T. Stewart. Women are nearly invisible in most accounts of this

period, but they were half the population and played important roles in diverse activities.

Profound changes occurred for African Americans in the years after the Revolution. In 1788, New York State enacted legislation making it easier for owners to free their slaves, no longer requiring a £200 bond. Helen Wortis (1906–1976) has traced the life of a woman named Matilda (circa 1748–circa 1820), manumitted in 1795 by Thomas Dering on Shelter Island. In 1799, the state adopted a gradual manumission law, providing that females born after July 4, 1799, had to be freed when twenty-five years of age (males were not to be fully free until they were twenty-eight). The owner was entitled to their service until then. Later laws ended all slavery in the state in 1827.[2]

DOMESTICITY IN HOMES, TAVERNS, AND INNS

Most women's lives, as in the colonial period and well into the 1900s, centered on family and children—the domestic sphere, with religion and "good works" also acceptable activities. Walt Whitman paid tribute to women and especially his own mother, Louisa van Velsor Whitman, in his poetry, as lines from his *Leaves of Grass* will illustrate: "Starting from fish-shape Paumanok where I was born, / Well-begotten, and rais'd by a perfect mother." And from his "To Think of Time": "To think how much pleasure there is!… / Do you enjoy yourself… with your wife and family? / Or with your mother and sisters? or in womanly housework? or the beautiful maternal cares?"[3]

Some women worked in other women's homes as domestic servants. In the early decades of the century, they included enslaved African Americans. Free black and white women also labored as domestics or hired help in households other than their own. Typically, they were young single women or unmarried female relatives. All played prominent roles in the household economy—raising, preserving and preparing food, making clothes and nurturing children, among their varied responsibilities.

President Washington's 1790 tour of Long Island was a major event and was commemorated in the 1930s by historical markers and three Works Progress Administration (WPA) murals in public buildings. Certainly women helped prepare food and lodging for his party along the way, and he stopped at Widow Blydenburgh's and Widow Platt's taverns. Women often assisted their husbands running taverns and took over after their husband's death. Ruth Norton Blydenburgh (1738–1802) operated what Washington wrote

was "a decent House" in Smithtown where his party baited their horses. Washington dined in the tavern run by Mary Carll Platt (1732–1795) in Huntington, where he called the food "tolerably good." Clearly, he was not effusive in comments in his journal on food and taverns.[4]

Historic house museums illuminate this domestic sphere of earlier years. They display the material culture that women created—including samplers, quilts and other needlework. Old Bethpage Village Restoration (OBVR) re-creates a typical nineteenth-century rural crossroads village, with buildings moved from various Long Island sites. Interpretation of these buildings focuses on domestic life and on other ways that women contributed to the household economy. Richard Kirby in Hempstead taught his live-in apprentice, Francis Golder, tailoring in the 1840s, but his wife, Rachel, had the responsibility of providing Golder with room and board in their home (now at OBVR).

Women sewed for other women at a time when cloth could be purchased at stores, but clothes had to be made by hand. In these years, seamstress Ester Williams, for example, lived with her brother and sister-in-law on the Williams family farm in what is now New Hyde Park; Ester's experience is interpreted at the Williams home at OBVR. Amelia Hallock Benjamin's husband, William, farmed and was a minister on the North Fork; their home in Northville is also now at Old Bethpage Village. In the mid-1800s, William submitted the lowest bid to the town to take in Mary Reeve, indigent and homeless in her eighties. Amelia certainly did most of the work taking care of her.[5]

Other married women and widows operated boardinghouses. Women did similar work within the larger domestic sphere at taverns and inns owned by their husbands. This was true, for example, of Mary Ann van Pelt Noon, whose husband operated the Noon Inn in East Meadow, 1848–59 (also now at OBVR). Elizabeth van Pelt, Mary Ann's younger sister, lived at the inn and helped when the Noons had a young child. Most shops on rural Long Island were extensions of the house, and women doubtless assisted their husbands in them as well.

Other examples come from Orient on the North Fork. Although Jane Hubbard's husband, William, was captain of a schooner, it was Jane who managed household finances and earned a "major source" of the family's income by "sewing for others, laying out the dead, and nursing the sick."[6] Also in Orient, August Griffin and his wife, Lucretia, operated an inn with the help of a hired girl, but he sold the inn after his wife died in 1849. Samuel and Roxanna Vail ran it as a boardinghouse until their son, Jeremiah, and

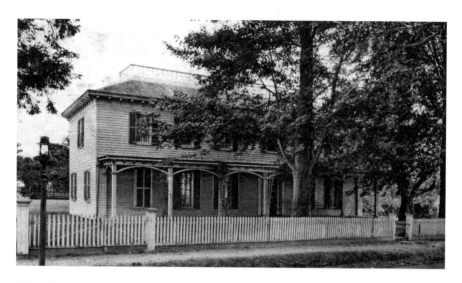

Village House in Orient, postcard circa 1905. Part of the Oysterponds Historical Society's museum complex, Village House is to be interpreted as a boardinghouse. *Courtesy Collection of the Oysterponds Historical Society.*

his wife, Nancy, took over in the 1880s. Both Samuel and Jeremiah Vail were fishermen; much of the boardinghouse work was done by the Vail women. In fact, a Village House business card has only the name of "Mrs. J. Vail."

Women also used their domestic skills to aid soldiers during the Civil War. The most visible culmination of their efforts was the Brooklyn and Long Island Sanitary Fair in 1864. New York City women had helped initiate formation of the federal government's Sanitary Commission in 1861, to coordinate women's volunteer work during the war. The fair was not exclusively a women's project, but the Woman's Relief Association led the endeavor, and women outnumbered men on the various committees. Food for the fair's restaurant and New England Kitchen came from Long Island, and women from throughout the island made handicrafts to sell. The 1864 fair at the Brooklyn Academy of Music raised a record $400,000.[7]

Detailed descriptions of daily domestic life of rural families in the early 1890s appear in a published account by Laura Hawkins. She and her widowed sister, who had grown up in what is now Centereach, visited friends and relatives there and in Lake Grove and Patchogue. They also visited a seaside hotel in Patchogue and took a midsummer excursion to Fire Island.[8]

Religious Institutions and Benevolence

Women have long been active in churches, usually the center of community life and women's main activity outside the home in the 1800s. Long Island remained overwhelmingly Protestant throughout most of the nineteenth century. Churches were usually home to ladies' aid societies, women's missionary societies and sewing circles. Women used their domestic skills to raise money for religious and other benevolent causes through fairs, donation parties, dinners and cookbooks, as food historian Alice Ross has documented.[9]

Women were probably the majority of church members and also of those attending services, though they usually could not vote in congregational meetings. No Long Island church had an ordained woman minister, although as in the colonial period, several Quaker women were public or "traveling ministers." Rachel Hicks (1789–1878) of Westbury had forty-five years of public ministry. Women made up one-third of the Friends' public ministers who came to Long Island.[10]

Sister Anne Ayres (1816–1896) began an order of Episcopal nuns and worked closely with Reverend William Muhlenberg (1796–1877) for what became St. Luke's Hospital in New York City. In 1866, Muhlenberg established St. Johnland in King's Park as a rural "Christian industrial community" for the poor—crippled boys, orphan girls and old men, with a school and farm. Sister Anne was on-site superintendent and administered St. Johnland for its first quarter century. Today, St. Johnland is a well-respected nursing home.[11]

The first Catholic churches on Long Island were organized in Brooklyn and Flushing in the 1820s. St. Andrews in Sag Harbor, St. Brigid's in Westbury and St. Patrick's in Glen Cove date from the 1850s.[12] Catholic nuns have long provided benevolent services, including some focused on women and girls. In 1867, the Dominican Sisters received the donation of an eighty-seven-acre farm in North Amityville, where they established their Motherhouse (now Rosemary Hall), a novitiate, orphanage and old age home. The Dominican Sisters of Amityville have evolved and expanded their ministries over the years. In addition to teaching in Brooklyn parish schools, they now run Benincasa Family Services agency, a literacy program for female immigrants, and sponsor Dominican Village, a retirement and assisted living facility.[13]

ACADEMIES, SCHOOLS AND TEACHING

The first academies chartered in New York State, in 1787, were Clinton Academy in East Hampton (which opened in 1785) and Erasmus Hall in Flatbush. Each enrolled girls in their English (elementary) course and prepared boys for college in their classical course. Academies in Jamaica (Union Hall, 1791), Huntington (1793), Oyster Bay (1800) and other Long Island communities soon followed in the antebellum years before public high schools were available. Besides the basic academic subjects, the Female Departments in these schools usually had a female teacher who taught needlework. Some surviving samplers in museums today came from these academies.[14]

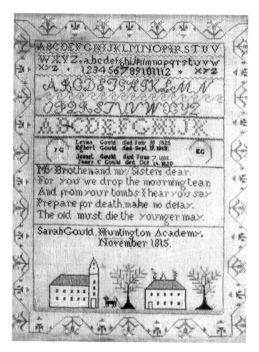

Sarah Gould embroidered this sampler in 1815, memorializing a brother and sister. She later added two more names and made "Brother" and "Sister" plural. *Courtesy Collection of the Huntington Historical Society, Long Island, New York.*

New York State laid out school districts in 1812–14 and mandated tax-supported elementary schools. Most Long Island schools initially had one room and one teacher, enrolling students of a range of ages. Teaching became one of the first occupations that women entered outside the home—an acceptable extension of traditional domestic activities of mothers teaching their own children. The young and single female teachers initially taught in the summer sessions and received only one-third to one-half of what male teachers were paid. By the 1860s, women exceeded men in district schools on Long Island and taught throughout the year. Schoolhouse museums on Long Island ably interpret this nineteenth-century education.[15]

Shipwrecks, Seafaring Sisters and Lighthouse Keepers

Many shipwrecks lie in the waters off Long Island. In 1836–37, two shipwrecks off the South Shore claimed the lives of 215 men, women and children. The 450-ton merchant ship *Bristol* ran aground on the Rockaway shoals during a winter storm. A "tremendous wave" engulfed the ship during the night, and almost everyone on board drowned. Most were emigrants from Ireland; the 8 women and girls who did survive occupied first-class cabins. Six weeks later, the barque *Mexico* wrecked off Long Beach, and 114 on board froze to death, including all 46 women and girls; the 8 survivors were all males. Local citizens purchased land to bury the victims at the Old Sand Hole Cemetery (now the Rockville Centre Cemetery in Lynbrook). Hempstead women bought funeral garments and prepared the bodies of women and children from the *Mexico* for burial. An obelisk memorial built from contributions from local citizens still stands in the cemetery. As is clear from just these two accounts, women were victims in the tragedies, and local women aided their burial.[16]

A surprising number of wives sailed on coastal sloops or schooners, whaling ships or merchant ships with their captain husbands. Joan Druett identified more than fifty "sister sailors" of Long Island in a "preliminary list" in her 1995 book *The Sailing Circle*. All created a home for their husbands on board, and some assisted in navigation or nursing ill crewmembers. Carrie Davis sailed Long Island Sound between Orient and Connecticut ports with her father and husband from the mid-1870s. She was cook and steward on board until her son's birth in 1884.

Other Long Island women traveled to distant ports on merchant ships and whaling vessels. In 1858, Mary Ann Hawkins and her children sailed on the *Village Queen* from Stony Brook to Washington, D.C. Mary Swift Jones of Setauket went with her husband as a bride on his merchant barque *Mary & Louise* to China and Japan that same year. When Martha Smith Brewer Brown from Orient sailed in the whaleship *Lucy Ann* out of Greenport in 1847, she left her two-year-old daughter with relatives. Martha's husband dropped her off in Honolulu to await the birth of their son, a customary practice, but Mary Satterley Rowland of Setauket gave birth to her son on board the brig *Thomas W. Rowland* out in the Atlantic. A few women took their young children on board. Although

not all captains were accompanied by their wives, the unusual experiences of these women were largely forgotten until recent years.[17] Other women had to manage at home when their ship captain husbands were away on long voyages.

Wives of lighthouse keepers often helped their husbands in the work and sometimes were officially appointed as their assistants or, when widowed, as the keepers. Elizabeth Shoemaker served as keeper of the Old Field Point Lighthouse (just west of Port Jefferson Harbor) for five months after her husband died in 1826. Her successor died after three years, and his widow, Elizabeth Smith, served for more than twenty-five years. She was succeeded by Mary Foster, who served thirteen years. Women were keepers of this lighthouse for more than half its nineteenth-century service.[18]

Carrie Hubbard Davis (1853–1950), circa 1873. Carrie sailed on a coaster schooner with her father, Captain William Hubbard, and her husband, Charles Davis. *Courtesy Collection of the Oysterponds Historical Society.*

William Sidney Mount and Alexander T. Stewart

Two important men in Long Island's nineteenth century, as noted earlier, were artist William Sidney Mount (1804–1868) and businessman Alexander T. Stewart (1801–1876). The first contact Mount had with painting was from his younger sister, Ruth Hawkins Mount (1808–1888). She took art lessons at age eleven and was the first in the Mount family to paint. In his writings, William Sidney Mount credited his sister with influencing his interest in art. She worked primarily in watercolors—typical of women's art at that time.[19]

Most of William Sidney Mount's genre paintings feature men or boys, but some do include women. His *Girl with a Pitcher* (1829), *Rustic Dance After a Sleigh Ride* (1830), *Courtship or Winding Up* (1836) and *Walking Out* (1854) show women's clothing on rural Long Island, as he did most of his paintings in the Setauket/

William Sidney Mount (1807–1868), *Walking Out*, 1854, oil on canvas, 27 in. x 22.25 in.
Courtesy The Long Island Museum of American Art, History & Carriages. Bequest of Rommel Wilson.

Stony Brook area. Attorney George Washington Strong commissioned Mount's *Recollections of Early Days, Fishing Along Shore* or *Eel Spearing at Setauket* (1845), in which the dominant figure is Rachel Holland Hart, an African American woman who had been a servant in Strong's home when he was a boy.[20]

William Sidney Mount, study for *Eel Spearing at Setauket*, n.d., oil on paper, 5 in. x 6.5 in. *Courtesy The Long Island Museum of American Art, History & Carriages. Bequest of Ward Melville, 1977.*

Millionaire Alexander T. Stewart is well known for starting the planned community of Garden City. But when Stewart died, Garden City still had few residents and was far from a thriving community. It was his widow who advanced his dreams, as will be discussed in the eighth chapter.

In addition to their primary roles in family and domestic life and in churches and benevolence, nineteenth-century women undertook additional public activities in inns, classrooms and fairs—and sometimes less traditional experiences on ships and in lighthouses. Women also played key roles in areas described in local histories. Two Long Island women who were traditional wives and mothers—yet also First Ladies in the nineteenth century—stand out in the next chapter.

Chapter 5

LONG ISLAND'S FIRST LADIES

Five First Ladies have associations with Long Island. Two grew up on eastern Long Island, while Edith Roosevelt lived in Oyster Bay for six decades and Eleanor Roosevelt and Jacqueline Kennedy had far briefer connections here. Julia Gardiner and Anna Symmes each grew up on the East End of Long Island but were from different generations and very different backgrounds.[1]

ANNA SYMMES HARRISON (1775–1864)

Anna Symmes Harrison was born in New Jersey yet had deep roots in Southold on eastern Long Island. Her mother died either in childbirth or when Anna was only a year old. Her father remarried, and his second wife also died, so when Anna was four, her father brought her to her maternal Tuthill grandparents in Mattituck. She attended Clinton Academy in East Hampton, probably boarding with a local family. After her grandparents' deaths in 1793, she entered boarding school in New York City. She had lived on the island's East End for fourteen formative years.

While Anna was growing up here, her father settled in the Northwest Territory, and her older sister married and lived in Kentucky. Anna met Captain William Henry Harrison at her sister's home and married him at age twenty, in 1795. Harrison entered public service and politics but

returned to the military and won fame at the Battle of Tippecanoe against the Shawnees in 1811. He served in the Ohio Senate and U.S. Congress and was elected president in 1840 on the Whig ticket under the now-famous slogan "Tippecanoe and Tyler too."

During their marriage, Anna Symmes Harrison was busy bearing, nursing and rearing their ten children. Depressed over the death of an adult son and not in good health, she did not accompany her husband to Washington in 1841, planning to come later. Harrison delivered the longest inaugural address in history (two hours), and he had the shortest tenure of office (one month). Those two facts are connected. At his inauguration on a cold day in March, he spoke outside without coat or hat and caught pneumonia. Anna never made it to the White House or back to Long Island. She lived the rest of her long life in North Bend, Indiana, with one of her sons and helped raise his children—including Benjamin Harrison, who became U.S. president in 1889.

JULIA GARDINER TYLER (1820–1889)

When Vice President John Tyler became president in 1841, his wife was an invalid. After her death in the last year of his term, Tyler married a Long Islander, Julia Gardiner. Julia had been born on Gardiner's Island, grew up in East Hampton and attended a fashionable boarding school in New York. Julia Gardiner's father was a lawyer and state senator, and she reveled in the social life of New York. When she returned to East Hampton, certain young men she had charmed in the city poured out their laments in verses in the newspapers for "Julia—the Rose of Long Island." Her picture appeared on a handbill advertising a New York shop. It did not mention her name, but it was an excellent likeness, and the caption referred to the "Rose of Long Island." Her family was embarrassed by the notoriety and had not patronized the store—it was neither exclusive nor fashionable enough for them. Her parents whisked Julia and her sister off on a grand tour of Europe.[2]

After returning in 1841, the Gardiners went to Washington, D.C., for the social season. They met President Tyler and his eldest son, and Julia flirted with them both, though each was married. Julia Gardiner was in her early twenties and a beautiful young woman—one of the great belles of her day and an accomplished coquette. Vivacious and charming, she captivated men. When the family returned to Washington some months later, Julia garnered five marriage

Julia Gardiner Tyler married the widower John Tyler and reigned as hostess of the White House for the last eight months of Tyler's presidency. *Courtesy of the East Hampton Library, Long Island Collection.*

proposals—one from the now-widowed president of the United States. John Tyler was thirty years older than Julia, and she did not agree to marry him until more than a year later, after a family tragedy. The Gardiners had been with the

presidential party on a navy frigate in the Potomac River when one of the guns exploded while firing a salute. Julia fainted when she heard that her father had been killed, and President Tyler carried her off the ship.

Julia married John Tyler in New York City in June 1844. She was First Lady for only a little over eight months, but she was the Jackie Kennedy of her day. Her role was primarily as hostess of the White House. She wrote to her mother, "I have commenced my auspicious reign and am in quiet possession of the Presidential Mansion." Julia had observed royalty in Europe and now assembled relatives as a court of ladies-in-waiting at public receptions for "Her Excellency and Mistress President" and "Lady Presidentress"—self-appointed titles. She even hired a press agent to ensure favorable publicity. Julia ended her reign as First Lady with a grand farewell ball with three thousand guests.[3]

The Tyler marriage was a very happy one, and they would have seven children. After the presidency, the Tylers lived on his Sherwood Forest plantation in Virginia; they visited East Hampton in 1845 and again the next year for the birth of their first child. Julia Gardiner Tyler is responsible for the portraits of first ladies in Washington. On a visit to the White House in 1868, she asked President Andrew Johnson why there were no portraits of the presidents' wives. Hers was the first to be hung.

EDITH KERMIT ROOSEVELT (1861–1948)

Edith Kermit Carow was born in Connecticut but grew up in Manhattan near the Roosevelts. She was a close friend of the Roosevelt children, particularly Corinne, who was her own age, and Teedie (as Theodore was known as a child), who was three years older. While Theodore Roosevelt was at Harvard, he met Alice Hathaway Lee, whom he married in 1880. She died four years later after giving birth to their daughter, Alice. TR left baby Alice in the care of his older sister, Anna, who also supervised construction of his Oyster Bay house, while TR spent most of his time in the Dakota Territory.

TR and Edith married in England in 1886. After a honeymoon in Europe, they returned to Sagamore Hill in Oyster Bay, and Edith insisted that young Alice be with them. For the first decade of their marriage, Edith was busy having children: Ted was born in 1887, then came Kermit, Ethel, Archie and Quentin in 1897.

Sagamore Hill was the Roosevelt home for more than sixty years. Roosevelt became president in 1901 following the assassination of William McKinley and served until 1909. In the summers, Edith and the children usually left Washington, or Albany when he was governor, for Sagamore Hill several weeks before TR, and they stayed there longer in the fall.

Within the marriage, Edith took on the traditional role of mother and homemaker at a time when domesticity was the only acceptable role for women of her class. As her biographer Sylvia Morris aptly put it, she was "the archetypal Victorian patrician lady, perfectly fulfilled as wife and mother, flawless in her interpretation of the role of First Lady, and 'liberated' in the sense that she lived, with enthusiasm and contentment, exactly as she wanted." Edith had primary responsibility for raising their six children and running the household—whether at Sagamore Hill or the White House—and managing the estate. Theodore was a wonderful father, but he *played* with the children. In fact, Edith sometimes referred to TR as her "oldest and rather worst child." Edith also coped with her

Edith Roosevelt with husband and children, 1907. *From left*: Quentin, Theodore, Archie, Kermit (seated with dog), Ted, Edith and Ethel. TR's oldest daughter, Alice, had married Congressman Nicholas Longworth in 1906 and is not in the picture. *Courtesy Sagamore Hill Historic Site, National Park Service.*

stepdaughter Alice, who could be very obstreperous, and tended to the children's illnesses. Besides the usual skinned knees and other childhood medical problems, Quentin and Ted had asthma, and Ted's double pneumonia and Archie's diphtheria were life threatening.[4]

Edith did have help from servants, so she did not have the drudgery of cooking, cleaning and laundry. The children had a nursemaid, Alice had a governess for some years and at times the boys had tutors. There was always a cook—apparently Edith did not cook at all—as well as one or more other servants in the Sagamore Hill house and outside help for the farm, horses and grounds. Edith hired and fired staff. When Archie was expelled from Groton for his "vulgar and profane" comments about Headmaster Endicott Peabody, Edith was "furious" that Peabody wrote her husband instead of taking it up with her. Another side to Edith as a mother is revealed in thirteen-year-old Kermit's 1903 letter to her from Groton. The authorities had confiscated chocolate and guava jelly in a package she sent him but did not discover a water pistol in the same package. Kermit thanked his mother for smuggling the water pistol, which he said he had used on a sleeping classmate.[5]

Whether in the White House or at Sagamore Hill, Edith had to cope with TR's proclivity for inviting people to lunch, and the numbers of guests could and often did grow. TR's biographer, Kathleen Dalton, cited one week in 1913 when they served 175 meals for family and guests at Sagamore Hill. (This was after TR's presidency and his Bull Moose campaign in 1912, when guests may have been even more frequent.) Some time later, relatives warned TR that "running Sagamore Hill with so many guests was 'killing' his wife."[6]

Edith was good with finances, which was fortunate because TR was apparently hopeless. Dalton wrote that TR "could not manage his own finances. She [Edith] had to look after their money because Theodore was careless about what he spent and always assumed he had enough. He lost checks and forgot for years at a time to balance his checkbook." Edith tried to put him on a budget and would give him $20, but he had no idea when he returned home what had happened to it ($20 in 1910 would be the equivalent of more than $450 today). Dalton added that TR "sometimes balked at the financial limitations she set on him, but he later told his friend Jacob Riis that Edith's competence had helped him get through life because men who were oblivious to finances 'need such business partners.'"[7]

Although Edith liked to remain in the background and was certainly much more reserved than the ebullient TR, their relationship was a political partnership as well as a marriage. She gave advice to TR, and many affirmed

that she was a much better judge of people than he. She also had keen political skills. One person who admired their political partnership recalled, "As a team they produced a judgment that was not infallible, of course, but dangerously near it, humanly and politically." Dalton pointed out that TR "confided in her about even the most top secret subjects" and that she was his "political alter ego." Edith sat quietly knitting during political meetings and afterward would speak with him. Author Owen Wister, a family friend, said, "She was the perfection of 'invisible government.'"[8]

Moreover, Edith was one of the few people who could keep TR's bluster and impulse in check. At such times, she would often interject, "Theodore!" and rein him back. Henry Adams, who was a good friend of the Roosevelts, observed that Edith "in her quiet way, controlled Theodore." In fact, Adams wrote, "He stands in such abject terror of Edith." Cousin Franklin Delano Roosevelt said, "Aunt Edith…managed TR very cleverly without his being conscious of it—no slight achievement as anyone will concede." Even within the family, Edith was something of a *grande dame*. A nephew, son of TR's older sister, Anna (known in the family as Bamie or Bye), said that he was "rather terrified" of his Aunt Edith. Morris pointed out that "even adults were in awe of her." Another relative said, "The only person I ever knew Auntie Bye to be a little afraid of was Aunt Edith."[9]

Theodore Roosevelt himself wrote to William Howard Taft of Edith's role: "I take the keenest pride in seeing Mrs. Roosevelt at the head of the White House—a gentlewoman, who gives to all the official life… an air of gracious and dignified simplicity, and who with it all is the ideal of a good American wife and mother who takes care of her six children in the most devoted manner.…Mrs. Roosevelt comes a good deal nearer my ideal than I do myself."[10]

Historians in 1982 and 2003 ranked Edith among the top ten First Ladies; she was fourteenth in 1993 and eleventh in a 2008 poll. *Life* magazine in 1948 noted that she was "one of the strongest-minded and strongest-willed presidential wives who ever lived in the White House." Elting E. Morison, editor of eight volumes of TR's letters, characterized her as "a most impressive First Lady" whose

John Singer Sargent's drawing of Edith Roosevelt at Sagamore Hill in 1921. *Courtesy Sagamore Hill Historic Site, National Park Service.*

qualities "enabled her to remain a person in her own right and thus to strengthen" TR.[11]

Sylvia Morris described Edith's typical days as "Mistress of Sagamore Hill." She went through her extensive mail in the morning; in the afternoon, she "discussed estate matters with the gardener, planted spring bulbs, rode her horse, went to the local sewing guild, and read aloud with Ethel."[12] The 1915 New York State census listed her occupation as "housework," the usual census designation for housewives, though ironically most of the other censuses report that she had *no* occupation, leaving the line blank or stating "none," ignoring her role in administering and managing the estate.

Edith began to fail physically in her eighties and died in 1948 at age eighty-seven, with her devoted daughter, Ethel Derby, at her side. Her obituary in the *New York Times* noted that "children were her chief occupation." Ethel supplied the information for her mother's death certificate and reported her occupation as "Lady." She was a widow for nearly thirty years, outliving not only TR, who had died in 1919, and his two sisters and brother but also her own sister and three of their sons. Devoted wife and mother, Edith Kermit Roosevelt was the First Lady of the United States for more than seven years and the Lady of Sagamore Hill for more than six decades.[13]

Eleanor Roosevelt (1884–1962)

Eleanor Roosevelt, Franklin Delano Roosevelt's wife, spent so few years on Long Island and at such a young age that she barely qualifies for inclusion here. Her father, Elliott Roosevelt, was Theodore Roosevelt's brother; hence she was TR's niece and Edith Roosevelt's niece by marriage. Elliott wanted to be close to the Meadow Brook Club for its polo, fox hunting and social activities. He rented a house in Hempstead village in 1887 and had a house built on today's Salisbury Park Drive in East Meadow. By the time Eleanor was four years old, her family was living in the new house her father called Half Way Nirvana. After her mother's death in 1892, she lived with her maternal grandmother, Mary Hall, in New York City or Tivoli upstate.[14] As a young girl, Eleanor visited Sagamore Hill and later remembered how her Uncle Theodore would hug her so tightly that her buttons would burst. She made visits to Long Island as First Lady and spoke to local civic groups in later years. Historians have always ranked Eleanor Roosevelt first "by a landslide" among the First Ladies; she is "the archetypal First Lady" who redefined the role.[15]

Jacqueline Bouvier Kennedy Onassis (1929–1994)

Jacqueline Bouvier was born in Southampton Hospital. Her parents had a New York apartment on Park Avenue but had been married in East Hampton. Both of Jackie's grandparents had country homes in the Hamptons, and she spent many summers there. Her paternal grandfather, Major John Bouvier, had summered there since 1912 and regularly gave speeches at the annual Memorial Day celebrations. Jackie and her mother were involved in local dog and horse shows and sometimes competed in Hampton horse shows.

Jackie's mother, Janet, rented a home in Bellport for the summer when her marriage was breaking up. After her mother's marriage to Hugh Auchincloss in 1942, Jackie moved to Virginia, lived in the District of Columbia for a time and summered in Newport, but she still visited her grandparents in East Hampton. Her Long Island connections thus were mainly summers in her childhood years. Historians have ranked her among the top ten First Ladies.

Each of these five First Ladies appears in *Notable American Women*.[16] The extent of their connections with Long Island range from Eleanor Roosevelt's few years as a young child to Edith Roosevelt's sixty-two years. Jacqueline Kennedy and Julia Gardiner Tyler were each born on Long Island, and Anna Symmes Harrison spent her formative years on the East End. Each of the women—in varying degrees—led traditional roles as wives and mothers. Eleanor Roosevelt was the most active First Lady, served the longest (1933–45) and expanded her public activities after FDR's death. Each of these First Ladies was the private woman behind the public man and, in different ways, supported her husband as president and throughout their lives together. Each, as well, was an eminent lady in her own right.

Chapter 6

NOVELISTS, POETS AND OTHER WRITERS

Beginning in the middle decades of the nineteenth century, periodicals and books expanded nationally as technological changes transformed publishing. Women were the majority of the reading public and significant among authors as well. Writing was an opportunity for women to earn income while still being within the domestic sphere of home. The popularity of novels by Harriet Beecher Stowe, Susan Warner, Mrs. E.D. Southworth and other women led Nathaniel Hawthorne to complain to his publisher in 1855 about "a damned mob of scribbling women" whose books often outsold his as well as those of other male authors.

Stowe was born in Litchfield, Connecticut, in 1811, but Catharine Beecher (1800–1878), her older sister, spent her first ten years in East Hampton, where her father, Lyman Beecher, was minister of the Presbyterian church, 1799–1810. Catharine Beecher wrote *A Treatise on Domestic Economy* (1841), which went through many editions, and later collaborated with Harriet in a revision under the title *The American Woman's Home* (1869). Catharine Beecher founded schools for young ladies in Hartford and Cincinnati, as well as organizations to promote women's education. She lectured and wrote extensively on women's education, and in her schools and her writings she encouraged women to become teachers.[1]

MARGARET FULLER (1810–1850)
AND MARY LOUISE BOOTH (1831–1889)

Margaret Fuller, early feminist and literary intellectual, had brief and only tangential connections with Long Island. While a literary critic of Horace Greeley's *New-York Tribune*, 1844–46, she visited William Cullen Bryant at Cedarmere, his country home in Roslyn Harbor. Fuller traveled as a foreign correspondent for the *Tribune* to Europe, where she met and married Giovanni Ossoli in Italy. They sailed for the United States in 1848, but the ship ran aground off Fire Island; Fuller, her husband and their infant son were drowned. A pavilion with a memorial plaque dedicated to Fuller was erected in Point of Woods but vanished in a storm in 1913.[2]

The most illustrious of literary women born on nineteenth-century Long Island was Mary Louise Booth. Her family lived in Yaphank (then known as Millville), and the home where she spent her first thirteen years has been preserved. The Booth family moved to Williamsburg (now part

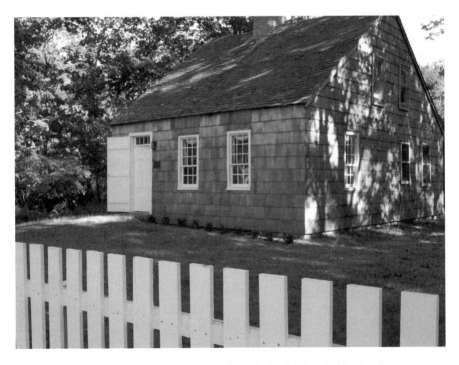

Mary Louise Booth's childhood home, 2012. The Yaphank Historical Society interprets Booth's life in this historic house museum. *Courtesy Yaphank Historical Society.*

of Brooklyn) in 1844, and after teaching briefly in her father's school there, Booth moved to Manhattan at age eighteen. One of the leading translators of her day, she translated some three dozen French literary and historical books beginning in 1856 and also wrote articles for journals and newspapers. Her *History of the City of New York from its Earliest Settlement to the Present* (1859) was reprinted and expanded to two volumes by 1880. Booth became the first editor of *Harper's Bazaar*, 1867–89, the influential weekly that had attained a circulation of 500,000 by 1880.[3]

ELIZABETH OAKES SMITH
(1806–1893)

Elizabeth Oakes Smith (circa 1848) was a poet, novelist, essayist and feminist. *Engraving from Thomas Buchanan Read's popular book,* The Female Poets of America, *1857 edition.*

When Elizabeth Oakes Smith moved to Patchogue in 1859 with her family, she was, as a recent biographer noted, already "among the most highly regarded and best-known literary women of mid-nineteenth-century America."[4] She had begun writing articles and poems for the newspapers that her husband, Seba Smith, owned and edited in their native Maine. (He later gained fame for his humorous Major Jack Downing letters.) The family experienced financial distress due to Seba's land speculations, however, and Smith expanded her own literary activities. They moved to Manhattan in 1839 and on to Brooklyn Heights three years later. Between 1838 and 1854, she published fifteen novels and collections of poetry, as well as poems and articles in magazines. A series of her articles in Greeley's *Tribune* was later published as a pamphlet, *Woman and Her Needs* (1851). Smith attended the Woman's Rights Convention in Worcester, Massachusetts, in 1850 and lectured widely on women's issues.

The Smiths next bought their large house in Patchogue, which they called The Willows. She started a lyceum and sometimes lectured to local

audiences—though most did not support her radical views on women's issues. During the Patchogue years, Smith published two novels, *Bald Eagle, or The Last of the Ramapaughs* (1867; earlier serialized, 1848) and *The Sagamore of Saco* (1868), as well as a series of "Autobiographic Notes" in *Beadle's Monthly*. She continued to publish poetry and articles and attend suffrage conventions. After Seba's death in 1868, Smith sold The Willows and lived for a time with her son in Blue Point, Long Island, and later summered there when living with another son in Beaufort, North Carolina. She died in Beaufort in 1893 but is buried next to her husband at the Lakeville cemetery on Main Street in Patchogue, near the site of the home where she had lived for a decade.[5]

FRANCES HODGSON BURNETT (1849–1924)

Frances Hodgson Burnett is the most prolific of the writers associated with Long Island. Born in England, she came to the United States with

Frances Hodgson Burnett (1908) was a popular novelist in her day, and some of her children's books are classics. Photograph by Virginia M. Prall. *Courtesy Library of Congress.*

her widowed mother and four siblings in 1865. She turned to writing to help support the family, selling her first stories to *Godey's Lady's Book* at age nineteen. In addition to her stories in various magazines, she wrote more than fifty books. Some were popular adult novels, but she is most remembered for her children's books, particularly *Little Lord Fauntleroy* (1886), a bestseller, and the classics *A Little Princess* (1905) and *The Secret Garden* (1911).

Burnett rented a cottage in East Hampton in the summers of 1902–3; here she wrote one of her adult novels and began another. A few years later, while living in England, she asked her son Vivian to find her a place on Long Island. She first rented a cottage in Sands Point and continued

her writing there. She bought two and a half acres in Plandome (now Plandome Manor) in 1908 and built the Italianate villa in which she lived for the rest of her life, with winters in Bermuda. Vivian built a home nearby in 1911, and she delighted in her two granddaughters. In the Plandome years, Frances Hodgson Burnett wrote more than a dozen books, including *The Secret Garden*, a century later still a beloved classic. She is buried at the Roslyn Cemetery on Northern Boulevard. At her grave site is a statue of her son Lionel, who died at fifteen in Paris, where he is buried.[6]

NELTJE BLANCHAN DE GRAFF DOUBLEDAY (1865–1918)

Neltje Blanchan De Graff Doubleday was a nature writer. In 1886, she married Frank Nelson Doubleday, who founded Doubleday Publishing a dozen years later. They lived in New York and from 1904 in their country home in Mill Neck. Using the pen name "Neltje Blanchard," Doubleday wrote five books on birds from 1897 to 1909, including two for children and two on flower gardens. Her adult books were large volumes of several hundred pages, well illustrated and "handsomely printed and bound." Most of her books on birds were reprinted in the early 1900s, and her *Birds Every Child Should Know* was reissued as recently as 2000 by the University of Iowa Press with new illustrations. Doubleday's biographer concluded that she was a "vivid and fairly authoritative nature writer." Her books had wide readership in her day, and she was among the "notable women writers on birds."[7]

EDITH LORING FULLERTON (1876–1931)

Edith Loring Fullerton is best known as the wife and partner of Hal B. Fullerton, who was a publicist, photographer and director of two experimental farms for the Long Island Railroad (LIRR). Born in Brooklyn, Edith Jones grew up in Pennsylvania and attended Brooklyn's Pratt Institute. She married Fullerton in 1898, and they lived successively in Brooklyn, Hollis (in Queens), Huntington (1902–1910), Wading River (1910–14) and Medford (1914–27). Edith Fullerton wrote articles and

books on gardening beginning in 1902. She documented the first year of the LIRR's Wading River farm in *The Lure of the Land* (1906), which went through four editions, and edited the *Long Island Agronomist* for the LIRR, a leaflet issued initially twice a month and then monthly in 1907–14, with a peak circulation of sixteen thousand. She also continued to write magazine articles, besides running the household, bearing and rearing three children, assisting with the farms and participating in civic activities. She was appointed assistant director of agriculture by the LIRR by 1915. After Hal retired as the LIRR's director of agriculture in 1927, Edith became director and closed down the railroad's

Edith Loring Fullerton, circa 1920. The "Lady of the Garden" was an author, editor, lecturer, educator and a horticultural and agricultural expert. *Courtesy Nauman Collection.*

Medford farm. She became a publicist for the LIRR and wrote a brief *History of Long Island Agriculture* (circa 1930).[8]

Gwendolyn Bennett (1902–1981) and Gabriela Mistral (1889–1957)

Gwendolyn Bennett graduated from Girls' High School in Brooklyn and the Pratt Institute, where she studied art and drama. Her poems, published in the NAACP's *Crisis* and the National Urban League's *Opportunity*, have been included in several anthologies. For *Opportunity*, she wrote from 1926 to 1928 the literary and fine arts column "Ebony Flute," which chronicled Harlem Renaissance writers and artists. She moved in 1930 to Hempstead, where her husband, Alfred Johnson, established a medical practice, and she published several articles during the 1930s. After Alfred's death in 1936, Bennett moved to New York and became director of the Harlem Arts Center in 1938. She did not pursue her writing in her later years. Bennett's years in Hempstead were few, but her earlier work has been deemed "central to the Harlem Renaissance."[9]

Gabriela Mistral was the pen name of Lucila Godoy Alcayaga, a Chilean poet who won the Nobel Prize in literature in 1945. She lived in various countries after 1925 but spent her final years from 1953 in Roslyn Harbor. Many of her poems have been translated into English, and her work has also been published posthumously.

MAY SWENSON (1913–1989) AND ROZANNE R. KNUDSON (1932–2008)

May Swenson was a distinguished poet who lived in Sea Cliff for her final twenty-two years. Born in Utah, she graduated from Utah State University and, after a few years, moved to New York City. She published her first poems in national publications in 1949 and soon in the *New Yorker* and other prestigious magazines. Eleven books of her poetry appeared between 1954 and 1987, including three for young adults. She taught as a writer-in-residence at several colleges. A Guggenheim Foundation Grant in 1959, the Bollinger Prize in Poetry in 1981 and a MacArthur ("Genius") Fellowship in 1987 are among her many awards.

In 1967, Swenson moved to a house in Sea Cliff overlooking Long Island Sound. She wrote "From Sea Cliff, March" in 1976, whose first stanza reads:

The water's wide spread
(it is storm gray)
following the border of the far shore ahead,
leads the eye south,
tucks into a cove
where, at the point of another line of hills,
big rocks like huts
strung along the flats
are embraced by the sliding
long arms of the tide.
A red buoy bangs (but you can't hear it,
size of a golf tee seen from here)
wind is picking up, cleats of the water
rising and deepening, no white ridges yet.[10]

Eight books of Swenson's poems have appeared posthumously, from 1991 to 2003, and her poems appear widely in anthologies. A recent evaluation of her poetry stated: "Respected for her colorful and perceptive observations of natural phenomena and human and animal behavior, Swenson playfully experimented with poetic language, form, and sound, making extensive use of such devices as metaphor, alliteration, assonance, and dissonance."[11]

May Swenson on the Hempstead Harbor beach near her Sea Cliff home, circa 1972. Swenson often walked the beach, seeking inspiration for her poems. *Courtesy of the Literary Estate of May Swenson, all rights reserved.*

Swenson's longtime partner and literary executor, Rozanne R. Knudson, lived in Sea Cliff for more than four decades. After teaching in high school and college, Knudson began writing young adult novels and biographies in 1972. Most of her more than forty books deal with girls and women in sports. Her "Zan" stories were particularly popular. Knudson collaborated with Swenson on a collection, *American Sports Poems* (1988), and later published *The Wonderful Pen of May Swenson* (1993) and co-authored *May Swenson: A Poet's Life in Photos* (1996).[12]

MARILYN FRENCH (1929–2009)

Marilyn French was born in Brooklyn and attended Hofstra College (now Hofstra University), earning a BA in 1951 and an MA in 1961. She lived in Rockville Centre, taught English at Hofstra from 1964 to 1968 and, after a divorce, earned a PhD from Harvard in 1976. Her first and best-known novel, *The Women's Room* (1977), was a popular depiction of the impact of the women's movement in suburbia and became a feminist classic. It was based in part on her experiences living and working on Long Island. French later lived in New York City and published numerous other novels, pieces of literary criticism and histories.

Each of these writers had differing connections with Long Island. Catharine Beecher and Mary Louise Booth spent childhoods on Long Island, while Margaret Fuller and Gwendolyn Bennett spent limited time here. Elizabeth Oakes Smith, Frances Hodgson Burnett, Gabriela Mistral and May Swenson moved to Long Island after establishing literary reputations elsewhere. Neltje Doubleday was a summer and weekend resident. Marilyn French attended college and lived and worked on Long Island in her early adult years. R.R. Knudson began writing young adult books after moving to Long Island. Edith Fullerton spent almost all her life on Long Island, and her writings are explicitly about Long Island. None of these women—nor any of Long Island's male writers—developed a regionalist literature, but living on the island doubtless inspired all these women.

Chapter 7

WOMEN AND THE ARTS

Colonial and nineteenth-century America had few professionally trained women artists. Women often expressed their artistic talents instead in their needlework. Skill with a needle was essential for women at home well into the 1800s and was a means of earning money for women who became seamstresses. Cloth could be bought, but ready-made clothing would not be available in stores until the last half of the nineteenth-century. Clothing, sheets, pillowcases, towels and bed coverings needed to be sewn. Crocheting, lacework and beadwork showed women's artistic handiwork. Rugs and quilted bedcovers also expressed women's creative abilities while being utilitarian.

Mothers taught daughters to sew and embroider, and samplers demonstrated embroidery skills. Young ladies learned fancy or ornamental needlework in private schools or from articles in *Godey's Lady's Book* and other popular magazines. Still-life paintings and mourning pictures were common, as were picture embroideries. Pencil and ink drawings and watercolor painting were also part of a fashionable education for young ladies. Often they copied engravings or used stencils to paint on paper or velvet with watercolors. Exquisite examples of this artwork are now preserved in museums, prized today as folk art.[1]

Women in the late 1800s—and later as well—faced discrimination in the visual arts world. Long Island was nonetheless home to sculptors and painters and an etcher and illustrator who received national recognition, as well as many who achieved regional reputations in the twentieth

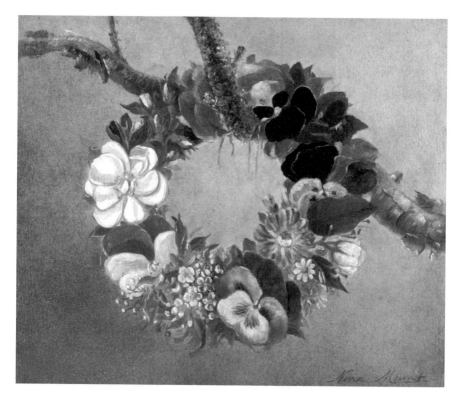

A floral painting by Evelina Mount (1836–1920), *Floral Wreath*, n.d., oil on panel, 10 in. x 11.5 in. *Courtesy The Long Island Museum of American Art, History & Carriages. Gift of Mr. and Mrs. Ward Melville.*

century. Female landscape architects also left their artistic imprint on Long Island estates.

Long Island's first professional woman artist, Evelina (Nina) Mount (1837–1920), was a niece of Ruth Hawkins Mount and of Long Island's famed artists William Sidney Mount and Shepherd Alonzo Mount (see fourth chapter). Her father, Henry Smith Mount, was also a painter but died when she was just four years old. Evelina lived in the Hawkins-Mount homestead in Stony Brook and received instruction from her uncle William and in New York from James McDougal Hart, another recognized artist of the day. She exhibited seven paintings at the National Academy of Design in New York in the 1870s. Most of her floral paintings are traditional women's art, but she also painted landscapes and worked in oils. She gave her paintings to friends and family and apparently sold few, if any, of them. Today, many of her paintings are in the collection of the Long Island Museum in Stony Brook.[2]

Sculptors: Sarah James Farnham and Gertrude Vanderbilt Whitney

Two women from well-to-do families became successful sculptors in the early 1900s, and each worked in a studio in her Long Island country home. Each had three children and had servants who freed them from many domestic responsibilities.

Born in Ogdensburg in upstate New York, "Sally" James Farnham (1869–1943) was seven when her mother died, and she moved to New York City with her father. In 1898, she married George Paulding Farnham, who designed jewelry for Tiffany & Company. The Farnhams lived in his Stepping Stones estate (named for a nearby lighthouse) in today's Kings Point on the Great Neck peninsula and maintained a residence in New York. Farnham began sculpting in her early thirties when convalescing from an illness. She did not formally study sculpture, though her husband, who was a sculptor, doubtless helped her begin. She also had advice from famed American artist Frederic Remington, a family friend.

Farnham's first works were portrait busts of friends. She had studios in both New York and Long Island and won several competitions for public memorial sculptures—including Civil War memorials in Ogdensburg (1905) and Rochester (1908), New York, and the handsome equestrian monument *Simón Bolívar* in New York's Central Park (1921). Farnham's husband resigned from Tiffany's about 1909, and he lost much of the family fortune in a mining venture in western Canada. After a divorce on grounds of desertion, Sally sold Stepping Stones in 1916 and stayed in New York City. Her career as a sculptor flourished in the 1920s and beyond. She died in her seventies and is buried in the All Saint's Episcopal Church Cemetery, Great Neck.[3]

Gertrude Vanderbilt Whitney (1875–1942) was a sculptor, art patron and founder of the Whitney Museum of Art in New York City. The daughter of Anne and Cornelius Vanderbilt II, at age twenty-one she married Harry Payne Whitney, who inherited his family's estate in Old Westbury after his father's death in 1904. The Whitneys also owned a townhouse on Fifth Avenue in the city and The Breakers in Newport, Rhode Island. Gertrude studied sculpture at the Art Students League in New York City and in Paris. She exhibited initially under an assumed name, and her sculptures soon received acclaim. She had studios in Manhattan's Greenwich Village and in Paris, and in 1913, she commissioned architect William Delano to build her a studio on the Whitneys' Old Westbury estate as well.

Sally James Farnham in her West Fifty-seventh Street Studio in New York City next to her bust of Herbert Hoover, 1921. *Courtesy Library of Congress, Bain Collection.*

Whitney often sculpted fountains and bas reliefs. Among her important public sculptures are the *Titanic Memorial* and *Aztec Fountain* in Washington, D.C.; the *Victory Arch* in Madison Square; the *War Memorial*

in Washington Heights; and the statue *Peter Stuyvesant* in Stuyvesant Square in New York City. Her most famous work is an equestrian statue, *Buffalo Bill—The Scout*, in Cody, Wyoming. Whitney supported other American artists—buying their paintings and providing exhibit space for their works. She established New York's famed Whitney Museum of American Art in 1931 after the Metropolitan Museum declined the offer of her collection of contemporary American art. The Whitneys' Long Island home was demolished, but Gertrude Whitney's Westbury studio survives, now remodeled as a private home.[4]

ARTISTS DISCOVER THE SOUTH FORK OF EASTERN LONG ISLAND

Long Island's South Fork attracted a diverse artist population in the twentieth century. Male artists in the Tile Club—including noted artists such as Winslow Homer—were among the first to travel to the East End in 1878. Thomas Moran and his wife visited later that summer, and when the couple moved to East Hampton in 1884, they were among the first professional artists to settle on the South Fork. Mary Nimmo (1842–1899) had studied at the Pennsylvania Academy of the Fine Arts in Philadelphia and married fellow artist Thomas Moran at age twenty, and they had three children. Nimmo Moran painted but soon focused instead on etchings, which won a number of awards. She was widely recognized as "the best woman etcher of the day," producing seventy landscape etchings, among them many Long Island scenes. Her life and career were cut short by typhoid fever; she was just fifty-seven when she died.[5]

Two women were responsible for bringing impressionist painter and art teacher William Merritt Chase to Southampton. Janet (Mrs. William) Hoyt, a wealthy and socially prominent amateur artist who summered in Southampton, first introduced Chase to Southampton in 1890. Together with Annie (Mrs. Henry Kirke) Porter, Hoyt urged him to conduct art classes in Southampton in the summer. The two women and Samuel L. Parrish, founder of the noted Parrish Art Museum, provided financial assistance for the school and for Chase's Long Island studio and home. In his Shinnecock Summer School of Art, Chase directed his famous plein-air (outdoor) classes and attracted about one hundred students each year from 1891 to

Left: Mary Nimmo "Nina" Moran in her garden in East Hampton. *Courtesy of the East Hampton Library, Long Island Collection.*

Below: Women painting plein-air at William Merritt Chase's Shinnecock School of Art, circa 1895. *Courtesy Southampton Historical Museum.*

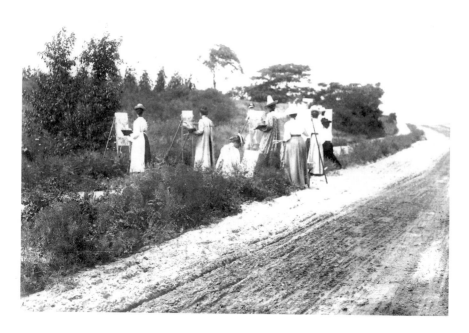

1902. Most of his Southampton students were women, though few became professional artists.[6]

One of Chase's students in Shinnecock was Annie Burnham Cooper Boyd (1864–1941), who had earlier studied art in New York. She became a prolific artist of her native Sag Harbor and its environs. The Sag Harbor Historical Society maintains her home at 174 Main Street as its headquarters, with an extensive collection of her paintings.[7]

May Wilson Preston (1873–1949) was born in New York, where at sixteen she was a founding member of the Women's Art Club (later the National Association of Women Artists)—America's oldest professional women's fine arts organization. It promoted women's art at a time when women were often not admitted to the male-only art organizations. She studied at the Art Students League from 1892 to 1897 and briefly with James McNeill Whistler in Paris. She also studied with William Merritt Chase in his New York City School of Art. In 1903, she married fellow artist James Moore Preston; the two were part of the "Ashcan School" and exhibited at the city's famous 1913 Armory Show. May achieved her greatest success as an illustrator for books and periodicals. They moved in 1935 to East Hampton, where she continued to illustrate *Saturday Evening Post* stories for a few years until illness led her to give up drawing. Her years as an illustrator on Long Island were few but clearly part of an eminent career as an artist.[8]

ARTISTS ON THE NORTH FORK OF THE EAST END

The North Fork has been home to many artists over the years. Geoffrey K. Fleming, director of the Southold Historical Society, has documented one hundred women who "lived, worked, visited, and exhibited on the North Fork" in the years before 1969.[9] Some of the better-known artists were summer residents for rather brief periods. Many of the year-round artists continued the nineteenth-century tradition of amateur artists, and some established regional reputations.

Like the Morans and Prestons, Edith and Henry Prellwitz were a successful art couple. Born Edith Mitchill (1864–1944), she was a New Jersey native who spent summers in East Hampton as a young girl and also in 1885–86. She studied at the Art Students League in New York with William Merritt Chase and others for six years (1883–89) and then for about a year in Paris.

She was a founder in 1889 of the organization that became the National Association of Women Artists.

Edith married fellow artist Henry Prellwitz in 1894. They first summered on Indian Neck in Peconic on the North Fork in 1899 and stayed year round from 1914 to 1928 and from 1938 to 1944. Several other artists joined them, summering in what became known as the Peconic Art Colony. Elected to the prestigious National Academy of Design in her early thirties, Edith won awards and critical acclaim. In her long, productive career, she painted figures, portraits, still lifes, allegories and landscapes. The late art historian Ronald Pisano judged her an "artist of the first rank."[10]

Of the long-term local artists on the North Fork, Caroline ("Dolly") M. Bell (1874–1970) was "one of the most recognized artists and an important teacher." Born in New York City, she had deep roots in Southold through her mother's family. As a child, she summered in Southold with her mother and settled in Mattituck in 1907. She studied with artists Whitney Hubbard and Edward Bell in Peconic and upstate in Woodstock. Dolly Bell showed her work on Long Island, in New York and on the North Shore of Massachusetts from 1919 to 1964. By the 1920s, she was teaching students herself, often plein-air painting. She is best known for painting landscapes and maritime scenes in oil.[11]

Gallery owner Terry Wallace has identified twenty-nine artists, including sixteen women, who were "Dolly's Crowd" of "Peconic Bay Impressionists." Helen M. Kroeger (1892–1986) was one of the younger members of the group. She spent summers in Laurel on the North Fork for some years, and after retirement from teaching school, she moved to Mattituck and opened the Anchorage Studio with fellow artist Otto J. Kurth. She also taught plein-air painting. In many of their works, these and other artists depicted the Long Island landscape.[12]

Betty Bierne Parsons (1900–1982) was an abstract painter and an important gallery owner who summered on the North Fork. Born in New York, she studied sculpture and painting in Paris and owned and operated a major New York gallery from 1946 to 1981. Parsons began coming to Southold by the early 1950s and, in 1959, commissioned a home and studio on the Sound. She has been called "the most important art dealer at the most important time in modern American art" because of the many young avant-garde artists she exhibited in her gallery—including Jackson Pollock, Lee Krasner and Perle Fine.[13]

MODERNISTS AND ABSTRACT EXPRESSIONISTS

Modernism and abstract expressionism emerged in American art in the twentieth century. Long Island has been home to many modernist and abstract expressionist artists, including four whose husbands were also artists. All four women had no children, and three gave priority to their husbands' careers. In recent decades, however, these female artists have received well-deserved recognition.

Helen Torr (1886–1967) pursued artistic studies at Drexel University and the Pennsylvania Academy of the Fine Arts but only began painting

Helen Torr and Arthur Dove, circa 1935. Photographer unidentified (Estate of Arthur G. Dove). *Courtesy The Heckscher Museum of Art, Huntington, New York.*

seriously after she met Arthur Dove, a pioneer of American modernism. Encouraged by him, Torr produced a body of work inspired by nature, incorporating abstracted elements of landscape, flowers, shells and other ephemera into flat, richly colored compositions. The two artists lived in Halesite near Huntington from 1924 to 1933. They moved in 1938 to Centerport, where they lived the rest of their lives. The Heckscher Museum of Art in Huntington purchased the Dove/Torr Cottage in 1998 and plans to use it as the Center for Dove/Torr Studies. The Heckscher organized a major traveling exhibition in 2003, Out of the Shadows: Helen Torr, a Retrospective.[14]

Born in Brooklyn, Lee Krasner (1908–1984) studied at Cooper Union and the National Academy of Design and with Hans Hofmann. In the late 1920s and early 1930s, she lived in Greenlawn, where her parents had moved. Krasner married Jackson Pollock in 1945, and the couple moved to Springs, a hamlet five miles northeast of the village of East Hampton. Krasner's painting style evolved over the years. While a gifted painter in her own right, she devoted much of her time to Pollock's career and achieved major recognition for her

Lee Krasner painting *Portrait in Green* in her studio in Springs, 1962. *Courtesy of the photographer, Mark Patiky, © 1969 and 2012.*

work only after his death in 1956. She adopted a "senuous painterly style" and "continued to refine the nature-derived imagery" that she had explored in her *Earth Green* series. Krasner "did her most innovative work" on Long Island and today "ranks with the foremost twentieth-century American artists." She bequeathed most of her estate to establish the Pollock-Krasner Foundation, which supports visual artists.[15]

Elaine de Kooning (1918–1983) studied art at Erasmus High School in Brooklyn, the Leonardo da Vinci School in Hoboken, New Jersey, in 1937 and the American Artists School in New York in 1938. She married artist Willem de Kooning at age twenty-five and, like Krasner, promoted her husband's career and stayed in his shadow for years. The De Koonings spent summers from 1951 to 1954 in either East Hampton or Bridgehampton on the South Fork and moved permanently to Springs in 1963. Elaine did semirealist portraits, as well as abstract paintings, and was an art critic for *Art News* for many years. She had many solo exhibitions, and her work is included in the collections of major museums. Her commissioned 1963 portrait of John F. Kennedy hangs in the National Portrait Gallery. Elaine de Kooning achieved a national reputation as an artist and art critic.[16]

Perle Fine (1905–1988) grew up outside Boston and attended the School of Practical Art. She moved to New York in her early twenties and studied at the Grand Central School of Art and the Art Students League and under Kimon Nicolaides and Hans Hofmann. She married fellow student Maurice Berezo in 1930. Berezo—an illustrator, painter, photographer and eventually art director in advertising—was very supportive of her work. Involved in the early years of abstract expressionism, Fine had more than thirty solo exhibitions beginning in 1945 and exhibited in numerous group shows as well. After visiting Krasner and Pollock on the South Fork, Fine moved her studio to Springs and became a year-round resident in 1954. She taught art at Hofstra from 1962 to 1973, and the Hofstra University Museum held a major solo retrospective of Fine's work in 2009.[17]

LANDSCAPE ARCHITECTS

Women have been important in the field of landscape architecture, although less than 1 percent of all American architects were women in 1900. The gardens on half of the large estates on Long Island's Gold Coasts and in the Hamptons were designed by women. Eighteen women received commissions to design gardens on the Long Island estates, most in the early decades of the twentieth century. Although not residents, these women did some of their most important work here. Unfortunately, gardens are not as lasting as houses, and few of their gardens survive intact.[18]

Ellen Biddle Shipman (1869–1950) had fifty-nine Long Island commissions, including those from Herbert L. Pratt in Glen Cove, Kermit Roosevelt in Oyster Bay and Virginia (Mrs. Robert) Bacon in Old Westbury. The best known of the women landscape architects, Beatrix Jones Farrand (1872–1959), had twenty-five commissions on Long Island. Among her clients were Helen (Mrs. George D.) Pratt in Glen Cove (Killenworth), Otto Kahn (Oheka) and Willard and Dorothy Whitney Straight in Old Westbury (Applegreen). Annette Hoyt Flanders (1887–1946) had twenty-one Long Island commissions, including Myron C. Taylor's residence in Locust Valley and the Vincent Astor estate in Sands Point. Among the seventeen Long Island commissions of Marian Cruger Coffin (1876–1957) were Henry Francis du Pont's Chesterton in Southampton, Childs Frick's Clayton in Roslyn (now the Nassau County Museum of Art; the formal garden was partially restored by Peggy Gerry in 2000, see the fourteenth chapter) and

Edward F. Hutton and Marjorie Merriweather Post's Hillwood (now LIU Post; restoration of gardens is currently underway).

Ruth Bramley Dean (Mrs. Aymar Embury II, 1889–1932) designed the sculpture garden for Guild Hall in East Hampton (now named for her), as well as the gardens for the Emburys' East Hampton residence and eight other Long Island commissions. Helen Elise Bullard (1896–1987) worked for the Long Island State Park Commission from 1933 to 1938 and designed plantings at Jones Beach and other state parks, as well as on the Southern State and other parkways. Alice Recknagel Ireys (1911–2000) worked primarily after World War II, designing more than two hundred gardens on Long Island. Most of her commissions were small residential projects, and she also did planting plans for the Shelter Island Library, Rock Hall Museum and Garden City schools, as well as designed a Japanese Demonstration Garden for Old Westbury Gardens.[19]

Today, garden clubs flourish on Long Island, and women are the overwhelming majority of members. Many of the clubs maintain historic gardens for museums. The plentiful nurseries and thriving horticulture industry are evidence that many Long Island homeowners care deeply about their gardens. Professional women artists and architects live and work throughout Long Island, and many women take art classes, participate in art exhibitions, volunteer as docents at art museums and in other ways are involved in art activities. All these women are heirs of the heritage of earlier women artists who were inspired by the island's beauty and who so skillfully depicted the Long Island landscape.

Chapter 8

PHILANTHROPISTS AND HUMANITARIANS

L ong Island has benefited profoundly from the philanthropy and benevolence of individual women and groups of women. The fourth chapter discussed religious institutions and their benevolences in the 1800s. Women continued this humanitarian work throughout the century, but in the last third of the nineteenth century, women expanded their activities well beyond churches and into other organizations serving their communities. Some wealthy women, most of whom had country homes on Long Island, were philanthropists who provided significant sums to worthy causes.

WEALTHY PHILANTHROPISTS

Cornelia Clinch (1803–1886) married Alexander T. Stewart in 1823. He became a millionaire from his department store in New York City, and in 1869, he bought more than seven thousand acres of the Hempstead Plains to develop the model suburb he named Garden City. After her husband's death in 1876, Cornelia, at age seventy-three, inherited $50 million and resolved to carry out his plans for the community. He had not envisioned a cathedral, but Cornelia Stewart convinced the Episcopal bishop of the Diocese of Long Island to move the seat of the diocese from Brooklyn to Garden City by offering to build a cathedral as a memorial to her husband, a house for the bishop, a deanery and two cathedral schools.

Garden City did not thrive in its early years, and Cornelia Stewart did not live to see all of her memorials completed, yet the Episcopalian institutions she financed made Garden City a unique Long Island community. The heirs of her estate formed the Garden City Company to complete the community development. Bessie Smith White, a grandniece of Cornelia and one of the heirs of her estate, was the wife of the famous architect Stanford White. Stanford White sat on the board of the Garden City Company, and he is the one who designed and remodeled the Garden City Hotel in 1895. The impressive Gothic Cathedral of the Incarnation and St. Paul's and St. Mary's schools envisioned by Cornelia Stewart and implemented by her philanthropy, as well as the imposing hotel, have given a distinctive character to the village of Garden City.[1]

Margaret Olivia Slocum (Mrs. Russell) Sage (1828–1918) was born in Syracuse, attended Troy Female Seminary and taught briefly. Olivia in 1869 married the widower and "miserly millionaire" Russell Sage. The Sages had a brownstone on Fifth Avenue in New York City and country homes in Lawrence and Sag Harbor. When Russell Sage died in 1906, his widow became one of the wealthiest women in America and soon America's preeminent woman philanthropist. She established Russell Sage College and the Russell Sage Foundation, made major gifts to various colleges and her alma mater (by then named for its founder, the Emma Willard School) and to women's organizations and causes, including suffrage. Sage's philanthropies also benefited the two Long Island communities in which she had country homes.

Sage spent summers from 1908 to 1912 at her Harbor Home in Sag Harbor, which today houses the Whaling Museum. She was the "Lady Bountiful" of Sag Harbor, where her large contributions left an imprint on the community. She donated to the fire department, helped finance repair of the steeple of the Presbyterian (Old Whaler's) church, gave a parsonage to the Eastville AME Zion Church, provided funds to build Pierson High School and built and endowed both Mashashimuet Park and the John Jermain Memorial Library. Certain gifts related to her mother, who had Pierson and Jermain ancestors and had been born in Sag Harbor. Sage also aided striking watch workers anonymously and financed publication of William Wallace Tooker's *Long Island Indian Place-Names* (1911), which is still the basic source on the subject.

In the Lawrence area, Sage financed an industrial or trade school for immigrants in Inwood (now in a new building, the Five Towns Community House). She donated the magnificent Russell Sage Memorial Church (the

Portrait of Mrs. Alexander T. Stewart, 1844, by Edward Dalton Marchant (American, 1806–1877), oil on canvas, 56 in. x 44 in. *Courtesy Collection of The Heckscher Museum of Art, Huntington, New York. Gift of Miss Kate C. Lefferts and Isabella Lefferts Edwards.*

First Presbyterian Church of Far Rockaway), which has an immense and beautiful Tiffany window that is a prized attribute of the church today.[2]

Alva Smith (1853–1933) married William K. Vanderbilt in 1875. Five years later, the Vanderbilts financed a new church and rectory for St. Mark's

Margaret Olivia Sage (1910) was an American philanthropist whose gifts enhanced the two Long Island areas where she had country homes. *Courtesy Library of Congress, Bain Collection.*

Episcopal Church in Islip near their Oakdale country home, Idle Hour. Alva built and financially supported Sea Side Children's Hospital in nearby Great River and donated $100,000 to Nassau Hospital (now Winthrop-University Hospital). She divorced Vanderbilt in 1895 and married Oliver H.P. Belmont the next year. In 1897, the Belmonts built a mansion in New York City and their country home, Brookholt, in East Meadow; they owned two mansions in Newport as well. Alva Belmont built and was the primary financial supporter of Hempstead Hospital in 1910. She became a major supporter of women's suffrage (see eleventh chapter).[3]

Katherine Duer (Mrs. Clarence) Mackay (1880–1930) lived in Roslyn for more than a decade, from 1898 to 1910. Her gifts to Trinity (Episcopal) Church in Roslyn included a new parish house and church—each designed by Stanford White, who was also responsible for the Mackays' Harbor Hill mansion in Roslyn—as well as a baptismal font, organ and stained-glass windows. She donated to Roslyn's library and high school and hosted parties

Belmont Memorial Hospital, located on the corner of Jerusalem Avenue and Henry Street in Hempstead, was also known as Hempstead Hospital; photograph circa 1935. *Courtesy Nassau County Department of Parks, Recreation & Museums, Photo Archives Center.*

on her estate for children, the community's Fourth of July celebration and fundraisers for Nassau Hospital.[4]

Louisine Waldron Elder (1855–1929) married Henry Osborne Havemeyer in 1883. They had three children, a mansion on Fifth Avenue in New York and a country home near Greenwich, Connecticut. They first rented then bought a house on Long Island's South Shore Gold Coast. In 1889, they built Bayberry Point in Henry Havemeyer's Modern Venice development in Islip. The Havemeyers were art collectors, particularly of impressionist and Spanish paintings. After her husband's death in 1907, Havemeyer became active in the women's suffrage movement. She exhibited her paintings in 1912 and 1915 as a benefit for suffrage—the only public exhibitions of her painting collection during her lifetime. The exhibition of her Edgar Degas and Mary Cassatt paintings in 1915 raised nearly $2,300 for suffrage—the equivalent of $53,000 today. Louisine Havemeyer later bequeathed much of her art collection to the Metropolitan Museum of Art.[5]

Martha Cowdin Bacon (1860–1940) was the wife of Robert Bacon—a partner in J.P. Morgan & Company, U.S. secretary of state under Theodore Roosevelt and ambassador to France under Woodrow Wilson. The Bacons had a home in New York City and a country estate, Old Acres, in Westbury. She chaired the committee that raised more than $2 million for the American Ambulance Service hospital in France beginning in 1914 and hosted benefits for the Nassau Hospital. After her husband died in 1919, Martha Bacon established the Robert Bacon Memorial Children's Library in Westbury, donating four and a half acres of land, the building, a cottage for the librarian, an income-producing house and an endowment.[6]

Emily Clara Jordan Folger (1858–1936) graduated from Vassar College and taught a few years in a private school before marrying Henry Clay Folger in 1885. He started with the Charles Pratt Company and eventually became president of the affiliated Standard Oil Company, but his passion was Shakespeare. Clara shared her husband's interest in Shakespeare, undertaking private studies and writing a thesis on "The True Text of Shakespeare," for which Vassar awarded her an MA degree in 1896. The two Folgers worked together collecting books and manuscripts related to Shakespeare. They rented a brownstone in Brooklyn and, for twenty years, a farmhouse in Glen Cove near his fellow industrialist Charles Pratt. When Henry retired in 1928, the Folgers bought a house in Glen Cove. After her husband's death two years later, Clara undertook supervision of the Folger Shakespeare Library in Washington, D.C., which they had planned together. The Folgers had no children, and Clara left most of her estate to the Folger

Library, which today has the "largest and finest collection of Shakespeare material" in the world. Clara Folger lived in Glen Cove for more than twenty years and deserves greater recognition for her role in amassing the Folger Shakespeare collection.[7]

Kate Mason Hofstra (1860–1933) did not envision establishing a college. Her husband, millionaire lumberman William Hofstra, died in 1932 and left her most of his estate, including their home, Netherlands, and fifteen acres of land in Hempstead. Kate Hofstra died sixteen months after her husband. Her will made a number of specific gifts but designated the property and remainder of her estate to be a memorial to her husband "for public, charitable, benevolent, scientific or research purposes." Following a suggestion from former Hempstead school superintendent Truesdel Peck Calkins, the executors established an extension branch of New York University on the Hofstra property. NYU's two-year Nassau College–Hofstra Memorial opened in September 1935. It became Hofstra College in 1937, a four-year college that would be independent of NYU after a two-year transition. The new college received an endowment of $700,000 from Kate Hofstra's estate in 1940 and expanded substantially in later years, building on the largesse of Kate Mason Hofstra's memorial to her husband.[8]

Dorothy Bigelow Melville (1894–1989) married Ward Melville in 1909. Her husband joined his family shoe business, and he made his fortune with Thom McCan shoes. The Melvilles had an apartment on Fifth Avenue in New York and, from 1924, a country home in Old Field, north of Stony Brook. Dorothy Melville was a volunteer nurse's aide during World War I in New York City hospitals and with the Red Cross in World War II. She worked with her husband on many community projects.

Dorothy Melville was a major benefactor in Stony Brook and a founder of today's Long Island Museum; photograph from the 1940s. *Courtesy The Long Island Museum of American Art, History & Carriages.*

Dorothy Melville was co-founder and president of the Suffolk Museum in Stony Brook for decades following its incorporation in 1942 and chairman for a further five years, from 1983 to 1988, when she became chairman emeritus. The Melvilles donated their world-renowned collections of some three hundred horse-drawn carriages and William Sidney

Mount paintings to the museum, now known as The Long Island Museum of American Art, History & Carriages. After her husband's death in 1977, she became president of the Stony Brook Community Fund, now the Ward Melville Heritage Organization. Dorothy Melville was "Stony Brook's Fairy Godmother." She was responsible for making the post office and other buildings in the Stony Brook Shopping Crescent accessible. Among other local causes she supported were the Three Village Garden Club, the restoration of the Caroline Church in Setauket, the Suffolk County YWCA and the League of Women Voters. She bequeathed a perpetual trust of $4 million to the Long Island Museum, which is the largest private museum on Long Island.[9]

These women were able to be philanthropists because of the wealth that their husbands derived from business, banking or other pursuits. Long Island's proximity to New York City enabled the wealthy to have country homes on the island, and local communities benefited immeasurably from their philanthropy.

CATHOLIC RELIGIOUS ORDERS

Some of the good work of Catholic nuns was noted in the fourth chapter. Besides staffing parish schools, some religious orders have founded and maintained other educational institutions, including many for girls and young women. The Sisters of St. Joseph, for example, ran the Academy of St. Joseph in Brentwood for more than 150 years, from 1856 to 2009. In addition to high schools and academies in Brooklyn and Queens, they founded Sacred Heart Academy in Hempstead in 1949. St. Joseph's College for Women in Brooklyn began in 1916, becoming coeducational in 1970. The college opened a Suffolk campus in 1971, which has been located in Patchogue since 1979.

Other Catholic orders instrumental in Long Island education include the Sisters of Mercy, who founded Our Lady of Mercy Academy in Syosset for young women in 1928. The Dominican Sisters of Amityville started Molloy Catholic College for Women in Rockville Centre in 1955; it is now coeducational as Molloy College.

The Daughters of Wisdom in Port Jefferson began to care for homeless Brooklyn children with disabilities in 1907. This humanitarian effort marked the beginning of today's St. Charles Hospital. The Sisters of the

Franciscan Missionaries of Mary opened St. Francis Camp in 1921 on property donated to them the year before by Carlos and Mabel Munson on Roslyn's Port Washington Boulevard. In 1937, the nuns began a sanatorium for children with rheumatic fever on the property. This evolved into St. Francis Hospital—today one of the country's leading cardiac care centers.[10] The benevolent work of Catholic religious orders on Long Island goes well beyond the examples cited here and has had a profound and generous influence over time.

INDIVIDUALS DOING GOOD

After the end of the Spanish-American War, soldiers exposed to tropical diseases in Cuba were quarantined in August 1898 to recuperate at Camp Wikoff in Montauk. Volunteers in the Women's National War Relief Association from Long Island and New York provided food, clothing and nurses to aid the men. At least one volunteer nurse died of typhoid that she contracted at the camp.[11]

In the twentieth century, women in churches continued their benevolent and charitable activities in women's societies, sewing circles and missionary societies. They used their domestic skills to raise money through teas, dinners, bake sales and fairs or by selling homemade goods in women's exchanges. Ella Smith (1849–1922), for example, was deeply committed to the First Presbyterian Church in Smithtown and its women's groups. She also helped raise money for the local lecture series, library and firehouse, as well as for European famine victims and Fresh Air Children from the city. As a eulogy to her stated, "No one can measure the good she has done, not alone in her own home village but reaching far out in places we little know of."[12]

Three other Smith women in St. James exemplify philanthropic work in a later generation. The lives of Josephine, Mildred and Dorothy Smith spanned nearly a century, from 1884 to 1972. The three sisters were active in benevolent activities in their own community and beyond. During the First World War, they volunteered in the Red Cross, raised money for Liberty Bonds and served as canteen workers at Camp Upton in Yaphank. Mildred Smith went to France with the National War Council of the YMCA, while Josephine directed the local "Farmerettes," who raised food on the homefront. The activities of these Smith women were fairly typical for women of their day in other Long Island communities.[13]

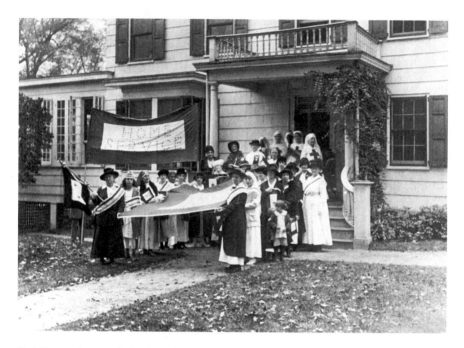

Red Cross volunteers in Roslyn, circa 1917. *Courtesy Nassau County Department of Parks, Recreation and Museums, Photo Archives Center.*

While volunteer activities continued, the work of benevolence evolved further into the profession of social work. Edith Terry Bremer (1885–1964), for instance, was educated as a social worker. She attended the University of Chicago for her AB and did graduate study there in social work. Beginning in the 1910s, she worked in New York City under the YWCA with immigrant girls and women. She is credited with founding the International Institute movement and became executive director of the National Institute of Immigrant Welfare in 1933 (later the American Federation of International Institutes), serving until she retired in 1954. Bremer was acting director of the New York Institute from 1955 to 1958 and lived with her husband in Port Washington.[14]

ORGANIZATIONS

In the last decades of the nineteenth century, Women's Clubs were forming throughout the country. Many began as reading groups for self-improvement,

then expanded their concerns to include community service and philanthropy. Long Island women were involved in numerous women's organizations. A 1922 directory, *Women's Clubs in America*, listed sixteen in Nassau County and ten in Suffolk. Among those with large memberships (ranging from 75 to 260) were the City Club in Glen Cove, Community Club of Hempstead and Garden City, Fortnightly Club in Rockville Centre and Sorosis in Patchogue, as well as Women's Clubs in Plandome and Riverhead.[15]

Women in East Hampton organized the Ladies Village Improvement Society (LVIS) in 1895 to improve the appearance of their community. The group has long been active in planting and maintaining flowers, trees and the village greens. Dues of members are augmented by an annual summer fair, thrift shops and periodic cookbooks to fund their beautification, conservation, preservation and community service activities.[16]

In Sayville, women inspired by the East Hampton LVIS started their own Women's Village Improvement Society in 1914. Their initial concerns involved garbage disposal, organizing the Library Association and securing a shorefront public park. The society changed its name in 1931 to Sayville Village Improvement Society, dropping "Women's" from its name, but its members have always been women.[17] Other women organized similar groups in their own communities in the 1920s—including the Amagansett Village Improvement Society, Ladies Village Improvement Society in Sag Harbor, the Bridge Hampton Village Improvement Society and the Three Village Garden Club in the Stony Brook area, with goals including "furthering of town beautification." Many of these (and similar) organizations continue to be active in the twenty-first century.

When Verina Harris Morton-Jones (1857–1943) moved to Hempstead in the 1920s after living for several decades in Brooklyn, she resumed her medical practice. She was the first African American woman physician in Hempstead and was also was among the women who organized the Harriet Tubman Community Club in 1928. Morton-Jones directed the settlement house herself for six years, from 1933 to 1939. The Tubman Community House organized Girl Scout, Boy Scout and other cultural and recreational clubs and organizations for children and adults for seven decades in Hempstead Village.[18]

Often, ladies auxiliary groups appear in photographs in local community histories, but their contributions to volunteer fire companies and other male organizations have not been well documented. Women did predominate in the Red Cross units especially active during the two world wars. They served as nurses, hospital aides, canteen workers and motor corps drivers at

Camp Upton in Yaphank, Mitchel Field in Garden City and other military installations. They were also active in the United Service Organization (USO) centers during the war. Women's auxiliaries at Long Island hospitals raised money, volunteered services as "pink ladies," ran gift shops and in other ways assisted the hospitals' work.

The individual women and organizations mentioned in this chapter are just a sample of local philanthropists and groups of women aiding Long Island communities. Most villages did not have residents as wealthy and philanthropic as Olivia Sage and Cornelia Stewart, neither of whom had children to inherit their estates, but all benefited from women's philanthropic and benevolent endeavors. The philanthropists, nuns in Catholic religious orders, the various women's organizations and individual women mentioned here exemplified the many kinds of humanitarian, benevolent and social services that women have performed over the years. Their activities have been vital to the cultural infrastructure of their communities. All of these women have enriched Long Island by their contributions.

Chapter 9

EARNING A LIVING

Entrepreneurs, Entertainers and Scientists

Women continued in traditional occupations in the enlarged domestic sphere in the late nineteenth century and the early decades of the twentieth century. Some women became entrepreneurs, entering less traditional occupations. Long Island was also home to entertainers, performers and scientists.

THE ENLARGED DOMESTIC SPHERE

In the "resort era" beginning in the late 1800s, when many Long Island communities catered to summer visitors, women often took in boarders. They could thus supplement family income while remaining within the domestic sphere. Babylon, Greenlawn, Bayport, Bridgehampton, Southampton, East Hampton and the North Fork are among the communities whose boardinghouses appear in local photo histories. Other women worked in rooming and boardinghouses or in the inns and hotels of larger communities, preparing and serving food or providing housekeeping services. Some worked as servants in private homes, whether in mansions or for upper-middle-class families.[1]

Patchogue was one of the larger communities in Suffolk County. In 1877, when its population was about two thousand, the local business directory included eleven women offering entrepreneurial services. Three

were dressmakers, two milliners, two conducted private schools, one a "hair worker," one both a milliner and dressmaker, one a milliner and hair worker and one listed as a "sewing machine." Eight of the women were single (identified as "Miss"), and three who may have been widowed were listed as "Mrs." Most of their occupations catered to female customers. Other women may have assisted in shops owned by their husbands. The Patchogue directory did not list teachers in the public school, but women were the majority of teachers in district schools by the 1860s. Women in other Long Island communities had similar occupations in these years. By the 1910s, hundreds of women worked in the large Patchogue Lace Mill, making lace curtains, nets and other products.[2]

In 1910, the federal manuscript census for Seventh Street in Garden City included a sixty-year-old widow who ran a boardinghouse with two widowed relatives as waitresses and an eighteen-year-old servant who was a kitchen worker. Another household was headed by a French-born widow who was a dressmaker. Her twenty-year-old unmarried daughter was a milliner, and their eighteen-year-old boarder was also a dressmaker. A surprising number of women in Long Island communities in the century's early decades were postmasters. The Garden City postmistress was a fifty-two-year-old divorced woman whose twenty-seven-year-old divorced daughter and seven-year-old grandson lived with her. Other single women—most in their twenties or early thirties—were servants for private families, including cooks and nursemaids. One married woman took in several boarders—among them two black women who were cooks for private families. The census lists the occupation for most wives as "housework" or "none." This small sample for one community is fairly typical of women's occupations, which were still predominantly within the broadened domestic sphere in the early decades of the 1900s.[3]

Hospitals, including the very large state mental hospitals (Kings Park and Central Islip, established in the late 1800s, and Pilgrim State, in 1931), employed many women as nurses and aides. Some hospitals had their own nursing schools and provided free training for nurses. Their graduates were exclusively women until the 1960s, when male employees at the state hospitals began to take advantage of the free training. Many women also worked as clerical staff in business offices and at hospitals. Women have entered diverse occupations in other Long Island businesses over the years. For example, an 1896 photograph of more than sixty employees of John Lewis Childs's seed business in Floral Park includes ten women.[4]

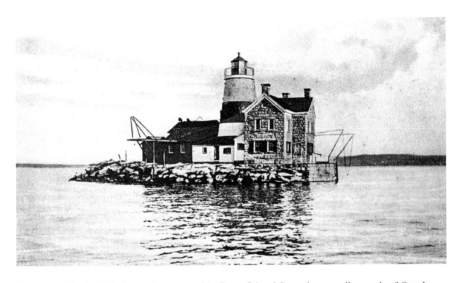

Execution Rocks Lighthouse is on a reef in Long Island Sound, one mile north of Sands Point. Henry Otto Korten photograph, postcard, circa 1910. *Courtesy Nassau County Department of Parks, Recreation and Museums, Photo Archives Center.*

The fourth chapter mentioned a few women who assisted as lighthouse keepers. Even more served in later years. Keeping the light lit, carrying fuel to the top and cleaning the lens and windows was often a family operation that involved wives and daughters. The Execution Rocks Lighthouse had several women who were assistant keepers, with Mary Lucy (Edwards) Sherman serving the longest at nine years, 1873–82. After passing an examination, Catherine Gunn became assistant keeper for her husband in 1876 at North Dumpling Light off Fisher's Island. When her position was abolished, the Gunns resigned. Stella Maria Prince assisted her father, George Prince, who served at the Horton Point Light in Southold for nearly twenty years, from 1877 to 1896. When his successor, Robert Ebbitts, broke his leg, Stella became acting assistant keeper from 1903 to 1904. Ann Fowler, daughter of the keeper at North Dumpling Light, was only twenty-five when she rescued eight men from a schooner wrecked off Block Island in 1905. She received a medal and $5,000 in gold from the admiral in charge of the lighthouse district. Doubtless other daughters and wives assisted their fathers and husbands who were lighthouse keepers without salary or documentation in official records.[5]

ENTREPRENEURS

Mary E. Martin (1866–1932) ran a mail-order seed business in Floral Park from the 1890s to the early 1920s. Born in Lakeville (now Lake Success), her father was an Irish immigrant who was a farm laborer. The aforementioned John Lewis Childs had established his large seed business in Floral Park in the 1880s. "Miss Mary E. Martin" issued a seed catalogue in 1896 for flowers and vegetables, listing her address as Jericho Road in Floral Park. In her catalogues, she always noted that she was not connected with any other seed business in Floral Park and that she personally handled all orders herself. (Childs had his brother-in-law manage his business.) In her 1896 catalogue, Martin attributed her lower prices to her gender: "*It is true, because I am a woman*, I do not need so much money to spend as some *Men and Firms do*, and can sell you *the same seeds much cheaper* because I give my business *my personal attention* because *I love it* and make my daily bread by it" (emphasis, both italics and underline, in original). Mary was assisted in the business by her sister, Catherine. The sisters owned their home, likely the location of the business. It is interesting to note that by the 1930 census, Mary Martin's occupation is no longer "seed store" but "seamstress," and in another census, the sisters were listed as "copyists."[6]

Helen Marsh developed the planned community of Bellerose in the early twentieth century. This charcoal portrait dates from 1956. *Courtesy Nassau County Department of Parks, Recreation and Museums, Photo Archives Center.*

A woman from Lynn, Massachusetts, first developed the community of Bellerose. Mrs. Helen Marsh bought seventy-seven acres near the Nassau-Queens border in 1907 for a planned development. She designed houses for families of differing income levels. Marsh lived in each of the first houses built to ensure that they met her standards. She laid out the streets, landscaped with flower beds and built a railroad station, adopting the railroad's name of Bellerose for her community.[7]

In Hicksville, goldbeating to produce sheets of gold leaf was an important craft and industry from the late 1800s to after World War I. Women were the "cutters" and often delivered the gold leaf to dealers

in New York. Some of Hicksville's more than twenty shops in the early twentieth century were owned by women.[8]

Christine McGaffey Frederick (1883–1970) was a household efficiency expert and entrepreneur. She married J. George Frederick after graduating from Northwestern University in 1906, and they had four children. The Fredericks moved to Greenlawn in 1910. She founded the League of Advertising Women in 1912 because women were not admitted to the existing advertising organizations. She soon established the Applecroft Home Experiment Station in her Greenlawn home, applying the principles of scientific management to the household and eventually testing consumer products. Frederick wrote articles and books and spoke widely on efficient home management. She is credited with standardizing the height of sinks and other kitchen work surfaces. Her books include *The New Housekeeping* (1913), *Household Engineering: Scientific Management in the Home* (1915) and *Selling Mrs. Consumer* (1929). She moved from Long Island in 1939 to New York City and eventually to California but had conducted her pioneering work in Greenlawn.[9]

Marjorie Merriweather Post (1887–1973) is well known as a philanthropist and businesswoman. She was the only child of the founder of Postum Cereal Company, C.W. Post, and inherited the business after his death in 1914. In the late 1920s, she was responsible for acquiring Birds Eye Frozen Foods, and the company became the General Foods Corporation. Married and divorced four times, she had three children and resumed using her maiden name after her last divorce. Long Island University bought her 177-acre Brookville estate Hillwood in 1937 for $200,000 and named the college it opened there in 1951 for her father. Marjorie Post herself donated $2 million to the college in the 1950s.[10]

Mabel Witte Merritt (1886–1962) was born in Brooklyn and graduated from Vassar College and New York University School of Law. For several years, she was secretary to the president of Columbia University. She married Jesse Merritt in 1918 and moved to Farmingdale, and they had two daughters. When her husband established the weekly *Farmingdale Post* newspaper in 1920, she was the first editor and primary writer for fifteen years. She then turned to the practice of law, initially with her father's firm in Brooklyn and then in her own practice in Farmingdale in the 1930s and 1940s.[11]

Syrena Stackpole (1888–1983) of Riverhead was also the daughter of an attorney. She graduated from Wellesley College and NYU's School of Law. She taught briefly in Bayport but was fired for criticizing the principal

Alicia Patterson, founder of *Newsday*, circa 1950. In her will, Patterson left $1 million to finance travel and study fellowships for young journalists. *Courtesy Nassau County Department of Parks, Recreation and Museums, Photo Archives Center.*

"for being no gentleman because he smoked cigars." She appealed to the state education commissioner and was reinstated with back pay, but then she resigned. She worked for a Wall Street law firm before opening her own practice in her hometown in 1928. Stackpole was the first Suffolk County woman admitted to the New York State Bar and the first to have her own law office. In another first, she was elected justice of the peace in 1931, which meant she also served on the town board. In recognition of her victory, fellow Democrats president-elect Franklin Delano Roosevelt and Mrs. Roosevelt invited her to the White House after his inaugural parade in 1932. Stackpole served only one four-year term in public office; she preferred her private law practice, which she continued in Riverhead into her nineties.[12]

Newspaper editor and publisher Alicia Patterson (1906–1963) was born in Chicago to a newspaper family. She married Harry Guggenheim in 1939 after her first two marriages ended in divorce. They bought the remnants of a defunct newspaper in Hempstead in 1940 and started *Newsday*. Since Guggenheim was soon recalled to active duty in the navy, Patterson, who retained her maiden name professionally, ran the paper alone in its formative years. Guggenheim held 51 percent of the stock and attended to the business operations after the war. Patterson held 49 percent and was the working editor. They did not always agree politically, and in the 1960 election, *Newsday* endorsed John F. Kennedy but printed Guggenheim's support for Richard M. Nixon. Under Patterson, *Newsday* grew into the largest suburban newspaper in the country and won its first Pulitzer Prize in 1954. She was a "strong partisan" of her adopted Long Island and through *Newsday* "helped create a Long Island identity." A New York State historic marker commemorates Patterson on Middleneck Road near the entrance to the Guggenheim estate in Sands Point.[13]

ENTERTAINERS AND PERFORMERS

Long Island was home to some national celebrities for brief periods in the first half of the twentieth century. Lillian Russell, for example, performed in Sayville; Helen Hayes stayed in Hampton Bays; and Annie Oakley rented in Massapequa in the 1920s and visited in Amityville. Marlene Dietrich summered in Point Lookout; Sarah Bernhardt stayed at the Orient Point Inn; Ethel Barrymore summered in Atlantic Beach; Fanny Brice lived in Halesite and Great Neck; and Marilyn Monroe summered in Amagansett in the late 1950s during her marriage to Arthur Miller. Other performers spent more extensive time on the island.

Violinist Maud Powell (1868–1920) grew up in Aurora, Illinois, where she began playing the violin as a child. After studying in Europe for five years, she returned to America and made her debut with the New York Philharmonic at age seventeen. Her career as a concert violinist included solo performances throughout the United States and in Europe. She married H. Godfrey Turner in 1904 and lived in Great Neck. During Powell's Long Island years, she was the first violinist to be recorded on Victor phonograph records. She also visited schools and colleges and entertained soldiers during World War I.[14]

Irene Foote Castle (1893–1969) was born in New Rochelle, studied dancing as a child and married Vernon Castle in 1911. Soon she was dancing with him and popularizing new ballroom dances in the dance-craze era in the 1910s. The Castles had an estate in Manhasset, as well as a place in New York. They danced at a nightclub, Castles by the Sea, on the Boardwalk in Long Beach and debuted in the silent film *Whirl of Life* in 1915. The Castles performed on Broadway, and Irene played in additional films as well. After Vernon was killed in a plane crash in 1918, Irene continued her film career for a few years and then moved from the New York area after she remarried. Her Long Island connections in the 1910s were brief but richly memorable.[15]

Born Maude Eding Kiskadden (1872–1953), Maude Adams (as she was known professionally) was "one of the most popular actresses of her generation," with more than 1,500 performances in *Peter Pan* at the "pinnacle of her career." Adams bought an estate in Ronkonkoma in 1900 and often retreated there. She later donated it with four hundred acres to the Catholic Sisters of the Cenacle in 1922, in gratitude for the spiritual support she had received at the St. Regis Cenacle Convent in New York City. Adams is buried at the Cenacle cemetery on the grounds, and the sisters have maintained the Maude Adams House where she stayed.[16]

Actress and author Cornelia Otis Skinner (1899–1979) married Alden S. Blodget in 1928, and they lived in their country home in Nissequogue for many years. She performed on Broadway, radio and television and wrote plays and monologues as well. Skinner presented her monologue *The Wives of Henry VIII* to raise money for the Smithtown Library Building Fund in 1948. She moved permanently to New York City after her husband's death in 1964.[17]

Folk singer and songwriter Jean Ritchie was born in 1922 in Kentucky, where she grew up and graduated from college. She moved to New York City in 1946 and soon began performing with folk singers. She married photographer George Pickow in 1950, and they lived in Port Washington for more than fifty years. Ritchie played a dulcimer, recorded hundreds of traditional Appalachian songs on different record labels and wrote many songs herself. Under a Fulbright grant in the 1950s, she collected traditional songs in Ireland and Britain. Known as the "Mother of Folk," in 2002 Ritchie was inducted into the Kentucky Music Hall of Fame and received the National Heritage Fellowship from the National Endowment for the Arts; six years later, she was inducted into the Long Island Music Hall of Fame.[18]

SCIENTISTS

Long Island has been home to several nationally famous women scientists. Many scientists have been associated with the Cold Spring Harbor Laboratory (CSHL) or the Brookhaven National Laboratory in Yaphank. The most notable of the scientists with the longest roots on the island was Barbara McClintock (1902–1992), who grew up in Brooklyn, where she attended Erasmus Hall High School. She studied botany at Cornell University, earning a BS in 1923 and a PhD in 1927. After some years of research grants and college teaching at the University of Missouri (which she did not enjoy), McClintock came to the Cold Spring Harbor Laboratory in 1941. She remained at the CSHL for the rest of her long life and would win a Nobel Prize for her scientific work in 1983.

McClintock's research focused on "transposable genetic elements" in corn, popularly known as "jumping genes." She achieved recognition and won many awards (e.g., in 1944, she was elected president of the Genetics Society of America and named to the National Academy of Science; in

1970, she won the National Medal of Science; and in 1981, she received a MacArthur Foundation Fellowship). She received her Nobel Prize at age eighty-one to international acclaim. McClintock lived in Cold Spring Harbor for more than fifty years, across from the lab or, in later years, on the grounds. She continued working at the lab until her death at age ninety. One of the laboratory buildings now bears her name.[19]

Hattie Elizabeth Alexander (1901–1968) grew up in Baltimore, graduated from Goucher College and received her MD degree at the Johns Hopkins School of Medicine in 1930. She taught pediatrics at New York's Columbia-Presbyterian Medical Center for more than thirty years, from 1932 to

Barbara McClintock at her desk at the Cold Spring Harbor Laboratory examining ears of corn, 1971. *Courtesy of the Cold Spring Harbor Laboratory Archives.*

1966, and also conducted research on influenzal meningitis, developing an antiserum. She published varied scientific papers and won a number of honors. The first female president of the American Pediatric Society in 1964, Alexander lived in Port Washington.[20]

Mary Steichen Calderone (1904–1998) was a physician and public health educator. She graduated from Vassar College in 1925 and studied acting briefly. After a marriage ended in divorce in 1933, she pursued her MD degree (1939), married Dr. Frank Calderone in 1941 and completed a master's in public health the following year. The Calderones lived in Old Brookville, and she worked part time as a school physician in Great Neck while raising their two daughters. She became medical director of the Planned Parenthood Federation of America in 1953 and served for more than a decade, until 1964. During those pivotal years in family planning, Calderone helped reshape the reputation of Planned Parenthood and crusaded for birth control. She became one of the founders of the Sex Information Council of the United States (SIECUS) in 1964, its executive director from 1964 to 1975 and president from 1975 to 1982. Calderone, who was SIECUS's most effective spokesperson, was called the "first lady of sex education" and wrote several books on sexuality and sex education. She lived on Long Island until the late 1980s and then moved to a Quaker retirement community in Pennsylvania.[21]

Physicist Gertrude (Trude) Scharff Goldhaber (1911–1998) worked at the Brookhaven National Laboratory for more than thirty years. She grew up in Germany, receiving her PhD at the University of Munich in 1935, and four years later she married fellow physicist Maurice Goldhaber in England. He taught at the University of Illinois, and she began her work in nuclear physics in his lab, where rules against nepotism relegated her to an unpaid assistantship. The Goldhabers moved to work at the Brookhaven Laboratory in 1950, and they lived in Bayport. She received diverse awards and accolades for her work, including election to the National Academy of Sciences in 1972. Goldhaber began the Brookhaven Lecture Series and was one of the founders of the Brookhaven Women in Science. After mandatory retirement at age sixty-six in 1977, she taught for a few years and then returned to do research at the Brookhaven Laboratory for another five years, from 1985 to 1990.[22]

These scientists, entertainers and entrepreneurs were hardly typical residents in their day, but each contributed to Long Island's storied past. More typical were teachers, nurses and others working in the enlarged domestic sphere.

A History of Eminent Ladies and Everyday Lives

The vast majority of women in the early twentieth-century decades spent most of their lives working within their own homes as housewives and mothers raising their children. In the 1930s, these homemakers stretched household budgets to enable their families to survive the Great Depression.

Chapter 10

PIONEERING PILOTS

Daring and Intrepid Airwomen

The Wright brothers made their first short flight at Kitty Hawk, North Carolina, in 1903. Five years later, Glenn Curtiss flew his *June Bug* airplane in Hammondsport, New York, just under 1 mile (1.6 kilometers) to win the Scientific American Cup for the first public flight of more than 1 kilometer. The next year, Curtiss brought his *Golden Flyer* biplane to Long Island and won a trophy for the first flight of 25 kilometers (about 15 miles). This was the first of many pioneering flights on Nassau County's Hempstead Plains, which earned Long Island the title of the "Cradle of Aviation." Most of the early flights were by men, but women were pioneering pilots as well. The Hempstead Plains were ideally suited for aviation because of the flat, treeless landscape. Today, the Cradle of Aviation Museum in East Garden City preserves and interprets Long Island's aircraft history.

BESSICA RAICHE (1875–1932) AND E. LILLIAN TODD (1865–1937)

The first woman who flew on Long Island was Bessica Raiche. When studying music in Paris, she had been inspired by a French flyer, Raymonde de la Roche, who was the first woman in the world to receive a pilot's license. Bessica and her husband, François Raiche, built a biplane in their living room in Mineola and assembled it on their front lawn. Raiche successfully

flew that plane on September 16, 1910. A few weeks later, the Aeronautical Society honored her at a dinner, proclaiming her the "First Woman Aviator of America" and awarding her a diamond-studded gold medal.[1] Although the Raiches built two more planes, Bessica soon gave up flying; she moved to California and became a physician.

E. Lillian Todd began to design an airplane in 1906. With financial assistance from Margaret Olivia Sage (see the eighth chapter), the plane was built at the Aeronautic Society's shed at Mineola Field in 1910. The first and only documented flight of her biplane that November was not very successful. The pilot, Didier Masson, was able to get Todd's plane in the air for only a very short distance.[2]

HARRIET QUIMBY (1875–1912)

Harriet Quimby grew up in Michigan and California. She first wanted to be an actress but pursued a career in journalism instead. Quimby moved to New York City in 1903 and became drama critic for *Leslie's Illustrated Weekly*. She also wrote screenplays and articles on other subjects, including automobiles. She owned and drove a car at a time when it was unusual for women to drive.

Quimby met pilot John Moisant at the International Aviation Tournament at Belmont Park in 1910 and asked if he would teach her to fly. The Moisant Aviation School and most of the early aviation flights were on the site of today's Roosevelt Field Mall.[3] In the spring of 1911, Quimby took flying lessons at the school, which was one of the few that accepted women. Four of the first ten American licensed women pilots learned to fly there.[4]

The best flying time then was in the early morning, when there is less wind. Quimby, who lived in Manhattan, rose early and drove to Long Island to begin her flying lessons at 4:30 a.m. She reported her experiences in *Leslie's* in such articles as "How a Woman Learns to Fly" and "How I Won My Aviator's License." She wrote of the tests she had to pass; takeoffs and landings were the most difficult part. On August 1, 1911, Quimby became the first woman in America to be licensed to fly.

Clothing was an issue for women. Skirts were impractical, and trousers were not yet accepted for women. Quimby designed a unique flying outfit—one-piece with a hood in a distinctive purple color. It could be converted from pants to a walking skirt when not flying. The Cradle

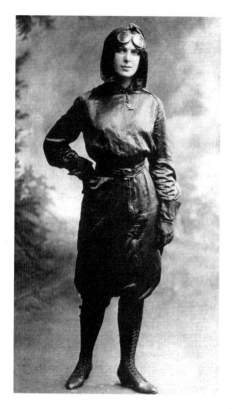

Harriet Quimby, 1911, in the flying suit she designed of wool-backed satin. She was the thirty-seventh person in the world to earn an aviator's license. *Courtesy of Giacinta Bradley Koontz.*

of Aviation Museum has a full-size diorama of Harriet Quimby in a replica of the costume she designed. She stands in front of a Blériot plane, the type she flew.

Quimby had an interesting but brief career in aviation. She flew in fairs in New Jersey and Staten Island and won an uncontested cross-country race at the Nassau Boulevard Air Meet in Garden City—circling the field for thirty minutes and winning the $600 prize (about $10,000 today). In 1911, Quimby and Matilde Moisant flew in Mexico in the Moisant exhibition flying team. In April the following year, Quimby was the first woman to solo across the English Channel. Quimby's aviation career lasted less than a year. Two months after her cross-channel flight, on July 1, 1912, Quimby's Blériot abruptly upended while returning from a flight around the Boston Lighthouse, thrusting her and her passenger out of their seats. They fell one thousand feet to their deaths. Quimby was only thirty-seven.[5]

Women were a great attraction at air meets. Plane manufacturers sponsored them to demonstrate that flying was easy—"even a woman could do it." Exhibition flying was common in those early decades and often lucrative for the daring airwomen. Women had their share of crashes, accidents and deaths, particularly in the 1910s. Cockpits were open, planes had neither seatbelts nor landing brakes. Accidents were frequent, and a number of women—and even more men—lost their lives in airplane accidents.

MATILDE MOISANT (1874–1964)

Matilde Moisant took lessons at the same time as Harriet Quimby, and they became good friends. She was licensed two weeks after Harriet, becoming the second woman in the United States to be licensed. The Moisant Aviation School, owned by her brother, Alfred, was one of the few that trained women; they had lost their brother, John, in an air crash in 1910. One Sunday during dinner at the Moisants' home, a French guest doubted that she—or any woman—could really fly a certain plane with a heavy engine. Matilde wanted to prove that she could, even though Nassau County police had orders to arrest anyone who flew on Sunday and were at the airfield to enforce the policy. Matilde went up and waved at the four motorcycle policemen ready to arrest her when she landed. However, she landed at a different field nearby. The police raced there, ready again to arrest her, but the Moisants asked them to show their arrest warrant, which they did not have. A crowd of three hundred had gathered meanwhile, and the ensuing riot lasted almost half an hour. The next day, Matilde went to the judge, who asked if she was flying for money (she wasn't). At the time, laws prohibited sales and certain activities on Sunday. The judge stated, "She's got just as much right to fly her airplane as you have to ride a motorcycle or anybody to drive an automobile," and dismissed her. Matilde Moisant gave up flying after a crash in 1912 in which she was severely injured, but she is nonetheless a colorful part of Long Island's aviation history.[6]

ELINOR SMITH (1911–2010)

Elinor Smith is the most famous of Long Island's early female pilots and is well worth attention. Born in New York, she grew up and lived in Freeport during most of her active years in aviation. Her father, Tom Smith, was a vaudevillian who fell in love with flying while touring with the Orpheum Circuit in California in 1916. Elinor had her first plane ride at age six. The family was out for a Sunday drive and came upon a French flier offering airplane rides from an abandoned potato field for five and ten dollars. Years later in her memoir, she wrote of the breathtakingly beautiful view, "I wanted never to leave." That was the first of many airplane rides for Elinor. One of those times, the pilot let her take the wheel and steer for a time. When

they landed, he said to her father, "She will fly one day, with the great ones. She has the touch." When Tom repeated this to his wife, she murmured, "Mmm…That's nice, but how can I get those awful grease spots out of her new pink dress?"[7]

Elinor's father customarily used airplanes on his tours. He hired a pilot and started taking flying lessons himself. Soon Elinor was getting lessons, too, though she needed wooden blocks to reach the rudder pedals. She had a much better "touch" than her father (who often had trouble with takeoffs and landings and wrecked more than one of his planes). By the late 1920s, planes were more reliable, and flying was not as dangerous, though crashes were still not uncommon. To take her lessons, Elinor got up at daybreak and drove to a field in Wantagh. Her instructor flew her to Roosevelt Field for lessons, and she returned home by 7:45 a.m. for school.

Elinor accumulated many hours of flying instruction by age fifteen, and she begged her parents to let her solo. They had told the instructor *not* to teach takeoffs or landings to ensure that she wouldn't go up alone. Yet one day, when Tom was away on tour, her mother finally consented to her pleas. Elinor started takeoff and landing lessons. Ten days later, after three and a half hours in the air, her instructor climbed out of the cockpit and told her, "Go." He had not said that morning that she was going to solo. She was stunned for a minute but did it and made three successful landings. She later recalled that "it was time to go back to Wantagh because I had to go to school."[8] Elinor Smith received her aviator's license at sixteen—the youngest person to be licensed to fly. Soon she was taking paying passengers for rides.

Elinor Smith is best remembered for flying under the four East River Bridges in New York City in 1927. It seems that a barnstormer from the Midwest had tried, without success, to fly under the Hell Gate Bridge—something Bert Acosta had already done and had his license suspended as a result. At Roosevelt Field, a photographer got tired of the midwesterner blaming his plane for his failure and tried to quiet him, saying, "It's been done before by an expert. *When* are you gonna knock it off? Why, even Ellie here could do it, couldn't you Sis?" Teenager Elinor Smith shrugged and said, "Sure, Mac. Anytime."

Well, within a few days, there was a betting pool at the airfield, and Elinor decided to fly not just under one bridge but *four* bridges. She planned carefully, deciding to go on a Sunday when there was less traffic on the river. She took off in a Waco plane from Roosevelt Field, flew first under the Queensboro Bridge and then the Williamsburg, Manhattan and Brooklyn Bridges. This

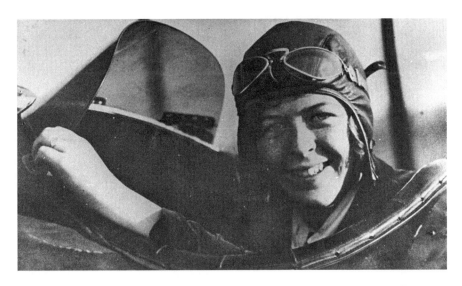

Elinor Smith at Roosevelt Field in May 1927, when she made her first solo flight in a Waco 9 airplane. *Courtesy Nassau County Department of Parks, Recreation and Museums, Photo Archives Center.*

required real skill and is a feat no one has duplicated to this day. Elinor was only seventeen. When summoned to city hall, she feared that her license would be suspended. New York mayor Jimmy Walker grounded her for ten days, but it was retroactive, so she was happy to miss only two days of flying. Moreover, Mayor Walker put in a good word for her with the Department of Commerce. She received a letter of reprimand from Washington, together with a personal note from the secretary requesting her autograph.[9]

Elinor Smith did cross-country flying and set speed, altitude and endurance records in 1929. Her endurance record of twenty-six hours and twenty-three minutes still stands. With another female flyer that year, she set a record endurance flight of forty-two and a half hours, refueling in the air. Smith received money for endorsements and flying exhibitions. At one exhibition, she had seven parachutists jump from her plane, which took some skillful flying lest she interfere with their parachutes. The press called her "The Flying Flapper," but she disliked the term since she felt that "flapper" implied someone who partied a lot, which she did not do. Smith also delivered and demonstrated planes for the Waco plane company and spent time in Hollywood flying in films, doubling in aerial shots for the starring actress. She was hired by NBC to be a radio commentator on aviation competitions and became a celebrity. At age eighteen, she received

her transport license, which she later described as "the pilot's doctoral degree…the ultimate proof of your competence to fly any aircraft anytime, anywhere," and she did fly all types of planes. She continued to fly and set four major world records in one year.[10]

In 1930, when Elinor was nineteen, the American Society for the Promotion of Aviation asked licensed aviators to vote on the country's best pilots. Elinor Smith was voted the best female pilot and Jimmy Doolittle the best male pilot that year, the first year of the award. Smith continued active flying in the early 1930s. She married Patrick Sullivan in 1933 and retired from flying for two decades to raise their four children. She became a charter member of the Long Island Early Fliers organization in the 1950s. In later years, she piloted a jet trainer and completed a successful simulated space landing when she was eighty-nine. Elinor Smith's 1981 autobiography is named *Aviatrix*.

THE CHALLENGE OF TRANSATLANTIC FLIGHT AND AMELIA EARHART (1898–1937)

Following Charles Lindbergh's solo, nonstop flight across the Atlantic in May 1927 from Roosevelt Field, a number of women caught transatlantic fever. Ruth Elder (1902–1977) was the first to attempt it. She flew from Roosevelt Field in October that same year with her instructor George Haldemann as the pilot. Elder was at the controls for nine hours before they encountered bad weather and an oil leak and had to ditch in the ocean three hundred miles short of land; by good fortune, they were rescued by an oil tanker. Frances Grayson (circa 1890–1927), who lived in Forest Hills, Queens, attempted the flight as well, leaving Long Island that December with a male pilot and navigator; their plane was lost. Mabel Boll (1895–1949) was the first woman to fly nonstop from Mitchel Field to Havana, Cuba, in March 1928, but she was a passenger, had no pilot training and never took the controls. Boll was a Hollywood actress known as the "Queen of Diamonds," as she liked to wear all of her jewels in public. She also sought to fly across the Atlantic.

Amy Phipps Guest of Westbury, daughter of the John Phipps who built Westbury House (today the centerpiece of Old Westbury Gardens), thought that Mabel Boll was not the "right sort of girl" to be the first to fly the Atlantic. She felt that "it just wouldn't do," so she decided to join the race herself to be first woman to fly the Atlantic. Guest leased a Folker plane from

Richard Byrd and hired a pilot and navigator. Amy Guest at this time was fifty-five years old, described as "stout and matronly" but physically daring. She had been big-game hunting in Africa and rode with the hounds, fox hunting. She told her brother, Howard Phipps, about her plans, and though she had sworn him to secrecy, he in turn told Amy's eldest son, Winston, who was attending Columbia Law School. Her son confronted his mother, saying that if she flew, he would not be able to study for his exams and she would make him fail. Amy Guest reluctantly bowed to family pressure but told her brother to find a well-educated female pilot with manners and the right image to fly in the plane with the male pilot and navigator she had hired. The pilot they picked was thirty-year-old Amelia Earhart.

Amy Guest financed the flight, and Amelia Earhart become the first woman to fly the Atlantic in June 1928—ahead of Mabel Boll, the Diamond Queen, whose flight was aborted in Newfoundland because of inclement weather. Earhart became a celebrity when she landed in Wales and received a ticker tape parade on her return to New York. She downplayed the accomplishment, saying, "I was just baggage."[11] Earhart never touched the controls on that flight because the plane used instrument flying for which she had not trained. Earhart did fly solo across the Atlantic in 1932. She disappeared over the Pacific in 1937 on her attempt to fly around the world.[12]

THE NINETY-NINES

The first National Women's Air ("Powder Puff") Derby was held in August 1929. It was a cross-country transcontinental race, open only to licensed pilots with more than one hundred hours of solo flying and at least twenty-five hours in cross-country flying. Only seventy women met those qualifications in 1929; twenty of them entered the race from California to Ohio. After some crashes, forced landings and one fatality, fifteen women completed the derby in the scheduled nine days. Alumnae of that race, including Faye Gillis (1908–2002) and Amelia Earhart (1897–1937), proposed organizing licensed women pilots. They called a meeting that November at Curtiss Field, Valley Stream (site of today's Green Acres Mall). Their purpose was "mutual support and the advancement of aviation." Twenty-six women attended, and various names were proposed for the organization including Climbing Vines, Bird Women, Gad Flies and Skylarks. They finally settled on something different—the number of charter members. They had 99

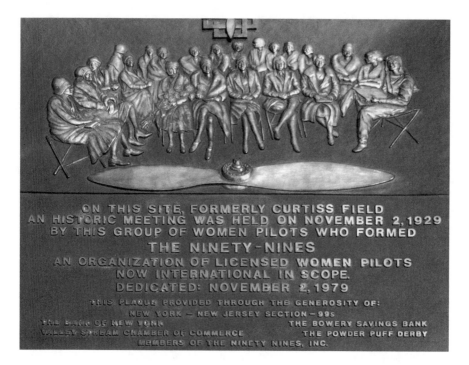

ON THIS SITE, FORMERLY CURTISS FIELD
AN HISTORIC MEETING WAS HELD ON NOVEMBER 2,1929
BY THIS GROUP OF WOMEN PILOTS WHO FORMED
THE NINETY-NINES
AN ORGANIZATION OF LICENSED WOMEN PILOTS
NOW INTERNATIONAL IN SCOPE.
DEDICATED: NOVEMBER 2, 1979
THIS PLAQUE PROVIDED THROUGH THE GENEROSITY OF:
NEW YORK — NEW JERSEY SECTION — 99s
THE BANK OF NEW YORK THE BOWERY SAVINGS BANK
VALLEY STREAM CHAMBER OF COMMERCE THE POWDER PUFF DERBY
MEMBERS OF THE NINETY NINES, INC.

Plaque commemorating the organization of the Ninety-Nines in 1929. Originally at the Sunrise Shopping Center in Valley Stream, it is now exhibited at the American Airpower Museum. *Courtesy of American Airpower Museum/Lori Biegler.*

members by a deadline date, and hence to this day the group is the Ninety-Nines. Today the Ninety-Nines is international, with 6,500 members. Its mission is to preserve the "unique history of women in aviation," provide "networking and scholarship opportunity for women and aviation education" and promote "world fellowship through flight."[13]

This chapter mentions only a few of the many women involved in aviation on Long Island in the earliest decades of flight.[14] Long Island's pioneer women pilots paved the way for other women. They proved that women make good pilots and that flying is safe. As aviation historian Claudia Oakes stated, they "contributed significantly in those early years to shaping the future of aviation" and inspired others because they "dared to defy convention, try their wings, and *fly!*"[15] The "daring and intrepid airwomen," as the press liked to call the pioneer pilots, are part of our remarkable aviation and Long Island heritage.[16]

Chapter 11

ACHIEVING VOTES FOR WOMEN

In July 1848, Elizabeth Cady Stanton, Lucretia Mott and a few other like-minded women convened the first Woman's Rights Convention in Seneca Falls, upstate in the Finger Lakes region of New York State. "That it is the duty of the women of this country to secure to themselves their sacred right to the elective franchise" was the most radical of the convention's twelve resolutions and the only one not adopted unanimously. Native Long Islander Amy Kirby Post attended the convention, signed its Declaration of Sentiments and was appointed to the committee to publish its proceedings. Within a few years, Susan B. Anthony had joined the cause of woman's rights. These leaders and many other women worked ceaselessly for woman's rights and suffrage. On nineteenth-century Long Island, however, these issues attracted little interest. More than 80 percent of the members of the National American Woman Suffrage Association (NAWSA) in New York in 1900 lived west of Utica, and 15 percent were in New York City, with less than 5 percent in the rest of the state, including Long Island.[1]

Two of America's famed suffrage leaders, however, did have some connection with Long Island in the late 1800s. Elizabeth Cady Stanton (1815–1902) moved from New Jersey to New York City after her husband's death in 1887 and spent summers on Long Island with two of her adult children and their families beginning in 1889. She visited her son, Gerrit, in homes he rented in Hempstead, Glen Cove and Thomaston and spent time in Shoreham, where her daughter, Harriot Stanton Blatch, had a home. Susan B. Anthony (1820–1906) visited Stanton for a week in Glen Cove in

1893, where Cady Stanton wrote suffrage speeches for Anthony to deliver at the Chicago Exposition. In 1894, Anthony spoke to a "large audience" in Riverhead on the Constitutional Amendment campaign of the Woman's Suffrage Association of New York State, which collected signatures on petitions for women's suffrage.[2]

SOCIALITE SUFFRAGISTS: KATHERINE DUER MACKAY AND ALVA VANDERBILT BELMONT

A number of wealthy Long Island women, including Katherine Duer Mackay and Alva Vanderbilt Belmont, helped bring respectability and financial support to the suffrage movement in the early 1900s. The philanthropic activities of Mackay and Belmont were discussed in the eighth chapter. Katherine Mackay (1880–1930) was the first woman on the Roslyn School Board, serving from 1905 to 1910. She began her suffrage activities in 1908 in New York City, where she organized the Equal Franchise Society. Mackay's involvement in the suffrage movement lasted only a few years, but she made significant financial contributions at a time when the movement was gaining momentum in New York City. She also introduced Alva Vanderbilt Belmont to suffrage leaders, and Belmont became actively involved in the cause.[3]

Alva Smith Vanderbilt Belmont (1853–1933) devoted much of her energies to suffrage and women's causes after her second husband's death in 1908. She was familiar with the militant English suffrage movement, having spent time in England. In 1909, she invited suffrage leaders to her mansion, Marble House, in Newport, Rhode Island, to give suffrage lectures. She soon founded the Political Equality Association (PEA), rented rooms on Fifth Avenue in New York for headquarters of the PEA and the National American Woman Suffrage Association and financed a suffrage press bureau. She also raised funds that year for striking shirtwaist workers in New York.[4]

On Long Island, Belmont organized the Brookholt Branch of the PEA in 1911 and launched a campaign "to put Long Island on the map" for suffrage by sending speakers to meetings in communities throughout the island. That same year, she began the Brookholt Agricultural School for Women on her East Meadow estate, Brookholt. She hired an experienced farmer's wife to direct the school and interviewed applicants herself. Belmont provided

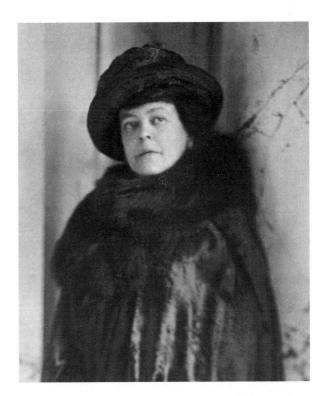

Right: Alva Vanderbilt Belmont (circa 1919) was an ardent suffragist who devoted much of her fortune to the cause. *Courtesy Library of Congress.*

Below: Belmont's Beacon Towers was the site of many suffrage meetings and lectures. This view shows the rear façade, circa 1920. Only the gatehouse is now extant. *Courtesy Nassau County Department of Parks, Recreation and Museums, Photo Archives Center.*

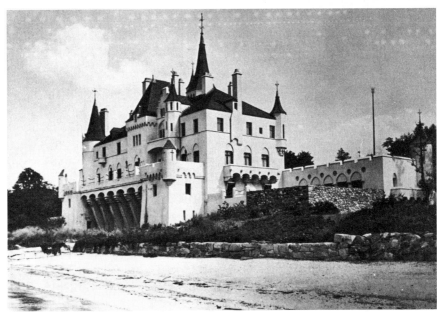

free room and board to twenty-five young women in a dormitory and paid the "farmerettes" four dollars per week. They worked ten hours per day and kept journals recording what they learned. She hoped that they would become farm superintendents or landscape architects. The school lasted for only one season, however, and did not reopen in 1912.[5]

Belmont built Beacon Towers at the northern tip of Sands Point in 1917. Alice Paul, head of the Congressional Union (CU) of NAWSA, visited there a number of times, as did as other suffrage leaders. In Washington, D.C., Belmont rented headquarters for the CU and, in 1921, purchased a home for its successor, the National Woman's Party (NWP).[6]

HARRIOT STANTON BLATCH AND HARRIET BURTON LAIDLAW

Harriot Stanton (1856–1940), Elizabeth Cady Stanton's younger daughter, became her political disciple in the suffrage movement. She had assisted her mother and Anthony in their book *History of Woman Suffrage* in 1881, writing the chapter on Lucy Stone's American Woman Suffrage Association. After traveling in Europe, she married an Englishman, William Henry Blatch, in 1882. Blatch lived outside London for two decades and was involved with the Fabian Society and English suffrage activities. She brought her daughter, Nora, to New York City, where they lived with her mother, Cady Stanton, her aunt and her brother on the Upper West Side while Nora attended the Horace Mann School. Harriot and her husband returned permanently to the United States in 1902 and lived in Shoreham, but Harriot spent most of her time in New York City.[7]

Blatch found the suffrage movement "completely in a rut in New York State." She organized what became the Women's Political Union (WPU) and began holding street meetings and parades in New York City. Though initially regarded as too radical and "unfeminine," the parades became popular and respectable annual events, with more participants every year. Blatch also focused on lobbying legislators in Albany and targeting suffrage opponents for defeat in elections. At the 1913 Suffolk County Fair in Riverhead, the WPU had the usual speakers and distribution of literature but also instituted infant and child care under a tent, which proved extremely popular. Blatch worked closely with Alva Belmont, Alice Paul and the radical wing of the suffrage movement.

After defeat of the state's 1915 suffrage referendum, Blatch turned her attention to campaigning in Washington, D.C., and the West, where she worked with Alice Paul and the Woman's Party. She was popular throughout the country as the daughter of Elizabeth Cady Stanton and in her own right as well. In the judgment of her recent biographer, Ellen Carol DuBois, Blatch was "the chief strategist of the woman suffrage movement in the largest and most important state in the Union" (New York), as well as "the senior stateswoman in the campaign that produced the Nineteenth Amendment."[8]

Harriet Burton (1873–1949) grew up in Albany, where she earned degrees at the Albany Normal College. She moved to New York City for her AB from Barnard College and taught high school English until her marriage to James Lees Laidlaw (1868–1923) in 1905. They lived in New York and had a country home in Sands Point. Harriet Laidlaw became Manhattan suffrage chairman in 1909 and later was vice-chairman of the state Woman

Above, left: Harriot Stanton Blatch (circa 1917) brought radical suffrage tactics to New York from England and held suffrage events at her Shoreham home. *Courtesy Bryn Mawr College Library, Special Collections, C.C. Catt Collection.*

Above, right: Harriet Burton Laidlaw (circa 1917) and her husband held offices in national and state suffrage organizations and hosted suffrage events at their Sands Point home. *Courtesy Bryn Mawr College Library, Special Collections, C.C. Catt Collection.*

Suffrage Party and also an officer of the National American Woman Suffrage Association from 1911 to 1920. Laidlaw was a founding member of the Port Washington Woman's Suffrage League in 1913 and headed the successful 1917 suffrage campaign in Nassau County. All her suffrage activities were with the mainstream organization or its affiliates; she opposed more militant approaches. She wrote a suffrage handbook, *Organizing to Win* (1914), toured with her husband in the West for suffrage, campaigned by automobile on Long Island distributing suffrage leaflets and marched in suffrage parades in New York City. Her biographer called Harriet Laidlaw an "eloquent speaker, an indefatigable worker, and a conscientious lieutenant" for suffrage. Her husband, James, organized the New York Men's League for Woman's Suffrage in 1910 and was president of the National Men's League for Woman's Suffrage from 1912 to 1920.[9]

GENERAL ROSALIE JONES

Rosalie Gardiner Jones (1883–1978) was born in New York City, but her family had deep roots on Long Island. Her mother, Mary Jones, inherited Jones Manor in Cold Spring Harbor (in today's Laurel Hollow) in 1882. After that house burned down in 1909, she built a twenty-five-thousand-square-foot concrete house on her property, and Rosalie lived in these homes in her early and later years. She was a socialite, but as a suffragist she rebelled against that background. She attended Adelphi College (then in Brooklyn) and traveled in the United States and Europe, where she first encountered women's suffrage activities. Once home again, in 1911, she placed suffrage signs and slogans prominently on land she owned in Syosset. She began to speak for suffrage, initially in Roslyn and then in New York City, joining with Alva Belmont and Harriot Stanton Blatch. Jones joined Elisabeth Freeman (1876–1942) on a 1912 tour of Long Island in a horse-drawn suffrage wagon. Freeman had been born in England, was brought to Long Island as a child and worked in England as a speaker, organizer and coordinator of the Women's Social and Political Union from 1905 to 1911 before returning to the United States.[10]

Rosalie Jones was president of the Nassau County branch of NAWSA from 1912 to 1913. She organized a hike from New York City to Albany in December 1912 to gain publicity and present suffrage petitions to the governor. Rosalie's mother, Mary, and her sister, Louise, were members

Rosalie Jones (on left) and Elisabeth Freeman on their 1912 tour of Long Island. *Courtesy Collection of the Huntington Historical Society, Huntington, Long Island, New York.*

of the New York State Anti-Suffrage Association, and her mother tried to prevent Rosalie from making the hike, which she said was "ridiculous" and "absolutely foolish." Rosalie Jones appropriated the title "General," and her second in command was "Colonel" Ida Craft from Brooklyn. They carried "Votes for Women" banners and yellow knapsacks—yellow being the suffrage color. Harriet Laidlaw spoke at an open-air meeting the hikers held in Yonkers.

The hike took twelve days to cover 170 miles, with detours for distributing leaflets and making speeches. Only five stalwart women (including Jones) walked the full distance, but others—and some men as well—joined for portions of the march. The hike attracted so much publicity that General Jones announced a march from New York to Washington, D.C., in February to present a suffrage petition to president-elect Woodrow Wilson. That "Suffrage Army" started in Newark and covered more than 250 miles in just over two weeks. This time, the hikers wore brown pilgrim capes with hoods. Again the hike garnered much publicity, and the hikers joined the suffrage parade in the capital the day before Wilson's inauguration.

Jones seemed tireless. When she returned to Long Island after the hike, she organized and conducted a series of pageants and parades, including a suffrage parade in Hempstead in May 1913. In July, she had a ten-day

Votes for Women campaign, traveling in a yellow horse-drawn wagon. In September, she arranged an all-night Suffrage Aviation and Encampment meeting at the Hempstead Plains Aviation Field in Garden City. Many flights were cancelled because of rain, but fifty women slept in one of the hangars. Jones organized another hike to Albany in 1914 and campaigned for suffrage in several states in the Midwest. The next year, she spoke on suffrage on Long Island and campaigned in New Jersey and New York City. She apparently dropped out of suffrage activities after the defeat of the 1915 suffrage referendum in New York and focused on continuing her education; she received four degrees in 1919 and became a lawyer.[11]

OTHER LONG ISLAND SUFFRAGISTS

Ida Bunce (1865–1943) was born in Cold Spring Harbor and was active in the temperance movement from a young age. After her marriage to Edgar Sammis in 1890, she lived in Huntington and continued her interest in the Woman's Christian Temperance Union (WCTU). On the national scene, temperance and suffrage were often allied. In April 1911, Sammis invited Harriet May Mills, president of the New York State Woman Suffrage Association, to speak in her home. Three weeks later, she founded the Suffolk County Political Equality League at another meeting in her parlor and was elected president. The local league was affiliated with both the state and national Woman Suffrage Associations and was the first women's suffrage organization in Suffolk County. Its concerns extended to sanitary conditions in the schools, such as abandoning common drinking cups and using paper instead of cloth towels. Suffrage became a key topic at local WCTU meetings, and Sammis became Huntington's superintendent—and frequent public speaker—for the Franchise Department in this capacity.[12]

Suffragist Edna (Mrs. Wilmer) Kearns (1882–1932) was born in the Philadelphia area and moved to New York after her marriage in 1904. The Kearns maintained an apartment in the city, but by 1907, they also had a house in Rockville Centre. Kearns edited articles on suffrage in the *Brooklyn Daily Eagle* in 1912 and chaired publicity for suffrage campaigns. She also toured Long Island with what was called the "Spirit of 1776" wagon, which was given to the state suffrage organization in 1913. Kearns used this wagon for several years in campaigning.[13]

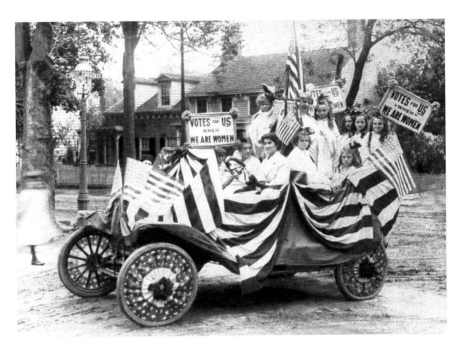

Car decorated for the county fair at Mineola, circa 1915, publicizing suffrage. *Courtesy Marguerite Kearns, from the archive of Edna Buckman Kearns.*

Irene Davison (1872–1948) of East Rockaway was from an old Long Island family. An "ardent and untiring" worker for women's suffrage, she participated in the hike to Albany with General Rosalie Jones. Davison led a detachment at the Suffrage Aviation Encampment that Jones organized at the Hempstead Plains Aviation Field. She was secretary of the Nassau County Woman's Suffrage Party and was one of the first members of the Nassau County League of Women Voters, which later named her "the outstanding suffragette in Nassau County."[14]

Gertrude Foster (Mrs. Raymond) Brown (1867–1956) of Bellport chaired the Long Island for Carrie Chapman Catt's Empire State Campaign Committee in 1915. Its activities included having poll watchers at the election, a suffrage exhibit at the Mineola Fair, "voiceless speeches" with the message on placards, open-air meetings, house-to-houses canvasses, distribution of suffrage literature and marching in parades. Brown was a vice-president of the National American Woman Suffrage Association (NAWSA) and chair of its organization for New York State in the 1917 suffrage campaign. She contributed significant amounts of money to the suffrage cause.[15]

Carrie Chapman Catt became president of NAWSA in 1916 and, aided by the more militant tactics of the Woman's Party, achieved the vote for women in New York State in 1917 when the statewide suffrage referendum was successful. The suffrage amendment passed both houses of Congress in 1919, and the Nineteenth Amendment was ratified by two-thirds of the states by August 1920, extending the vote to women nationwide. NAWSA dissolved, having achieved its goal, but Catt established the League of Women Voters in 1920. Alice Paul continued the Woman's Party and proposed an Equal Rights Amendment in 1923. The full story of the women's suffrage movement on Long Island has yet to be written. The overview in this chapter introduces some of the leaders involved during the decade of suffrage activities that achieved votes for women in New York State and the nation.[16]

Chapter 12

CIVIC AND POLITICAL ACTIVISTS

Although women did not secure the vote in New York State until 1917, some were involved in civic and political activities earlier. The village improvement societies and other social welfare concerns discussed in the eighth chapter were a form of civic activism. The women's suffrage movement was also a major expression of political activism. Ratification of the Nineteenth Amendment in 1920 opened the door to women's full participation in politics.

PRE-SUFFRAGE CIVIC ACTIVISM

Sarah Ann Baldwin (1814–1893) grew up in Baldwin, which had been named for her family, father Thomas and brother Francis. After she married Peter Crosby Barnum in 1846, they lived on a 2,500-acre farm, cattle ranch and dairy that her father owned in East Meadow. While her husband worked in his family's clothing stores in New York City, Sarah managed the farm complex. She also took an interest in civic affairs, attending most meetings of the Queens County Board of Supervisors and earning respect as an unofficial "extra member." The *Brooklyn Daily Eagle* in 1889 noted that she had been the "foremost political power in the Town of Hempstead" and was "the most remarkable woman Long Island has produced."[1]

Sarah Ann Barnum (circa 1865) was Long Island's leading woman civic activist in the nineteenth century. She was involved in both Hempstead Town and Queens County politics. *Courtesy Nassau County Department of Parks, Recreation and Museums, Photo Archives Center.*

A History of Eminent Ladies and Everyday Lives

In 1862, a new state law allowed towns in Queens County (including Hempstead) to sell their common lands if approved by popular referendum. After two votes to sell the common lands of the Hempstead Plains were defeated, Barnum publicized how passage would reduce taxes, since two-thirds of the proceeds would be used for public schools and the balance to help the town's poor. The next referendum did narrowly pass, opening the way for the purchase of more than seven thousand acres of the plains by Alexander T. Stewart in 1869 and the development of Garden City (see eighth chapter).

Barnum's next campaign related to her public service as head of a Ladies Committee for Relief of the Poor. The Queens County almshouse in Freeport needed improvement. Barnum recommended moving it to a farm on Hog Island, south of Oceanside. The county voted to buy the land, but the purchase encountered bureaucratic delay. Meanwhile, a syndicate wanted to buy the property for a resort. The determined Sarah drove ten miles in a snowstorm in a horse-drawn carriage and reportedly waded across a creek to Hog Island. She persuaded the owners to sell the 450 acres to her rather than to the syndicate, advancing $13,360 of her own money for the property. The syndicate offered her $75,000 for the land, but she turned it over to the county for only what she had paid. In appreciation, the county named it Barnum Island. Barnum continued to oversee the almshouse as chair of the Visiting Committee. After Nassau County separated from Queens in 1899, the Barnum Island property was sold. Nassau County used its $40,100 share of the sale to build its new courthouse in Mineola.[2]

Abigail Eliza Leonard (1852–1945) exemplifies a woman who led the local Women's Club in civic activities. After retiring from teaching in Brooklyn, she moved to Farmingdale in 1912. Leonard was one of the founders of the local Women's Club and was its president for a decade, from 1915 to 1925. Among the club's accomplishments during these years were providing signposts for village streets, pressuring the village fathers to pave the streets and collect garbage and starting the Farmingdale Free Public Library in 1924. Leonard served on the board of education from 1918 to 1922, and in these and other ways she worked hard for the good of her adopted community.[3]

Women started many Long Island libraries. Some grew out of a book club (as in Babylon), a literary society (Amityville), a neighborhood association (Westbury) or a suffrage club (Lake Ronkonkoma) or were promoted by a Women's Club (Farmingdale). Usually the first librarians were women as well, some of them volunteers.

ELECTED GOVERNMENT OFFICIALS

Ida Bunce Sammis had headed suffrage activities in Suffolk County and represented Suffolk's Second District in the State Assembly from 1919 to 1921. Photograph from *The New York Red Book, 1919. Courtesy Nassau County Museum Collection, Long Island Studies Institute, Hofstra University.*

Suffragist Ida Bunce Sammis (1865–1943, see eleventh chapter) of Huntington ran for the New York State Assembly in 1918, the first year women had achieved full suffrage in New York. She defeated a four-term incumbent in the primary and was endorsed in the general election by both Republican and Prohibition Parties. Sammis was one of the first two women in New York to be elected to the State Assembly. Among her first acts was polishing the cuspidor (spittoon) by her seat and filling it with ferns. Ten of the fourteen bills she introduced were successful, including one equalizing pay for men and women in state hospitals doing the same work. This was important for doctors, nurses and aides at Long Island's large state mental hospitals in Central Islip, Kings Park and (later) Pilgrim State in Brentwood. She is credited with the success of a bill regulating hours for women elevator operators. Although Sammis ran for reelection in 1921, she was defeated. Her groundbreaking "equal pay" legislation foreshadowed one of today's critical issues.[4]

Louise Udall Skidmore (Mrs. Roswell) Eldredge (1860–1947) became mayor of the village of Saddle Rock in 1926, the first woman mayor in New York State. She served as mayor for twenty-one years, until her death at age eighty-seven. Decades earlier, at the age of twenty and before she married, she planned a fundraiser for a proposed library. One of the founders of the Great Neck Library, she along with her husband built and donated a building for the library in 1907 and provided additions in 1926 and 1930 (the building is now Great Neck House on Arrandale Avenue). Louise Eldridge was also a founder of the Great Neck Park District, as well as its original Arts Center. She bequeathed the eighteenth-century Saddle Rock Grist Mill to the Nassau County Historical Society, which deeded it to Nassau County in 1955. Restored to circa 1845, the tidal mill first opened as an operating mill museum in 1961.[5]

Ruth Baker (1877–1965) married John Teele Pratt Sr. in 1903, and they had five children. The Pratts lived in New York City and in their 1915 Manor House mansion in the Pratt family complex in Glen Cove. Ruth Pratt was

the first woman to serve on the New York City Board of Aldermen, from 1925 to 1929, and was the first woman from New York State to serve in Congress, from 1929 to 1933; she represented Manhattan's "Silk Stocking District." After her husband's death in 1927, Pratt became a member of the Republican National Committee from 1929 to 1943 and president of the Women's National Republican Club from 1943 to 1946. She was also a delegate to eleven state and national Republican Conventions between 1922 and 1940. Ruth Pratt's political base was in New York City, but she lived in Glen Cove for half a century. The Pratt home on Dosoris Lane is now the Glen Cove Mansion Hotel and Conference Center.

Nassau County was first represented by a woman in the state legislature in 1945. Genesta Strong (1885–1972) of Plandome had long been active in civic concerns, including the Red Cross, Women's Clubs and the Manhasset Mother's Club. By the late 1930s, she was serving on the Nassau County Board of Health and was involved in county and state Republican Party activities. Elected to the New York State Assembly in 1944 for the first of eight terms, she served for fourteen years, from 1945 to 1959. Strong was proudest of her bill providing state funds for special classes for developmentally challenged children, but her claim to fame was legislation permitting the sale of colored margarine in 1952. Dairy interests promoting butter had prohibited the sale of yellow margarine. During roll call, Strong demonstrated in the State Assembly the tedious process of mixing yellow coloring into white margarine, which won votes for passage of the bill. Strong resigned from the State Assembly in 1959 to run for the New York Senate. She was elected but suffered a serious heart attack and resigned before taking office, following her doctor's orders.[6]

OTHER CIVIC ACTIVISM IN THE POST-SUFFRAGE YEARS

At the final meeting of the National American Woman Suffrage Association in 1920, as noted earlier, its president, Carrie Chapman Catt, founded the League of Women Voters (LWV). The Nassau County League began later that year and elected Helen (Mrs. George) Pratt (1869–1923) its first president. She and her husband had both supported women's suffrage, and Helen Pratt was also a founder of the Lincoln Settlement House in Glen Cove. She hosted a LWV convention in her country home in Glen

Cove, Killenworth, but her untimely death in her mid-fifties cut short her involvement in the league and other Long Island activities.

Nassau County LWV committees in the 1920s included Child Welfare, Education, Legal Status of Women, Legislation, Efficiency in Government, International Cooperation and Women in Industry. Studies and discussions of a proposed new county charter lasted sixteen years, until a new charter was adopted in 1938. Local LWV chapters then emerged in a number of communities. The county's roads, hospitals, health department and schools were among topics of discussion and study, as were child labor and the World Court. In later years, permanent personal registration and the United Nations became issues of concern. The LWV continues to publish *Voter Guides* and sponsor nonpartisan election activities. Over time, it has also served as a training ground for women who later secured elected or appointed governmental positions.[7]

Pauline Morton (1887–1955) married Charles Sabin in 1916 (her first marriage had ended in divorce in 1914). The Sabins had a house in New York and, by 1918, had built their Bayberryland estate in Southampton's Shinnecock Hills. She often held Republican fundraising lawn parties at the estate. Pauline Sabin was on the Suffolk Republican Committee in 1919 and, the next year, joined the party's state executive committee. She founded the Women's National Republican Club in 1921 and was president for five years, from 1921 to 1926. An excellent fundraiser and organizer, she became a Republican National Committeewoman for New York in 1923 and a delegate to Republican National Conventions in 1924 and 1928.

Sabin initially had favored prohibition of liquor, which was banned nationwide by the Eighteenth Amendment in 1919. She grew disenchanted at the hypocrisy of officials, however, especially given the ineffectiveness of the law and the decline of temperate drinking. In 1929, Sabin resigned from the Republican Party to work for change in the law and organized the Women's Organization for National Prohibition Reform (WONPR). Sabin testified in Congress, lobbied both parties and built support for repeal of the Eighteenth Amendment. Within two years, membership in the WONPR surpassed that of the Woman's Christian Temperance Union—once the largest organization advocating prohibition. In 1933, Congress passed and the states quickly ratified the Twenty-first Amendment repealing Prohibition. *Time* magazine featured Pauline Sabin on its cover, a tribute to her key role in overturning Prohibition.[8]

Ernestine Rose (1880–1961) grew up in Bridgehampton, graduated from Wesleyan University and received her library degree from the New York

Ernestine Rose chaired the Bridgehampton Tercentenary Committee in 1956. *Courtesy of the East Hampton Library, Long Island Collection.*

State Library School in Albany. She spent most of her career with the New York City Public Library. As director of the library's Harlem Branch on 135th Street for more than twenty years, 1920–42, she purchased materials collected by black historian Arthur Schomburg that today are the core of the renowned Schomburg Center for Research in Black Culture. Rose returned to Bridgehampton in 1946 and, in her retirement years, helped organize the local Community Council and the Bridgehampton Women's Association. Rose wrote and produced a pageant for Bridgehampton's Tercentenary in 1956 and was elected the first president of the Bridgehampton Historical Society the same year.[9]

AN EXEMPLARY CIVIC-MINDED WOMAN

Ethel Roosevelt Derby (1891–1977) has been called the "First Lady of Oyster Bay." Of the six children of Theodore Roosevelt, Ethel had the longest association with Oyster Bay. She married Dr. Richard Derby in 1913 and went with him to France in August 1914, where she served as a nurse in the American Ambulance Hospital. She was a Red Cross volunteer nurse for sixty years and a chairwoman of the Nassau County Nursing Service. When she had her portrait painted, she chose to wear her Red Cross uniform.

Ethel Roosevelt Derby in an undated portrait in her Red Cross uniform by Elizabeth Shoumatoff (1868–1980), who lived in Locust Valley. *Courtesy of Sagamore Hill Historic Site, National Park Service.*

Ethel Derby exemplifies a committed civic activist devoted to local community service. When she was named Oyster Bay Citizen of the Year in 1962, the list of local organizations in which she had actively served was lengthy indeed, including the Village Improvement Society, the Visiting Nurse Association, the Girls Club, the Progressive Mothers Club, St. Hilda's Society (of Christ Episcopal Church), the Red Cross, the American Legion Auxiliary, Oyster Bay Community Center and Roosevelt Memorial Park in Oyster Bay. Derby also worked for low-income housing in the community. Perhaps her greatest contribution was preserving the Roosevelt family home, Sagamore Hill. More than any other person, she was responsible for saving the home, which was opened to the public under the Theodore Roosevelt Association in 1953 and since 1963 has been a National Historic Site under the National Park Service.[10]

This chapter can touch on only a sampling of the Long Island women and organizations involved in civic and political activism.[11] The concerns of these and numerous other women who have been civic and political activists over the years have been vital to the cultural and civic infrastructure of

Long Island communities. Some of their efforts have shown the feasibility of activities ultimately assumed by government. In recent decades, women's civic activities have expanded still further, and women are increasingly successful in achieving elected office.

Chapter 13

YEARS OF CHANGE, 1930–1980

Long Island's population increased from 464,000 in 1930 to 2.6 million in 1980, with most of the growth in the 1950s and 1960s. The Great Depression in the 1930s, World War II and the postwar years brought profound changes to the nation and the world, affecting women on Long Island and in the rest of the nation. Those events have shaped even the recent past.

THE DEPRESSION YEARS

The stock market crash in October 1929 launched the depression years of the 1930s with widespread unemployment. Long Island, with an economy still predominantly agricultural, was not as hard hit as urban areas, but many people lost their jobs or experienced wage cuts. New housing and commercial construction virtually ceased on the island. A few Long Island banks failed, but most avoided financial chaos. Women were disproportionately affected by the Great Depression. Federal government legislation in the years 1932–37 prohibited more than one family member working in the civil service, and its popular Civilian Conservation Corps enrolled only young men. The National Youth Administration did provide work and job training for young women as well as men, but it employed far fewer people than did the CCC.

Most government public works projects employed men. Private companies also often gave hiring preference to men as the presumed breadwinners, and many school districts cut salaries and did not allow married women to teach. In the 1920s, women working outside the home were primarily single and young. Despite restrictive laws and policies, the proportion of married women in the country's paid workforce rose during the depression years out of economic necessity. Most women were still homemakers and had to stretch household budgets. Some sewed their own clothes, took in boarders, doubled up with relatives or economized in other ways. The Social Security Act in 1935, with its Aid to Families with Dependent Children, provided some assistance. However, many women were employed in occupations initially excluded from Social Security's unemployment insurance and old-age pension programs—among them teachers, librarians, nurses, domestic servants and farmworkers.

Not everyone's lives were greatly affected by the Great Depression. Some women aviators were able to continue flying and setting records. Nancy Hopkins (1909–1997) had earned her commercial flying license at Roosevelt Field in 1929. She moved to Long Island, and in 1930, at age twenty-one, she entered the Women's Dixie Derby and was also the only female pilot in the five-thousand-mile Ford Reliability Air Race. Elinor Smith (see tenth chapter) set women's altitude records in 1930 and 1931, flying from Roosevelt Field. Laura Ingalls (1901–1967), who had first soloed at Roosevelt Field in 1928, set a women's east–west record from Roosevelt Field to California in 1931. Many of the subsequent transcontinental races shifted to Floyd Bennett Field after it opened in Brooklyn in 1931.

The September 1938 hurricane wreaked havoc, especially on the South Shore of the East End. More than fifty Long Islanders were killed and hundreds of houses destroyed, with property damage estimated at $6.2 million—about $100 million in today's dollars. In Westhampton Beach, the center of storm destruction, women were nineteen of the twenty-three people who died in hurricane-related deaths.[1]

WORLD WAR II

World War II began in Europe in 1939 when Germany invaded Poland, although the United States did not enter the war until after the Japanese attacked Pearl Harbor on December 7, 1941. America had begun to mobilize

for possible war in 1940, with a peacetime draft and providing aid to Britain by sending destroyers in exchange for leases on bases in the North Atlantic. The Lend-Lease program to Allies followed in March 1941.

To increase the number of U.S. pilots, the Civil Aviation Administration had started a Civilian Pilot Training Program (CPTP) in 1939. Selected colleges provided ground instruction with flight training at cooperating flying fields; women made up about 9 percent of those enrolled. In 1939, Ruth Nichols (1901–1960), a celebrated aviator, started a CPTP program at Adelphi College in Garden City, which was then a woman's college. In 1940, when participants were required to pledge for military service in case of war, women were excluded from the CPTP program despite protests by First Lady Eleanor Roosevelt. Some women continued as instructors in CPTP programs, but they could no longer be students.[2]

One of the most famous women aviators of the day was Jacqueline ("Jackie") Cochran (1906–1980), who had learned to fly at Roosevelt Field in 1932. She set records and won aviation awards in the late 1930s and served as president of the Ninety-Nines from 1941 to 1943. Cochran recruited American female aviators to fly military planes for the British Air Transport Auxiliary in 1939 and lobbied for the United States to use women pilots as well. The federal government did begin a Women's Auxiliary Ferrying Squadron (WAFS) in 1942. Within a year, this had expanded into the Women Airforce Service Pilots (WASPs), directed by Cochran. Nationally, 25,000 women applied to join; some 1,800 were accepted, and nearly 1,100 joined. The WASPs did not have military status, but they ferried military planes, flew gunnery, towed targets and relieved male pilots for combat service.[3]

The first woman to qualify for the WAFS in 1942 was Betty Huyler Gillies (1908–1998) from Syosset. She had been president of the Ninety-Nines for three years, from 1939 to 1941. Gillies was squadron leader for women pilots (WAFS, then WASPs) at New Castle Army Air Base in Wilmington, Delaware, where she was the first woman to fly a Republic P-47 Thunderbolt.

Marjorie Gray (1912–2008), who had roots on eastern Long Island and had taken her first flight at Westhampton Beach, was in the first class of WASPs in Houston. During the war, she was stationed in Wilmington, and afterward she joined the Air Force Reserve, ran a flight school on Long Island and worked for Grumman and other aviation companies. She founded the Long Island chapter of the Ninety-Nines in 1965.

Margaret Gilman grew up in Great Neck and dropped out of college to take flying lessons. She obtained her pilot's license in 1941 and, three years later, was in the last class of WASPs, in 1944. After the war, she worked in

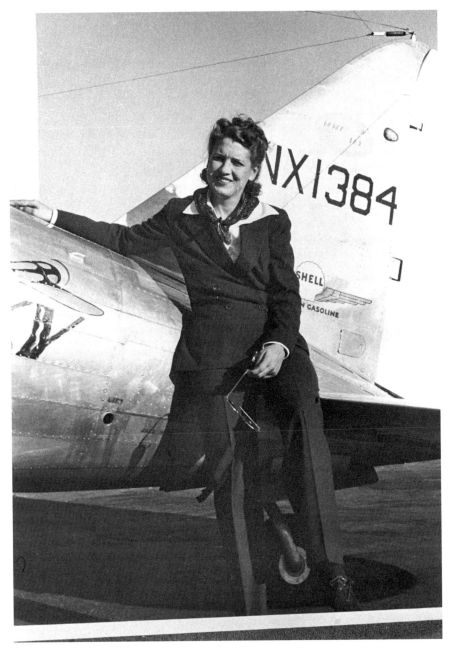

Jackie Cochran learned to fly at Roosevelt Field in 1932. She is standing next to her 1938 Seversky AP-7 Racer, circa 1938. *Courtesy Nassau County Department of Parks, Recreation and Museums, Photo Archives Center.*

aviation for a time. She married and settled in Garden City, where she lived for almost five decades.

Gillies, Gray and Gilman are only a few of the Long Island women who served our country flying during the war for the WASPs. By the time the WASPs disbanded in December 1944, thirty-eight had lost their lives in accidents during the war. The WASPs would finally achieve military status retroactively in 1977, and in 2010, surviving WASPs—including Long Island's Margaret Gilman—received the Congressional Gold Medal.

In 1942, women were being accepted in the military services, though in Auxiliary Services or Reserves, including the Women's Army Corps (WACs), Navy Women Accepted for Volunteer Emergency Service (WAVES), Women Marines and Coast Guard SPARS. Many of the military women served as nurses or in clerical positions, freeing men for combat and other war duties. Air WACs served as Link Trainer and gunnery instructors, aircraft mechanics, radio operators and air traffic controllers and in the Aircraft Warning Service. WAVES in naval aviation, like the Air WACs, did not fly as pilots but served in aeronautical engineering, air transportation, assembly and repair training, flight desk, noncombat crew and other positions.[4]

One Long Islander spent some of the war years as a photographer in Europe. Antoinette (Toni) Frissell (1907–1988) had married Francis McNeal Bacon 3rd in 1932. Within a few years, they had bought a country home in Head of the Harbor, near St. James, where they lived for nearly fifty years. Frissell became a renowned fashion photographer for *Vogue* but was also well known for her photographs of children, portraits of the rich and famous and sports activities (she was the first woman photographer for *Sports Illustrated*). During World War II, Frissell was a photographer for the Red Cross and Women's Army Corps, documenting military and civilian activities. Today, more than 300,000 of her photographs are in the Library of Congress collections.[5]

Born in New York City, Alice Throckmorton McLean (1886–1968) spent decades in St. James at her estate, Tulip Knoll, starting in 1919. After learning about the British Women Volunteer Services while in England, she organized in 1940 the American Women's Voluntary Services (AWVS). By the time the United States entered World War II, the AWVS had more than 18,000 members who had learned to drive ambulances, operate mobile kitchens and administer first aid. Their activities expanded during the war to provide relief and food for servicemen, sales of war bonds and other war-related services. AWVS membership grew to more than 325,000 women by 1945. After spending much of her fortune on the AWVS, McLean sold her

Long Island property and moved upstate to family property in 1944, but she continued as president of the AWVS, which after the war provided food and clothing to Europe.[6]

When war first broke out in Europe in 1939, Long Island's aircraft industry began to increase production. Sperry Gyroscope in Lake Success, Grumman Aircraft in Bethpage and Republic Aviation in Farmingdale were Long Island's largest airplane manufacturers during the war, but there were many smaller firms as well. As men enlisted or were drafted into military service and the aviation industries expanded production, women were recruited to enter the paid workforce as a patriotic duty. At its peak, during the war, women were 30 percent of Grumman's workers and an estimated 60 percent at Republic. Most of the women were on the production line, the famous "Janes Who Made the Planes," and received good wages in these wartime jobs.[7]

With the manpower shortage during the war, women were needed and encouraged to work outside the home. The typical women working

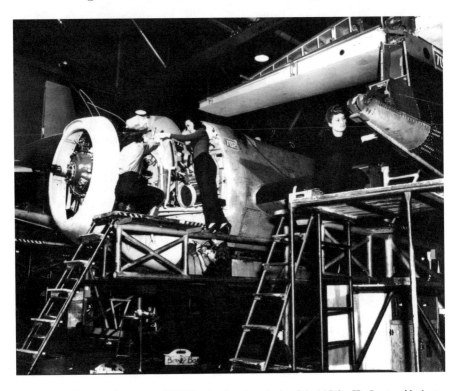

Women working on Grumman TBF Production line during World War II. *Courtesy Northrop Grumman History Center.*

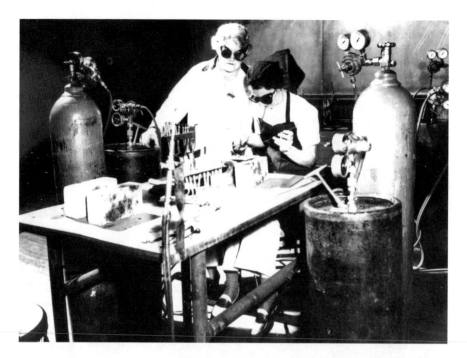

Woman with a welding instructor at Gumman during World War II. *Courtesy Northrop Grumman History Center.*

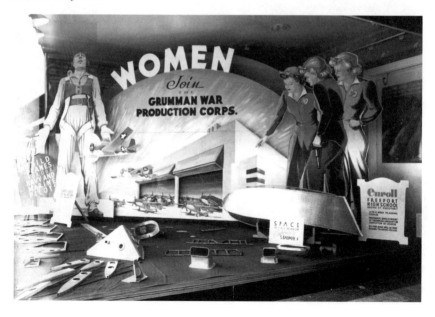

Grumman recruitment display in a Freeport store. Women were paid while learning and offered immediate employment on completion of a four- to six-week course. *Courtesy Northrop Grumman History Center.*

in the paid labor force during the war were middle-class, married and middle-aged, whereas before the war most were single, younger and from working-class families. At Grumman, the average age of women workers was thirty-six, with the range from seventeen to women in their sixties. Several aviation schools on Long Island provided training for women in riveting and other production jobs, while New York University offered free engineering courses to women at Adelphi College. Adelphi also established a nursing program in 1943 and began the first U.S. Cadet Nurse Corps in New York State. A number of subsidized child-care facilities were established to assist working mothers, though relatives and neighbors likely provided most of the child care.

Three women at Grumman were pioneer test pilots in the war years, including Cecil ("Teddy") Kenyon (1905–1985). Born in New York City, she grew up in Dobbs Ferry, New York, and Kent, Connecticut. At twenty-one, she married pilot Ted Kenyon, who taught her how to fly in 1929, and

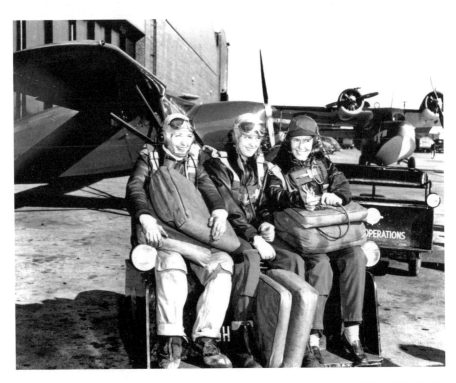

Women test pilots at Grumman Bethpage, 1943. *From left*: Barbara Jayne Kibbes, Elizabeth Hooker and Teddy Kenyon. *Courtesy Northrop Grumman History Center.*

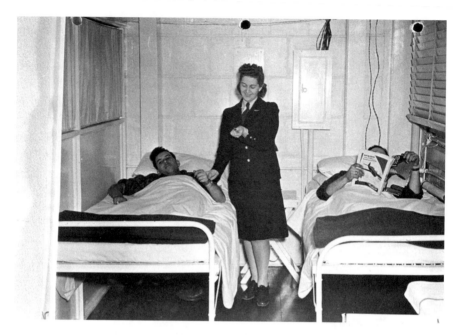

Nurse and soldiers at the New Dispensary at Mitchel Field Army Air Force Base, circa 1943. *Courtesy Nassau County Department of Parks, Recreation and Museums, Photo Archives Center.*

she soon earned her federal pilot's license at Roosevelt Field. The Kenyons moved to Huntington in 1936, where Ted worked for Sperry Gyroscope and later Grumman. That year, Teddy won the women's championship of the Amateur Air Pilots at a Charity Air Pageant at Roosevelt Field. Grumman hired her in 1942 to deliver airplane parts. Soon Grumman's Bud Gillies, whose wife, Betty, was a WASP pilot, asked Teddy Kenyon, Barbara Jayne and Elizabeth Hooker if they would like to test warplanes. Grumman was the first American company to employ women as test pilots. The three women initially encountered some resistance among the male pilots, but they proved that they were good fliers and soon won acceptance.[8]

Many women, including those working in war industries, also served on the homefront by buying war bonds, planting Victory gardens, coping with shortages and rationing meat, sugar, shoes and other goods. They served as air raid wardens, hostesses at USO camps and Red Cross staff and visited wounded servicemen in hospitals. Virtually all Long Islanders and Americans were affected by the war. For many women, their lives changed forever with the deaths of sons, husbands and other relatives in the war on distant shores.

THE POSTWAR YEARS

Employment in the aircraft industry declined drastically after the end of the war. Many women returned—not always willingly—to their homes or took lower-paying jobs. Women were dismissed or encouraged to give up their jobs to returning servicemen. Grumman laid off 80 percent of its employees and hired back only men. In 1947, only 213 women worked at Grumman—210 of whom were office workers—whereas more than 8,000 women had worked there during the war. Women who wanted or economically needed to work were now often relegated to "pink collar" (i.e., clerical) jobs at considerably lower pay.

Long Island population boomed in the postwar years, particularly in Nassau County and western Suffolk. The Levitts built affordable housing for returning veterans, aided by federal mortgage insurance, and Levittown became the symbol of suburbia. In Levitt houses, the front door opened into the kitchen, which was at the center of the house. Other developers also built single-family homes on Long Island, though not on the scale of the Levitts. After wartime shortages and with the benefit of prosperity, women were major agents of consumption. Shopping centers replaced some of the airfields.[9]

Like other Americans, most Long Island women focused their lives on children, home and local civic activities in the postwar years. Communities built new schools to accommodate growing enrollments and employed many women teachers. Districts abandoned traditional and depression-era restrictions against employing married women teachers. In the 1960s, Amityville, Malverne, Manhasset and Roosevelt school districts faced pressures from the state to eliminate their de facto segregated elementary schools. Women played active roles in school boycotts and other civil rights activities in these and other Long Island communities.

Women's opportunities for higher education on Long Island expanded greatly in the postwar years. Adelphi was a women's college when it moved to Garden City in 1929 and became coeducational in 1946 with the return of veterans aided by the GI Bill to attend college. Enrollments increased also at the island's existing coeducational colleges, Hofstra and Farmingdale. Long Island University opened C.W. Post College in Brookville in 1954. Molloy College opened in 1955, first admitted men to its nursing and business programs in 1972 and became completely coeducational in 1982. Public colleges developed in the late 1950s and 1960s, including Stony Brook College, Suffolk and Nassau Community Colleges, the College at Old

Westbury and, in 1971, Empire State College. In 1974, the U.S. Merchant Marine Academy in Kings Point was the first of the five federal service academies to admit women. The following year, the private Webb Institute of Naval Architecture in Glen Cove admitted its first female student.

By the 1970s, many women who had dropped out of college to work or marry were returning to college. They were joined by others who had not entered college after high school. The increased number of Long Island colleges and branch campuses facilitated higher education within an easy commute for these mature women, as well as the traditional seventeen- to twenty-one-year-old students. The expansion of the SUNY system upstate also made higher education more accessible, and many women now received degrees and certification to teach. Aided by the newly established doctoral programs, a medical school at Stony Brook University and a law school at Hofstra University in the 1970s, more women also went on to graduate and professional schools, becoming college professors, doctors and lawyers.

THE RECENT PAST

Federal legislation was positively affecting women's employment and education situation by the 1970s. Title VII of the Civil Rights Act of 1964 prohibited discrimination in employment on the basis of gender, as well as color and race. Although the act provided that the Equal Employment Opportunities Commission (EEOC) could investigate complaints, it initially accomplished little for gender equality until feminist organizations pressured the EEOC and the state Human Rights Commission. Title IX of the Education Act of 1972 provided for equal opportunities in education for females and males. This ended sex-segregated home economics and shop classes in schools and opened up greater opportunities for girls and women in high school and college athletics.

Betty Friedan (1921–2006), feminist crusader, journalist and national activist, lived in Kew Gardens Hills in Queens in the early years of her marriage and, beginning in 1970, summered at various places in the Hamptons. She bought a Sag Harbor house in 1975 and was an active member of the summer community. Friedan's noted 1963 book *The Feminist Mystique* helped initiate the modern women's movement. She was one of the founders of the National Organization for Women (NOW) in 1966, the National Association for the Repeal of Abortion Laws in 1969 and the

National Women's Political Caucus in 1971. In 1987, she was one of the conveners of the Sag Harbor Initiative, a weekend seminar on political, economic and social issues that included members of the local black community. Friedan wrote her last three books, including her autobiography, during summers on Long Island's East End.[10]

Friedan was not yet a Long Islander when she wrote *The Feminine Mystique,* but that book and her later books and articles affected women's lives on Long Island and, with the ensuing women's movement, throughout the country. Looking back at the mid-1990s, *Newsday* columnist Marilyn Goldstein asserted that "Long Island was, in the 1970s, a veritable hotbed of feminism." Goldstein cited many examples of feminist activism. Florence Howe started the Feminist Press at SUNY at Old Westbury, Hannah Komanoff was elected supervisor in Long Beach and Karen Burstein was elected to the New York Senate in 1972. Among the bills Burstein supported were ones permitting girls to deliver newspapers and prohibiting charging for women's toilets when men's were free. Eileen Brennan in Hicksville fought to become the first woman police officer in Nassau County, and Jenny Leeds of Great Neck won the right to play Little League baseball. Farmingdale teachers successfully challenged a district requirement that they leave teaching when four months pregnant. Women at *Newsday* filed a class action suit charging sex discrimination in 1973, which resulted in some limited progress. The Nassau County chapter of NOW was the third largest in the country in the mid-1970s, with more than five hundred members.[11]

The South Shore NOW in Suffolk County was founded in 1972. Linda Lane-Weber, who was one of the founders of the South Suffolk chapter of NOW in 1985, recounted some of the issues that the organization dealt with—among them equal opportunity for girls in public education, domestic violence, child support and reproductive rights. A Political Action Committee (PAC) was organized to endorse pro-women candidates.[12] Other NOW chapters have supported similar concerns. These examples of the impact of the women's movement on Long Island are only a few among many in these years of change.

In 1979, on the fiftieth anniversary of the founding of the Ninety-Nines, the Long Island chapter of the women's pilots organization installed a bronze plaque with a sculptured relief of the women attending the founding meeting of the Ninety-Nines (see tenth chapter). The plaque was dedicated at the Green Acres Shopping Center, formerly the site of Curtiss (Air) Field in Valley Stream where the Ninety-Nines had organized in 1929.[13] The plaque is now part of an exhibit in the

American Airpower Museum at Republic Airport in East Farmingdale that commemorates the World War II service of the WASPs, many of whom belonged to the Ninety-Nines.

During these years of change, Long Island women participated in aviation, setting records and joining other female pilots in the Ninety-Nines. They coped with the Great Depression, serving the nation in active war service and on the homefront at Grumman and other war industries. After the war, women initiated the baby boom and helped create suburbia on Long Island. Women enrolled in college in greater numbers, and some became feminist activists, many inspired by Betty Friedan's writings. The half century from 1930 to 1980 was truly a time of significant change for Long Island and its women. These were also years when women wrote histories of Long Island and helped to preserve the island's historic homes.

HISTORIANS AND PRESERVATIONISTS

M en have written most of the histories of Long Island, but from the middle third of the twentieth century, quite a number of women have written local histories and biographical accounts of Long Island literary figures. Women have been active also in historical preservation, historical societies and museums. This chapter focuses on women who have published books on the history of Long Island or its communities and people or who have preserved its history in other ways. Among the earliest were two women photographers who documented Long Island's past in the late nineteenth and early decades of the twentieth century.

PHOTOGRAPHERS RACHEL HICKS AND MATTIE EDWARDS HEWITT

Photographs preserve a pictorial record of Long Island's past. Rachel Hicks (1857–1941) was a Quaker born in Westbury. After studying drawing, painting and art history at the Swarthmore Preparatory School in Pennsylvania, she painted oils and watercolors. She became a self-taught amateur photographer, taking most of her glass-plate photographs near her Westbury home in just over a decade, from 1885 to 1896. With her "artist's eye for composition and the effects of light and shadow," she documented rural activities on the family farm. Hicks did

Photographer Rachel Hicks (circa 1920) preserved images of rural Long Island in the late nineteenth century in her photographs. *Courtesy Nassau County Department of Parks, Recreation and Museums, Photo Archives Center.*

Mattie Edwards Hewitt (circa 1915) photographed hundreds of estates on Long Island and elsewhere. Portrait by Frances Benjamin Edwards. *Courtesy Library of Congress.*

not marry, but after her mother's death in 1896, she became second mother to the many nieces and nephews of her sister and six brothers. She became active in civic concerns and women's suffrage and helped found the Nursing Association and Village Improvement Society in Roslyn, where she lived after the "Old Place" in Westbury was sold in 1900. About one hundred of Hicks's photographs were donated by her niece, Edna Hicks Seaman, to the Nassau County Museum Collection and are now in its Photo Archives Center.[1]

Mattie Edwards Hewitt (circa 1870–1956) was born in St. Louis and studied art but learned photography from her husband Arthur, whom she assisted. They divorced in 1909, and she moved to New York and worked with Frances Benjamin Johnston, becoming her partner in an architectural photography business. After the partnership dissolved in 1917, Hewitt started her own business, specializing in landscape photographs. Although she did not live on Long Island, she photographed many Long Island estates, as well as residences in New York City, upstate New York, New Jersey and elsewhere. The Nassau County Museum's Photo Archives Center owns more than four thousand Hewitt photographs of Long Island estates, gardens and interiors, most from the 1920s and 1930s.[2]

LONG ISLAND HISTORIANS

Martha Bockée Flint (1841–1900) grew up in Dutchess County, where she also spent her final years. She was a graduate of Elmira College in 1859 and taught in various schools and colleges in New York and the Midwest. Flint wrote two genealogies of her ancestors, some of whom lived in Hempstead, before publishing *Early Long Island: A Colonial Study* (1896), which was reprinted in 1967 as *Long Island Before the Revolution: A Colonial Study.* (Both titles are somewhat misnomers since the book includes the Revolutionary War years.) A lengthy review in the *Brooklyn Daily Eagle* in 1896 began with a paragraph disparaging women's "exploits in historical literature." Flint's book, however, met with the approval of the anonymous reviewer, who praised her "careful and untiring industry" and "excellent judgment in the mention and weighing of men, events and the times." The reviewer continued, "The style is lucid and stately and the story is told with a manifest desire to instruct as well as to interest the reader."[3]

Jacqueline Overton (1887–1954) was the librarian at the Robert Bacon Memorial Children's Library in Westbury from when it began in 1924 until she retired in 1949. She wrote *Long Island's Story* (1932; second edition, 1961). She also wrote numerous articles on Long Island history for local newspapers, the *Long Island Forum, New York History* and the *Nassau County Historical Society Journal* (including book reviews for issues of the *NCHSJ,* 1937– 43). Overton was a trustee of the Nassau County Historical Society, chaired the history subcommittee of the Hempstead Tercentenary and collected books and materials on Westbury and Long Island history for the Westbury Children's Library.[4]

Bernice Schultz Marshall (1902–1973) wrote her master's thesis at Columbia University under Allan Nevins, who encouraged her to publish it as *Colonial Hempstead*, 1937. She also wrote a new final chapter ("sequel") for the second edition of Jacqueline Overton's *Long Island Story* entitled "The Rest of the Story, 1929–1961." Marshall taught school in Hempstead, spoke frequently on Long Island history and published articles for more than three decades in the *NCHSJ,* from 1939 to 1970.[5]

Jeannette Edwards Rattray (1883–1974) wrote articles, pamphlets and books on maritime history and the village and town of East Hampton. Among her books are *East Hampton History, Including Genealogies of Early Families* (1953); *Ship Ashore! A Record of Maritime Disasters off Montauk and Eastern Long Island, 1640–1955* (1955); and *Up and Down Main Street: An Informal History of East Hampton and Its Old Houses* (1968).[6]

Mildred H. Smith (1901–1991) was the official historian of the village of Garden City for many years and wrote *History of Garden City* (1963; revised, 1980) and *Garden City, Long Island in Early Photographs, 1869–1919* (1987). She also wrote *Early History of the Long Island Railroad, 1834–1900* (1958) and several articles in the *NCHSJ* from 1961 to 1971.

Edith Hay Wyckoff (1916–2003) was editor and publisher of the *Locust Valley Leader* weekly newspaper for fifty-five years. In 1978, she published *The Fabled Past: Tales of Long Island*, which deals with the Indians, early settlements and primarily colonial history. In her foreword, Wyckoff explained that she has tried to tell the history of Long Island by recounting the "flavor of the period instead of the daily detail."[7]

COMMMUNITY HISTORIANS

Other women focused their historical writings on their local town or community. Kate Wheeler Strong (1879–1977) of Strong's Neck in Setauket was the most prolific contributor to the *Long Island Forum*, writing nearly four hundred articles beginning in 1939. She drew on family documents for some, and others were stories passed down in her family from colonial times. Strong continued to write even after losing her sight in the final decades of her life.[8]

Harriet G. Valentine (1902–1990) wrote *The Window to the Street: A Mid-Nineteenth-Century View of Cold Spring Harbor, New York, Based on the Diary of Helen Rogers* (1981) and numerous articles for the *Long Island Forum*. She was one of the authors of *Cold Spring Soundings* (1953) and, with her husband, Andrus Valentine, co-authored *An Island's People: One Foot in the Sea, One on Shore* (1976).

Dorothy Horton McGee (1913–2003), an "Oyster Bay legend," served as Town of Oyster Bay historian for twenty years, from 1982 to 2003, and chaired the town's Bicentennial Commission. She was active in historical organizations and spoke frequently on historical subjects. Perhaps best remembered for her fictionalized biography *Sally Townsend, Patriot* (1952), she also wrote a brief history of *Raynham Hall, 1738–1960* (1961, reprinted from the 1960 *NCHSJ*) and newspaper articles.[9]

Not all of the early histories by women (or men) are up to twenty-first-century standards of historical writing. Like many of the men who have written local history, few of these women were trained historians. Most

were teachers, librarians, journalists or avocational historians. Missing from most of the older histories is inclusion of women and African Americans, as well as the experience of everyday people. From a traditional emphasis on politics, wars and white males, history in academia has broadened since the 1960s to include women, people of color and social history. Recent scholarship has shown most of the early histories to be particularly dated in their treatment of Long Island's Native Americans. Despite these caveats, all the books mentioned in this chapter are still useful.

BIOGRAPHERS OF LONG ISLAND'S LITERARY FIGURES

Interestingly, women have predominated in publishing books documenting the local connections of Long Island writers. Long Island's most famous literary native son, Walt Whitman (1819–1892), has received the most attention. Whitman was born in West Hills (now part of Huntington Station); his restored birthplace is a New York State Historic Site and Interpretive Center. His family moved to Brooklyn when he was four years old, but Whitman returned to Long Island to teach in local communities from 1836 to 1841 and often visited later. He worked at newspapers in Brooklyn and Manhattan and in 1855 published *Leaves of Grass*, which he continued to expand throughout the rest of his life. Katherine Molinoff, a professor at C.W. Post College of Long Island University (now LIU Post), wrote a series of brief booklets focusing on Whitman in Smithtown and Southold, as well as his family and miscellaneous material, from 1941 to 1966.[10] Bertha H. Funnell was a native of Huntington and a trustee of the Walt Whitman Birthplace Association when she wrote *Walt Whitman on Long Island* in 1971.

Christopher Morley (1890–1957)—a noted "man of letters," novelist, poet and editor of the *Saturday Review of Literature*—lived in Roslyn Estates for nearly four decades, from 1920 to 1957. Helen McKelvey Oakley wrote a pamphlet, *Christopher Morley on Long Island* (1967), and a full biography of Morley, *Three Hours for Lunch: The Life and Times of Christopher Morley* (1976).[11] Joan D. Berbrich's *Three Voices from Paumanok* is subtitled, *The Influence of Long Island on James Fenimore Cooper, William Cullen Bryant, [and] Walt Whitman* (1969). Cooper (1789–1851) spent some time in Sag Harbor, which influenced his sea novels. Poet and newspaper editor Bryant (1794–1878) had a country home in Roslyn Harbor from 1843 until his death. Diane Tarleton Bennett and Linda Tarleton co-authored *W.C. Bryant in Roslyn* (1978).[12]

DIARIES AND NOVELS

Over the years, many women have kept diaries. Only a few have been preserved in historical repositories and even fewer published. Mary Cooper's surviving diary covering the colonial years, 1768–73 (see second chapter), is primary source material for historians, as is Helen Rogers's diary of mid-nineteenth-century Cold Spring Harbor, which Harriet Valentine used for her *Window to the Street*. Nettie Ketcham of Moriches kept a diary for a decade, beginning in 1886 when she was twelve years old.[13]

Personal Recollections of the American Revolution: A Private Journal, Prepared from Authentic Domestic Records presents a different situation. Published by Lydia Minturn Post (1812–1875) in 1859 and in a second edition in 1866, it was reprinted in 1970. Post had ancestors in Westbury, where the book is set, though she herself lived most of her life in Manhattan. Her book is one of the few of the period presented from a woman's perspective. However, researchers in recent years have shown conclusively that Post's book is not an authentic journal but rather a fictionalized history.[14]

Historical novels, carefully used, can be a resource for the historians. The first chapter refers to the novel *Lords of the Soil* (1905), co-authored by Lydia A. Jocelyn. Two other fiction examples are Cornelia Huntington's 1857 novel *Sea Spray: A Long Island Village*, which provides information on mid-nineteenth-century East Hampton, and the popular romantic novels of Faith Baldwin, which give the "flavor" of some aspects of Long Island in the 1920s and 1930s.[15]

UNSUNG WIVES

Wives often have assisted their husbands in writing articles and books, whether assisting in research, editing, proofreading or simply by ensuring time for them to do their work. Some have been credited in acknowledgements or dedications, but usually they are invisible. Wives who assisted the first three editors of the *Long Island Forum* received recognition when Gaynell Stone dedicated *The Shinnecock Indians: A Culture History* (1983) to "*The Long Island Forum* and the unique husband and wife teams whose devotion kept it going for 45 years: Paul and Florence Wyckoff Bailey, 1938–1959; Charles and Jeanie McDermott, 1959–1964; and Carl and Madelene ("Twinkie") Starace, 1964–[1991]." In most *Forum* issues,

however, the wife's name does not appear on the masthead. Florence Wyckoff Bailey kept the books, billed subscribers and wrote addresses by hand for mailings. Madelene Starace was listed as circulation manager initially but disappeared from the masthead until the fall 1986 issue, when she was acknowledged as "Editorial Assistant." Though the contributions of these women to the *Forum* are not fully documented, they certainly played a role preserving the historical record in the pages of the *Forum* for more than fifty years.[16]

Preservationists

Women have been active in the historic preservation movement. Bertha Benkard (Mrs. Reginald P.) Rose (1906–1982) was one of the outstanding early leaders on Long Island and in New York City. A resident of Upper Brookville and New York, she supervised the period rooms in the Metropolitan Museum of Art and the Museum of the City of New York. Locally, she served

Bertha Benkard Rose (on left) and SPLIA's president, Huyler C. Held, presenting SPLIA's Sherwood Award for preservation of Sagamore Hill to Ethel Roosevelt Derby, 1977. *Courtesy of SPLIA.*

on the board of the Society for the Preservation of Long Island Antiquities (SPLIA) and, for more than twenty-five years, on the executive committee of the Theodore Roosevelt Association. Rose supervised the initial restorations of Rock Hall in Lawrence, the Joseph Lloyd Manor House in Lloyd Harbor, Raynham Hall in Oyster Bay and Theodore Roosevelt's Sagamore Hill home in Oyster Bay—an extraordinary record in preserving Long Island's historic houses.[17]

Peggy Newbauer Gerry (1919–2000) lived nearly fifty years in Roslyn, beginning in the 1950s. She worked tirelessly with her husband, Roger, for the preservation and restoration of their adopted village. A talented painter, she devoted herself to preserving, protecting and enhancing the architectural heritage of Roslyn. Though her husband was the more active and visible force in the community, for decades Peggy brought her detailed research, artistic talents and "determined mindset" to her chairmanship of the Roslyn Historic District Board. A trustee of the Nassau County Museum of Art located in the former Frick mansion in Roslyn Harbor and chair of its landscape committee, she was responsible personally for initiating and sponsoring the restoration of its 1926 Marian Cruger Coffin garden, dedicated in 2000. Over the years, the Gerrys received recognition of their efforts from national, state and local preservation organizations.[18] In 2001, the Town of North Hempstead named its park in the heart of Roslyn the Dr. Roger and Peggy Newbauer Gerry Pond Park, in honor of the myriad preservation activities of the Gerrys.

Barbara Ferris (Mrs. Harry) Van Liew (1910–2005) was a "living legend in preservation circles." She edited and was the primary author of SPLIA's *Preservation Notes* (1965–2001). Van Liew inventoried Long Island historic properties, was the prime mover in establishing the (Smithtown) Branch Historic District in 1964 and wrote the still useful *Long Island Domestic Architecture of the Colonial and Federal Periods* (1974), as well as *50 Years: Head-of-the Harbor* (she was the village historian and lived in St. James). A founding member and chair of the Suffolk County Historic Trust Committee, she wrote its manual outlining standards for acquiring and maintaining historic properties. She also served on the Suffolk County Council on Environmental Quality.[19]

Peggie Phipps (Mrs. Etienne) Boegner (1906–2006) preserved her childhood home, Westbury House, as a nonprofit charity in 1959, and the exquisite Old Westbury Gardens was added to the National Register of Historic Places in 1976. Boegner also was the co-author (with Richard Gachot) of a Phipps family history, *Halcyon Days: An American Family Through Three Generations* (1987).

Peggy Gerry, her husband, Roger, and their dog, Bogey, sitting on their terrace in the late 1980s. *Courtesy of the Roslyn Landmark Society.*

Sylvester Manor on Shelter Island was a provisioning plantation in the seventeenth century for the family's sugar plantations in Barbados. Alice H. Fiske (1917–2006) moved to the circa 1735 manor house in 1952 when she married Andrew Fiske, a descendant of the original 1652 Sylvester settlers. After her husband's death in 1992, Alice Fiske donated the Sylvester Manor Archive to New York University and established the Andrew Fiske Memorial Center for Archaeological Research at the University of Massachusetts–

Boston, which conducted excavations on the Manor site for ten summers, from 1998 to 2007, yielding valuable historic information.[20]

Librarians and archivists have been important in preserving historical records and books essential for accurate historical research. Women have predominated in these professions, whether working in public, university or historical society libraries.

HISTORICAL SOCIETIES

Women started many of Long Island's historical societies. The Huntington Historical Society began in 1903 when a group of women prepared an exhibition for the town's 250th anniversary. Afterward, the women organized the Colonial Society of Huntington to "perpetuate an interest in things Historic." Initially, all members were women, but within a decade, the society had changed its name and extended its membership to men in 1911. The Suffolk County Historical Society in Riverhead was started by men in 1886, but it was local resident Alice Perkins who donated the land for its present building in the 1920s. Decades later, gifts from Cora Reeves Barnes and Sylvia Staas financed construction of the three wings to the building.[21]

The Suffolk County Historical Society (300 West Main Street, Riverhead) has permanent and changing exhibitions in its museum, a reference library and an excellent selection of local history books in its Weathervane Shop. *Courtesy Suffolk County Historical Society.*

A History of Eminent Ladies and Everyday Lives

Women have been an active force in many other local historical organizations as well, as both volunteers and officers. They have also aided husbands holding offices in historical organizations. These diverse societies have preserved local history and shared it with their local communities through exhibitions, lectures and other educational programs.

Over the years, women have documented Long Island's history as photographers, historians and preservationists. They have written about the history of Long Island, its communities and its literary figures who have lived on the island. They have preserved records and historic houses and worked tirelessly in local historical societies. Women continue to be vital to these activities, preserving our heritage to the present day.

EPILOGUE

In Long Island's recent decades, as throughout the first four centuries of the island's recorded history, many of the changes in women's lives have mirrored changes in the broader society and the national scene.[1] Increasingly, Long Island women have volunteered for military service and, most recently, served in conflicts in Iraq and Afghanistan. Some women and many men have died in military service and terrorist attacks at home and abroad. The lives of mothers, wives, daughters and other relatives, male and female, of the victims have changed as a result. Other women are the primary caregivers for wounded warriors or first responders to the World Trade Center disaster on 9/11.

More Long Island women have been elected to political office—including village, town and county officials, state legislators and one member of the U.S. Congress. May Newburger (1920–2012) served as supervisor of North Hempstead Town from 1994 to 2003 after four terms in the State Assembly (1979–86) and election to the town council in 1992. Carolyn McCarthy was first elected to Congress in 1996 where she continues to conscientiously serve.

Women have continued to be civic and political activists. A notable example is Nora Bredes (1950–2011), who starting in 1979 led the successful decade-long campaign against opening the Shoreham nuclear power plant; Shoreham became the first nuclear plant to be decommissioned. Bredes later served as a Suffolk County legislator, from 1992 to 1998. The first woman elected to the Suffolk County legislature was Maxine Postal (1942–2004), who served fifteen years from 1988 and became presiding officer in 2003.[2]

Women students now outnumber men nationally in colleges and universities, and their percentage in many professional schools has increased significantly. The number and percentages of female lawyers, doctors, dentists, engineers, scientists, professors, business executives and entrepreneurs have increased. Long Island reflects this national trend. Women now hold leadership positions in Long Island school districts as superintendents, principals and other administrators. Stony Brook University and SUNY College at Old Westbury have had female presidents. Many Protestant churches and conservative and reformed Jewish synagogues now have women clergy.[3] Nonetheless, most women still work in such traditional women's occupations as office workers, bank tellers, sales clerks, waitresses, teachers, librarians, social workers, nurses and other healthcare professionals.

The women's movement encouraged many women to choose careers, but it also has made the choice of being a full-time homemaker more respected. The personal computer, the Internet, e-mail, cellphones and social networking have affected the lives of virtually everyone since the 1990s. For women in particular, the electronic devices facilitate working in home offices or managing family and other responsibilities.

Nationally, more married women and mothers of young children are entering the paid labor force. A gender disparity in income continues, despite legislation such as the Fair Pay Act of 2005 and efforts of local organizations for greater equity.[4] Child care remains a national and local issue, and women are also affected severely by the economy, facing unemployment and foreclosures during recessions.

Recent decades have seen increasing awareness of domestic violence and sexual harassment in the workplace—and women are usually the victims. Women are among the island's many homeless, and single mothers often struggle to provide for their families.[5] Abortion remains a volatile political issue decades after the Supreme Court's 1973 *Roe v. Wade* decision. New York State adopted the Marriage Equality Act in 2011, which enables lesbian couples to marry.

In churches, synagogues and social service organizations, Long Island women continue their extensive benevolent and humanitarian activities. Some remain active, as in the past, as writers and artists. Among contemporary writers who call Long Island home are poet and novelist Hilma Wolitzer of Syosset and the bestselling novelist Susan Isaacs, who was born in Brooklyn and has lived in Manhasset and, more recently, in Sands Point. Johanna Hurwitz of Great Neck is a prolific author of children's books. Cynthia Blair, who grew

up in North Babylon and now lives in Stony Brook, has published many novels and young adult books.[6] Numerous other writers have second homes in the Hamptons. Professional women artists and architects live and work throughout Long Island today, most notably Jane Freilicher and April Gornik.

Agriculture continues its importance for Long Island in the twenty-first century, particularly on eastern Long Island. Most farms are still family enterprises in which women play essential roles. Suffolk County has for years ranked first in the state in the wholesale value of its agricultural products, which include fisheries, horticulture and vineyards. Marilee Foster, who is the fifth generation of her family to farm on the South Fork, is the author of *Dirt Under My Nails: An American Farmer and Her Changing Land* (2002). She described operating a farm stand and farming potatoes and vegetables in Sagaponack, in the heart of the Hamptons. Louisa Hargrave recounted how she and her husband established the first vineyard on Long Island in 1973 in *The Vineyard: The Pleasures and Perils of Creating an American Family Winery* (2003). The Hargraves initiated the thriving Long Island wine industry, which has grown to more than fifty wineries on the East End.

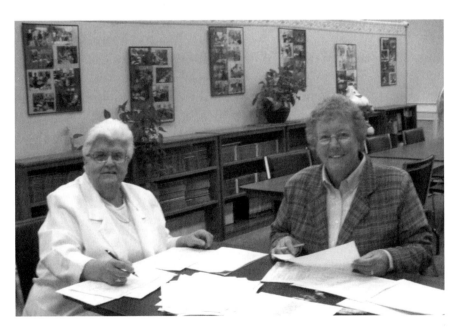

S. Kathleen Carberry, director of the Sisters of St. Joseph's Learning Connection, is on the right; S. Mary Theresa Donlon, assistant director, is on the left. *Courtesy of the Sisters of St. Joseph's.*

Beginning in the 1980s and 1990s, Long Island became increasingly multicultural and multiracial. According to the 2010 census, of Long Island's more than 2.8 million population 9 percent are African Americans, 15 percent are of Hispanic origin, 5 percent are Asians and nearly 5 percent are categorized as "Other" (including Native American Indians and those of two or more races). Racial segregation persists, and pockets of poverty still exist in the predominantly affluent counties. In their "Learning Connection" program, the Sisters of St. Joseph of Brentwood teach English to empower women, who are mostly from Latin America. Immigrant women as well as men have been exploited, but some have been aided by the Work Project in Hempstead, an advocacy organization begun by a woman to help immigrants secure the legal rights to which they are entitled.[7]

It has been a New York State law for nearly a century—since 1919—that every county, city, town and incorporated village appoint an official historian. In 2012, nearly fifty women were official public historians in Nassau and Suffolk Counties. These women and other local historians have contributed substantively to the historical record by writing articles for newspapers and journals and by publishing books on community history. Computers and the Internet now offer new possibilities for disseminating historical information. Women are active in local historical and preservation organizations and increasingly serve in leadership positions in the island's historical societies and as directors of museums, as well as being the majority of the volunteers.

Today's Long Island women are making tomorrow's history. They join the pioneers discussed in these pages who paved the way for women to take their place in the island's history thus far. The good they all have done, their strengths, achievements and their influence and power are the legacy of our foremothers on Long Island.

ABBREVIATIONS

DLB *Dictionary of Literary Biography**

LIF *Long Island Forum*

LIW *Long Island Women: Activists and Innovators*†

LIHJ *Long Island Historical Journal*‡

NCHSJ *Nassau County Historical Society Journal*

NAW *Notable American Women* (five volumes)§

OBHS Oyster Bay Historical Society

SPLIA Society for the Preservation of Long Island Antiquities

**DLB* is a multivolume series of more than three hundred books (Detroit, MI: Gale Publishing). Each book cited has its own title, listed in the notes.

†*LIW* was edited by Natalie A. Naylor and Maureen O. Murphy (Interlaken, NY: Empire State Books, 1998). All the articles have references, and a "Bibliography on Long Island Women" appears on 340–46.

‡*LIHJ* vols. 1–20 were issued in print form from 1985 to 2008 and are now also available online. *LIHJ* is also the abbreviation for the successor to the *Long Island Historical Journal*, the *Long Island History Journal*, which is an online, open-access, electronic journal that began in 2009 with vol. 21. The year of publication and the volume number differentiate the two versions. Each has its own website. A different journal, the *Journal of Long Island History*, was published by the Long Island Historical Society (since 1985, the Brooklyn Historical Society) from 1961 to 1982 (18 vols., from one to four issues per year).

§*NAW* (*Notable American Women: A Biographical Dictionary, 1607–1950*) was edited by Edward T. James and Janet Wilson James, 3 vols. (Cambridge, MA: Belknap Press of Harvard University Press, 1971); *Notable American Women, the Modern Period: A Biographical Dictionary* was edited by Barbara Sicherman and Carol Hurd Green (Cambridge, MA: Belknap Press of Harvard University Press, 1980), includes women who died from 1951 to 1975 and is cited as *NAW*, vol. 4; and *Notable American Women: A Biographical Dictionary, Completing the Twentieth Century* was edited by Susan Ware and Stacy Braukman (Cambridge, MA: Belknap Press of Harvard University Press, 2004), includes women who died from 1976 to 1999 and is cited as *NAW*, vol. 5. Each entry includes a bibliography.

NOTES

Introduction

1. Growth has leveled off in recent decades. Historical population figures are from *To Know the Place: Exploring Long Island History*, ed. Joann P. Krieg and Natalie A. Naylor, 2nd rev. ed. (Interlaken, NY: Heart of the Lakes Publishing, 1995), 156–57.
2. *Notable American Women* (*NAW*), 1:xi. Full biographical information for the five volumes of *NAW* is in the Abbreviations section preceding the endnotes.
3. "Long Island's Notable Women," parts 1 and 2, *Long Island Forum* (*LIF*) 47 (June and July 1984): 104–9, 135–39. Two-thirds of those women lived in Brooklyn, not surprising since it was the third-largest city in the United States by 1860. A list of "Long Island's Nationally Notable Women" for geographical Long Island is in *Long Island Women: Activists and Innovators* (*LIW*), ed. Natalie A. Naylor and Maureen O. Murphy (Interlaken, NY: Empire State Books, 1998), 337–39.
4. Naylor, *LIW*, 18.

Chapter 1. The First Long Islanders

1. Juet's *Journal* is available on various websites; the quote is from Brea Barthel's transcription of the 1625 edition of *Purchas His Pilgrimes* on the HalfMoonreplica.org website, 592.

2. "Daniel Denton's Long Island, 1670" (reprinted from his *Brief Description of New York*), in *The Roots and Heritage of Hempstead Town*, ed. Natalie A. Naylor (Interlaken, NY: Heart of the Lakes Publishing, 1994), 194–95.

3. Ibid., 195. "Squaw" is now usually denoted as an offensive word for Indian women, but "sunksquaw" is a generally accepted term. Both words are found in colonial records. Sunksquaw has sometimes been translated as "queen" or "wise woman."

4. John A. Strong, *The Algonquian Peoples of Long Island from Earliest Times to 1700* (Interlaken, NY: Empire State Books, 1997), 213–14, 322 n.2; John A. Strong, "The Role of Algonquian Women in Land Transactions on Eastern Long Island, 1639–1839," *LIW*, 27–42; and Bernice Forrest Guillaume, "Women's Lives at the William Floyd Estate and the Poosepatuck Indian Reservation, 1800–Present," *LIW*, 82.

5. Strong, "Role of Algonquian Women," 27–42; and Guillaume, "Women's Lives," 81–82.

6. Strong, *Algonquian Peoples*, 219, 278.

7. Ibid., 279, 281.

8. Robert Steven Grumet, "Sunksquaws, Shamans, and Tradeswomen: Middle Atlantic Coastal Algonkian Women During the 17th and 18th Centuries," in *Women and Colonization: Anthropological Perspectives*, ed. Mona Etienne and Eleanor Leacock (New York: Praeger, 1980), 43–62.

9. John A. Strong, *The Unkechaug Indians of Eastern Long Island: A History* (Norman: University of Oklahoma Press, 2011), 169–78.

10. Unfortunately, after Jefferson's presidency, the trunk in which he packed his papers with the Unkechaug words was stolen and the papers thrown in a river. Some of the pages were found and are now at the American Philosophical Society in Philadelphia. The 271 Unkechaug words that survive, thanks to the women and Thomas Jefferson, are the only record we have today of the Unkechaug language.

11. "Readings in Long Island History and Ethnohistory," in vol. 3, *The History and Archaeology of the Montauk*, 1979, 2nd ed., 1993 (more than triple the number of pages in the 1st ed.); vol. 6, *The Shinnecock Indians: A Culture History* (1983); vol. 8, *Native Forts of the Long Island Sound Area* (2006); and co-editor, vol. 4, *Languages and Lore of the Long Island Indians*, ed. Gaynell Stone Levine and Nancy Bonvillain (1980).

12. See Marjorie Weinberg, *The Real Rosebud: The Triumph of a Lakota Woman* (Lincoln: University of Nebraska Press, 2004). The Indian Village at Jones Beach continued into the 1950s.

13. John Strong, "How the Land Was Lost," in *The Shinnecock Indians: A Culture History*, ed. Gaynell Stone (Stony Brook, NY: Suffolk County Archaeological Association, 1983), 104–6; and John Strong, *"We Are Still Here!" The Algonquian Peoples of Long Island Today*, 2nd ed. (Interlaken, NY: Empire State Books, 1998), 18.

14. Strong, *"We Are Still Here!"* 22; Guillaume, "Women's Lives," 85; and Harriett Crippen Brown Gumbs, "The Land Defended: The Cove Realty Case," in Stone, *Shinnecock Indians*, 118–29.

15. Strong, *"We Are Still Here!"* 81–84.

16. Ibid., 53–54.

Chapter 2. Colonial Long Island

1. Linda Biemer, "Lady Deborah Moody and the Founding of Gravesend," *Journal of Long Island History* 17 (1981): 24–42; and George DeWan, "Religious Dissenter Lady Deborah Moody: A 'Dangerous' 1600s Woman," in *Long Island: Our Story* (Melville, NY: Newsday, 1998), 58.

2. T.H. Breen, *Imagining the Past: East Hampton Histories* (Reading, MA: Addison-Wesley, 1989), 115–16, 127–36. See also George DeWan, "Witchhunt in East Hampton," in *Long Island*, 80–81.

3. Hugh King and Loretta Orion, "'It Were as Well to Please the Devil as Anger Him': Witchcraft in the Founding Days of East Hampton," in *Awakening the Past: The East Hampton 350th Anniversary Lecture Series, 1998*, ed. Tom Twomey (New York: Newmarket Press, 1999), 122.

4. George DeWan, "Setauket: Scene of More Charges," in *Long Island*, 80; and "Witchcraft Trial of Ralph and Mary Hall," in *Long Island as America: A Documentary History to 1896*, ed. James E. Bunce and Richard P. Harmond (Port Washington, NY: Kennikat Press, 1977), 54.

5. Mildred Murphy DeRiggi, "The Wright Sisters of Oyster Bay: Seventeenth-Century Quaker Activists," in *LIW*, 21–26; and George DeWan, "The Sisterhood of Friends," in *Long Island*, 78.

6. Natalie A. Naylor, *"The People Called Quakers": Records of Long Island Friends, 1671–1703* (Interlaken, NY: Empire State Books, 2001), 13–15.

7. Edgar J. McManus, *A History of Negro Slavery in New York* (Syracuse, NY: Syracuse University Press, 1966), 43, 60, 197–98; and Edmund B. O'Callaghan, ed., *The Documentary History of the State of New York*, 4 vols. (Albany, NY: Weed, Parsons and Company, 1849), 1:471.

8. Lynda R. Day, *Making a Way to Freedom: A History of African Americans on Long Island* (Interlaken, NY: Empire State Books, 1997), 30, 32.

9. Mary Cooper, *The Diary of Mary Cooper: Life on a Long Island Farm, 1768–1773*, ed. Field Horne (Oyster Bay, NY: Oyster Bay Historical Society, 1981), 15. Cooper's spelling has been modernized for readability. Mary's husband, Joseph Cooper, and his brother inherited all the land on the Cove Neck peninsula, which they farmed. Today, Cooper's Bluff is still the name of cliffs near Theodore Roosevelt's Sagamore Hill National Historic Site on Cove Neck.

10. Cooper, *Diary*, 6, 9, 26.

11. Krieg and Naylor, *To Know the Place* (see Introduction, n.1), 157.

Chapter 3. The Revolutionary Schism and the Occupation of Long Island

1. See Natalie A. Naylor, "Surviving the Ordeal: Long Island Women During the Revolutionary War," *LIHJ* 20 (Fall 2007/Spring 2008): 114–54, which includes more details and full documentation.

2. Quoted by Mary Beth Norton in *Liberty's Daughters: The Revolutionary Experience of American Women, 1750–1800* (Boston: Little Brown, 1980), 169.

3. Population from Krieg and Naylor, *To Know the Place* (see Introduction, n.1), 157; percentages of allegiance from Joseph S. Tiedemann, "Queens County," in *The Other New York: The American Revolution Beyond New York City, 1763–1787*, ed. Joseph S. Tiedemann and Eugene R. Fingerhut (Albany: State University of New York Press, 2005), 44.

4. Shirley G. Hibbard, *Rock Hall: A Narrative History* (Mineola, NY: Friends of Rock Hall, 1997), 6.

5. Edna Howell Yeager, *Around the Forks*, ed. Eileen Yeager Carmer (n.p.: privately printed, 1984), 30–31, 46; and Linda Grant De Pauw, *Four Traditions: Women of New York During the American Revolution* (Albany: New York State Bicentennial Commission, 1974), 21–22.

6. On Catherine Floyd's engagement, see "Madison's Unrequited Love," in *Long Island* (see ch. 2, n.1), 151. Family tradition is that Hannah Floyd buried the family silver on the estate grounds, but there is no documentation for this in the Floyd archives (Ranger MaryLaura Lamont at the William Floyd Estate, personal communication). Home to eight generations of the Floyd family, the National Park Service maintains the property as a cultural preservation and interprets the continuum of change over the years of the Floyd family, the house and the land.

7. Percentages calculated from population figures and estimate of number of refugees in Frederic Gregory Mather, *The Refugees of 1776 from Long Island to*

Connecticut (1913; reprint, Baltimore, MD: Genealogical Publishing Company, 1972), 187.

8. Henry Onderdonk Jr., *Revolutionary Incidents of Suffolk and Kings Counties* (1849; reprint, Port Washington, NY: Ira. J. Friedman, 1970), 261. Laurel Thatcher Ulrich analyzed the needlework and journal of Prudence Punderson, whose Loyalist family left Norwich, Connecticut, in 1778 for Long Island in *The Age of Homespun: Objects and Stories in the Creation of an American Myth* (New York: Alfred A. Knopf, 2001), 208–10, 228–45.

9. Thomas Jones, *History of New York During the Revolutionary War*, ed. Edward Floyd deLancey, 2 vols. (1879; reprint, New York: New York Times and Arno Press, 1968), 2:277–78, 300.

10. Onderdonk, *Revolutionary Incidents*, 99.

11. Kate W. Strong, "Nancy's Magic Clothesline," *LIF* 2 (November 1939): 13. See *LIW*, 344 for reprints and Strong's other articles in the *Forum* on the clothesline. On the Culper Spy Ring, see Alexander Rose, *Washington's Spies: The Story of America's First Spy Ring* (New York: Bantem Dell, 2006).

12. McManus, *History of Negro Slavery* (see ch. 2, n.7), 199.

13. Yeager, *Around the Forks*, 37–47; see also William Donaldson Halsey, *Sketches from Local History* (Bridgehampton, NY: privately printed, 1935), 179–81.

14. Augustus Griffin, *Griffin's Journal* (1857; reprint; Orient, NY: Oysterponds Historical Society, 1983), 193–94. Some of Griffin's Revolutionary War accounts are conveniently reprinted in *Journeys on Old Long Island: Travelers' Accounts, Contemporary Descriptions, and Residents' Reminiscences, 1744–1893*, ed. Natalie A. Naylor (Interlaken, NY: Empire State Books, 2002), 34–41. *Journeys on Old Long Island* also includes a family's account of the British occupation in Flatbush during the war, 19–33.

15. Yeager, *Around the Forks*, 44–45. See also Dorothy Horton McGee, *Sally Townsend, Patriot* (New York: Dodd, Mead, 1952), a fictionalized biography.

16. John Gerard Staudt, "'A State of Wretchedness': A Social History of Suffolk County, New York in the American Revolution," PhD diss., George Washington University, 2005, 122–23. Copies are in the Hofstra University and Stony Brook University Libraries.

17. John Staudt, "From Wretchedness to Independence: Suffolk County in the American Revolution," *LIHJ* 20 (Fall 2007/Spring 2008): 135.

18. Silas Wood, *A Sketch of the First Settlement of the Several Towns on Long Island…*, new edition (Brooklyn, NY: Alden Spooner, 1828), 118–19.

19. Tiedemann, *The Other New York*, 50–55.

Chapter 4. Expanding the Domestic Sphere in the Nineteenth Century

1. Barbara Welter, "The Cult of True Womanhood: 1820–1860," *American Quarterly* 18, no. 2 (Summer 1966): 151. Other historians have subsequently modified this interpretation, but her analysis is still useful.

2. Helen Zunser Wortis, *A Woman Named Matilda and Other True Accounts of Old Shelter Island* (New York: Shelter Island Historical Society 1978), 27–30, 48–58. The essays first appeared in the *Long Island Forum*.

3. *Walt Whitman: Complete Poetry and Collected Prose*, ed. Justin Kaplan (New York: Library of America, 1981), 176 and 103.

4. George Washington, "Tour of Long Island, 1790," reprinted from his diary in Naylor, *Journeys on Old Long Island* (see ch. 3, n.14), 56. For the murals, see Natalie A. Naylor, "Local History in Long Island's New Deal Murals," *NCHSJ* 59 (2004): 1–18.

5. The Benjamins received sixty-five cents per week plus clothing expense for taking care of Mary Reeve. Before institutions such as workhouses, almshouses and poor farms existed, town overseers of the poor sometimes exercised their responsibility for homeless residents by auctioning them off to the lowest bidder. The town, of course, wanted to discharge its responsibility at the lowest possible cost, hence it was reverse bidding and the lowest bidder who became the "keeper" for the pauper. See Robert E. Cray Jr., *Paupers & Poor Relief in New York City & Its Rural Environs, 1700–1830* (Philadelphia, PA: Temple University Press, 1988), which includes Queens and Suffolk Counties.

6. Joan Druett, *Captain's Daughter, Coasterman's Wife: Carrie Hubbard Davis of Orient* (Orient, NY: Oysterponds Historical Society, 1995), 45.

7. Melissa Brewster, "Women of the Union: The Brooklyn and Long Island Sanitary Fair of 1864," *LIHJ* 12 (Fall 1999): 92–100.

8. Laura L. Hawkins, "A 'Mid-Summer Outing,' 1893," in Naylor, *Journeys on Old Long Island*, 269–332.

9. Alice Ross, "Long Island Women and Benevolence: Changing Images of Women's Place, 1880–1920," in *LIW*, 107–18.

10. Christopher Densmore et al. "After the Separation," in *Quaker Crosscurrents: Three Hundred Years of Friends in the New York Yearly Meetings*, ed. Hugh Barbour et al. (Syracuse, NY: Syracuse University Press, 1995), 137–39; and *Memoir of Rachel Hicks (Written by Herself), Late of Westbury, Long Island; A Minister in the Society of Friends…* (New York: G.P. Putnam, 1880).

11. Virginia Nelle Bellamy, "Anne Ayres," in *NAW*, 1:74–75; and Virginia B. Colyer, *Dr. Muhlenberg's St. Johnland: An Informal History, 1866–1991* (Kings Park, NY: Society of St. Johnland, 1992).

12. Stuart Vincent, "A Catholic Presence on LI," in *Long Island* (see ch. 2, n.1), 230.

13. See www.amityvilleop.org.

14. Natalie A. Naylor, "The 'Encouragement of Seminaries of Learning': The Origins and Development of Early Long Island Academies," *LIHJ* 12 (Fall 1999): 11–30.

15. Natalie A. Naylor, "'Diligent in Study and Respectful in Deportment': Early Long Island Schooling." *NCHSJ* 43 (1988): 1–13.

16. Arthur S. Mattson, *Water and Ice: The Tragic Wrecks of the Bristol and the Mexico on the South Shore of Long Island* (Lynbrook, NY: Lynbrook Historical Books, 2009), 76–79, 83–84, 87, 145, 205, 207–9, 230–32, 255.

17. Joan Druett and Mary Anne Wallace, *The Sailing Circle: 19th Century Seafaring Women from New York* (Setauket, NY: Three Village Historical Society, 1995). See also Druett, *Carrie Hubbard Davis*; Joan Druett, *"She Was a Sister Sailor": The Whaling Journals of Mary Brewster, 1845–1851* (Mystic, CT: Mystic Seaport Museum, 1992); Anne MacKay, ed., *She Went A Whaling: The Journal of Martha Smith Brewer Brown* (Orient, NY: Oysterponds Historical Society, 1993, 1995); and the exhibition The Sailing Circle: 19th Century Seafaring Women from New York at the Three Village Historical Society (93 North Country Road, Setauket).

18. Robert G. Müller, *Long Island's Lighthouses, Past and Present* (Patchogue, NY: Long Island Chapter of the U.S Lighthouse Society, 2003), 92–93, 253. See also the chapter "Earning a Living: Entrepreneurs, Entertainers and Scientists" in this book for other female lighthouse keepers.

19. After marrying Charles Seabury, Ruth Mount had eight children and less time to devote to painting. Alfred Victor Frankenstein, *William Sidney Mount* (New York: Abrams, 1975), 17, 19; and Is Art Hereditary? The Mount Family of Artists, the 2005 exhibit at the Long Island Museum, wwwtfaoi.com/aa/2aa/2aa622.htm, see the chapter "Women and the Arts" in this book on Evelina Mount and her art.

20. Deborah J. Johnson, *William Sidney Mount: Painter of American Life* (New York: American Federation of Arts, 1998), 62–65. Some of William Sidney Mount's paintings are always on exhibit at the Long Island Museum in Stony Brook; Mount paintings also can be viewed on its website. His brother, Shepherd Alonzo Mount, painted many portraits of girls and women. The *Eel Spearing* painting is owned by the New York State Historical Association in Cooperstown and exhibited in its Fenimore Art Museum.

Chapter 5. Long Island's First Ladies

1. Portions of this chapter are from my articles "Long Island's Mrs. Tippecanoe and Mrs. Tyler Two," *LIHJ* 6 (Fall 1993): 2–16; and "To the Manor Born: Theodore Roosevelt, Country Gentleman and Edith Kermit Roosevelt, the Lady of Sagamore Hill," *NCHSJ* 65 (2010): 25–42, where more details and full documentation can be found.

2. The handbill is reproduced on the cover of *LIHJ* 6 (Fall 1993).

3. Naylor, "Mrs. Tippecanoe and Mrs. Tyler Two," 8–10.

4. Sylvia Jukes Morris, *Edith Kermit Roosevelt: Portrait of a First Lady* (New York: Coward, McCann & Geoghegan, 1980), 3, 148.

5. Kathleen Dalton, *Theodore Roosevelt: A Strenuous Life* (New York: Alfred A. Knopf, 2002), 387; and Dwight Young and Margaret John, *Dear First Lady* (Washington, D.C.: National Geographic, 2008), 72–73.

6. Dalton, *Theodore Roosevelt*, 422 and 632, n.147.

7. Ibid., 123.

8. Ibid., 220, 507; and Morris, *Edith Kermit Roosevelt*, 259.

9. Paul F. Boller Jr., *Presidential Wives: An Anecdotal History* (New York: Oxford University Press, 1988), 197; and Morris, *Edith Kermit Roosevelt*, 126, 195 and FDR quote (initial epigraph).

10. Morris, *Edith Kermit Roosevelt*, 270.

11. Edith was ranked tenth in 1982 and ninth in 2003 in Siena Research Institute's poll ("Ranking America's First Ladies," www.siena.edu/sri); and Elting E. Morison, "Edith Kermit Carow Roosevelt," in *NAW*, 3:193. See also Betty Boyd Caroli, *First Ladies*, Expanded Edition (New York: Oxford University Press, 1995), 417–22 for rankings.

12. Morris, *Edith Kermit Roosevelt*, 348.

13. *New York Times*, October 1, 1948; a copy of the death certificate is in the Sagamore Hill curatorial files.

14. Elliott Roosevelt suffered from alcoholism, and before he died in 1894, he was treated in different institutions. His family also lived in New York City during these years and traveled to Europe in 1890, so Eleanor probably spent only a portion of the four or five years on Long Island. Her earliest photographs in 1887 were taken in Huntington, perhaps when she visited the Theodore Roosevelts in nearby Oyster Bay. The FDR Library in Hyde Park also has three photographs dated 1889 that were probably taken outside Halfway Nirvana. Although these photographs are identified as "Hempstead," that would have been the name used at the time for the Hempstead environs in East Meadow.

15. Siena Research Institute, "Ranking America's First Ladies."

16. Louis Leonard Tucker, "Anna Symmes Harrison," in *NAW*, 2:143–45; Robert Seager II, "Julia Gardiner Tyler," in *NAW*, 3:494–96; William H. Chafe, "Anna Eleanor Roosevelt," in *NAW*, 4:595–601; and Edith P. Mayo, "Jacqueline Lee Bouvier Kennedy Onassis," in *NAW*, 5:485–87. (See endnote 11 for Edith Roosevelt's entry in *NAW*.)

Chapter 6. *Novelists, Poets and Other Writers*

1. Barbara M. Cross, "Catharine Esther Beecher," in *NAW*, 1:121–24. Stowe is also in *NAW*, 3:393–402.
2. Paul Bailey, *Long Island: A History of Two Great Counties, Nassau and Suffolk*, 2 vols. (New York: Lewis Historical Publishing, 1949), 1:518, re: visits to Cedarmere; Madeleine C. Johnson, *Fire Island, 1650s–1980s* (Mountainside, NJ: Shoreland Press, 1983), 52, re: memorial; and Warner Berthoff, "Margaret Fuller," in *NAW*, 1:678–82.
3. Maurine H. Beasley, "Mary L. Booth," *American Magazine Journalists, 1850–1900*, ed. Sam G. Riley, vol. 79, *DLB* (1989), 69–73; and Madeleine B. Stern, "Mary L. Booth," in *NAW*, 1:207–8. Booth's childhood home is on East Main Street, just east of Yaphank Avenue.
4. Susan Belasco, "Elizabeth Oakes Smith," in *The American Renaissance in New England*, Fourth Series, ed. Wesley T. Mott, *DLB*, vol. 243 (2001), 274.
5. Ibid.; in addition, information is from Timothy H. Scherman, "Elizabeth Oakes Smith," in *American Women Prose Writers: 1920–1870*, ed. Amy E. Hudock and Katharine Rodier, *DLB*, vol. 239 (2001), 222–30; Alice Felt Tyler, "Elizabeth Oakes Prince Smith," in *NAW*, 3:309–10; and Scherman's excellent website, the Elizabeth Oakes Smith Page, at Northeastern Illinois University's website.
6. Bea Tusiani, "Last Stop Plandome: Frances Hodgson Burnett," in *LIW*, 247–57; Beatrice Hofstadter, "Frances Hodgson Burnett," in *NAW* 1:269–70; Phyllis Bixler, "Frances Hodgson Burnett," in *American Writers for Children Before 1900*, ed. Glenn E. Estes, *DLB*, vol. 42 (1985), 97–117; and L.M. Rutherford, "Frances Hodgson Burnett," in *British Children's Writers, 1880–1914*, ed. Laura M. Zaidman, *DLB*, vol. 151 (1994), 59–78.
7. Robert B. Welker, "Neltje Blanchan De Graff Doubleday," in *NAW*, 1:508.
8. Natalie A. Naylor, "Edith Loring Fullerton's Partnership with Hal B. Fullerton," *NCHSJ* 63 (2008): 28–42; and Anne Nauman, *The Junior Partner: Edith Loring Fullerton, Long Island Pioneer* (Las Vegas, NV: Scrub Oak Press, 1997). Nauman is a granddaughter of the Fullertons.

9. Lorraine Elena Roses, "Gwendolyn Bennett," in *NAW*, 5:50–51; and Walter C. Daniel and Sandra Y. Govan, "Gwendolyn Bennett," in *Afro American Writers from the Harlem Renaissance to 1940*, ed. Trudier Harrris, vol. 51, *DLB* (1987), 3–10.

10. Reprinted from May Swenson, *New and Selected Things Taking Place: Poems* (Boston: Little, Brown and Company, 1978), 13. Copyright © 1978 by May Swenson, reprinted with permission of the Literary Estate of May Swenson, all rights reserved.

11. "May Swenson," in *Contemporary Literary Criticism Select* (Detroit, MI: Gale, 2008), Literature Resource Center website. Swenson appears in *NAW*, 5:622–23, entry by Kirstin Hotelling Zona. Forthcoming from Modern Library in 2013 is a centennial volume, *May Swenson: Collected Poems*.

12. *New York Times*, obituary, May 10, 2008; and Knudson biography from hwwilsonweb.com.

Chapter 7. Women and the Arts

1. Kathryn Curran discusses how samplers, quilts and other material culture shed light on women's domestic life in "'To Blush Unseen': A View of Nineteenth-Century Women," in *LIW*, 96–106. On women's folk art, see books such as Mirra Bank, *Anonymous Was a Woman* (New York: St. Martin's Press, 1979); C. Kurt Dewhurst, Betty MacDowell and Marsha MacDowell, *Artists in Aprons: Folk Art by American Women* (New York: E.P. Dutton, 1979); and Judith Reiter Weissman and Wendy Lavitt, *Labors of Love: America's Textiles and Needlework, 1650–1930* (New York: Knopf, 1987).

2. Ita G. Berkow, "The Last of the Mount Family Artists, Evelina Mount (1837–1920)," *LIHJ* 9 (Spring 1997): 245–51. Alfred Frankenstein described Evelina as "a hopeless amateur" in *William Sidney Mount* (see ch. 4, n.19), 466. Berkow acknowledged that the National Academy of Design may have exhibited her paintings "mainly in deference to the memory of her father and uncles," 249. The Long Island Museum in Stony Brook owns sixty of Evelina Mount's paintings and has images of thirteen on its website (under Collections Database).

3. Michael Reed, "The Intrepid Mrs. Sally James Farnham: An American Sculptor Rediscovered," *Aristos*, November 2007, aristos.org/aris-07/farnham.htm. See also Reed's excellent website, which has extensive material on Farnham and her work (www.sallyjamesfarnham.org). Michael Reed provided additional information to the author on Farnham in Great Neck.

4. Stuart Preston, "Gertrude Vanderbilt Whitney," in *NAW*, 3: 601–3; and Claris Stasz, *The Vanderbilt Women: Dynasty of Wealth, Glamour and Tragedy* (New York: St. Martin's Press, 1991). The Metropolitan Museum in 2010 announced a collaborative agreement to take over the Whitney Museum's building on Madison Avenue at Seventy-fifth Street in 2015 when the Whitney Museum moves into a new building. Ironically, the Met plans to show its modern and contemporary art in the Whitney building.

5. Thurman Wilkins, "Mary Nimmo Moran," in *NAW*, 2:576–77. The Morans' home and studio in East Hampton (229 Main Street) was named to the National Register of Historic Places in 1965, and the Thomas Moran Trust hopes to restore it. The East Hampton Library owns a number of Nimmo Moran's paintings and etchings.

6. Helen A. Harrison and Constance Ayers Denne, *Hamptons Bohemia: Two Centuries of Artists and Writers on the Beach* (San Francisco, CA: Chronicle Books, 2002), 47–50. See also D. Scott Atkinson and Nicolai Cikovsky Jr., *William Merritt Chase: Summers at Shinnecock, 1891–1902* (Washington, D.C: National Gallery of Art, 1987); and the National Gallery's video *William Merritt Chase at Shinnecock* (1987).

7. See *Anchor to Windward: The Paintings and Diaries of Annie Cooper Boyd*, ed. Carolyn Oldenbusch (Sag Harbor, NY: Sag Harbor Historical Society and SPLIA, 2010). Boyd's diaries were written between 1880 and 1935.

8. Jane Grant, "May Wilson Preston," in *NAW*, 3:98–100; and Nancy Allyn Jarzombek, "May Wilson Preston," in *American Book and Magazine Illustrators*, ed. Steven E. Smith, Catherine A. Hastedt, and Donald H. Dyal, vol. 188, *DLB* (1998), 270–73.

9. Based on count of the "Artist Biographies," in *A Shared Aesthetic: Artists of Long Island's North Fork*, ed. Geoffrey K. Fleming and Sara Evans (New York: Southold Historical Society, in association with Hudson Hills Press, 2008), 182–236. The authors chose a 1969 cutoff date because of the large number of artists on the North Fork in more recent decades.

10. Ronald G. Pisano and William H. Gerdts, *Painters of Peconic: Edith Prellwitz and Henry Prellwitz* (New York: Spanierman Gallery, 2002). Pisano's essay is reprinted from *Henry and Edith Mitchill Prellwitz and the Peconic Art Colony* (New York: Museums at Stony Brook [now Long Island Museum], 1995). See also Fleming and Evans, *Shared Aesthetic*, 56–63 and 108–11. Wendy Prellwitz, an architect and the great-granddaughter of the Prellwitzes, contributed to *Shared Aesthetic*.

11. Fleming and Evans, *Shared Aesthetic*, 73. On Bell, see also Terry Wallace, *Caroline M. Bell and the Peconic Bay Impressionists* (East Hampton, NY: Wallace Gallery, 2006).

12. Terry Wallace, *Helen M. Kroeger & Otto J. Kurth: The Anchorage Studio and Peconic Bay Impressionism* (East Hampton, NY: Wallace Gallery, 2010), includes additional information on Caroline Bell and mentions other women artists besides Kroeger.

13. Kirstin Ringelberg, "Betty Parsons," in *NAW*, 5:497–99. Parsons is discussed briefly in Fleming and Evans, *Shared Aesthetic*. See also Lee Hall, *Betty Parsons: Artist, Dealer, Collector* (New York: H.N. Abrams, 1991).

14. In 2000, the Dove/Torr Cottage at 30 Centershore Road in Centerport was added to the National Register of Historic Places and the Historic Artists' Homes and Studios Program administered by the National Trust for Historic Preservation. Interestingly, the historical marker erected many years ago for the cottage mentions only Arthur Dove. David Everitt, "The Spotlight Shifts to Helen Torr, and Her View of Nature's Rhythms," *New York Times*, February 9, 2003, LI section; and additional information from Anne Cohen DePietro (personal communication), who was curator of the exhibition and co-author with Mary Torr Rehm of the 2003 exhibition catalogue, *Out of the Shadows: Helen Torr, a Retrospective*.

15. Helen A. Harrison, "Lee Krasner," in *NAW*, 5:352–54; Helen A. Harrison, "Lee Krasner 'From There to Here,'" in *LIW*, 286, 296; and Helen A. Harrison, "Moving In, Moving On: Lee Krasner's Work in Jackson Pollock's Studios," *LIHJ* 20 (2008): 1–14. Harrison is the director of the Pollock-Krasner House and Study Center (830 Springs-Fireplace Road, East Hampton). For Krasner and other South Fork artists, see also Harrison and Denne, *Hamptons Bohemia* (see ch. 7, n.6). The most recent biography is by art historian Gail Levin, *Lee Krasner: A Biography* (New York: William Morrow, 2011).

16. Celia S. Stahr, "Elaine de Kooning," in *NAW*, 5:161–62.

17. Kathleen L. Housley, *Tranquil Power: The Art and Life of Perle Fine* (New York: MidMarch Arts Press, 2005). The 2009 Hofstra exhibition had the same title. See also www.perlefine.org.

18. Cynthia Zaitzevsky, *Long Island Landscapes and the Women Who Designed Them* (New York: SPLIA in Association with W.W. Norton, 2009), 25. All information on landscape architects is from this excellent book.

19. Beatrix Jones Farrand is the only one of these landscape architects in *NAW* (4:221–23), entry by Eleanor M. McPeck. This may be a reflection of the obscurity of landscape architects, perhaps because so few of their gardens are extant. (Farrand's gardens at Dumbarton Oaks in Washington,

D.C., have survived.) For additional information on the estates and their owners, see Robert B. MacKay, Anthony Baker and Carol A. Traynor, eds., *Long Island Country Houses and Their Architects, 1860–1940* (New York: SPLIA, in association with W.W. Norton, 1997) and the several books by Raymond E. and Judith A. Spinzia, such as *Long Island's Prominent North Shore Families: Their Estates and Their Country Homes*, 2 vols. (College Station, TX: VirtualBookworm, 2006); their later volumes deal with the South Shore (towns of Babylon and Islip) and the towns of Hempstead, Southampton and East Hampton.

Chapter 8. Philanthropists and Humanitarians

1. M.H. Smith, *Garden City, Long Island in Early Photographs, 1869–1919* (Mineola, NY: Dover, 1987), 22. See also her *History of Garden City, 1963*, rev. ed. (Garden City, NY: Garden City Historical Society, 1987).
2. Irvin G. Wyllie, "Margaret Olivia Slocum Sage," in *NAW*, 3:222–23; and Ruth Crocker, *Mrs. Russell Sage: Women's Activism and Philanthropy in Gilded Age and Progressive Era America* (Bloomington: Indiana University Press, 2006).
3. Raymond E. Spinzia, "In Her Wake; The Story of Alva Smith Vanderbilt Belmont," *LIHJ* 6 (Fall 1993): 101, 104, n.21–22. Belmont's Hempstead Hospital has not survived; it was not related to the Hempstead Hospital built on Front Street in the 1950s.
4. Richard Guy Wilson, *Harbor Hill: Portrait of a House* (New York: SPLIA, in association with W.W. Norton, 2008), 121–31.
5. Neil Harris, "Louisine Waldron Elder Havemeyer," in *NAW*, 2:156–58; and Alice Cooney Frelinghuysen et al. *Splendid Legacy: The Havemeyer Collection* (New York: Metropolitan Museum of Art, 1993).
6. When it opened in 1924, it was one of the first libraries in America created for children. The public (adult) library in Westbury was not created until 1956; it merged with the Children's Library in 1965.
7. Constance D. Ellis, "Emily Clara Jordan Folger," in *NAW*, 1:637–38; and Robert Harrison, "The Folgers and Shakespeare: A Long Island Story," *NCHSJ* 56 (2001): 11–18.
8. Geri E. Solomon, "Kate Mason Hofstra and Alicia Patterson: Founding and Building Hofstra University," in *LIW*, 185–88.
9. Victoria Costigan, "In Remembrance of Mrs. Ward Melville," *The* [Long Island] *Museums Newsletter* 18 (Fall 1989): 2–3; and Leo Seligsohn, "Stony Brook's Fairy Godmother," *Newsday*, February 7, 1982, LI section, 22–29.

10. St. Charles website, history; and Lois van Delft, FMM, "Women of Faith: The Spiritual Legacy of the Founders of St. Francis Hospital," in *LIW*, 146–53.

11. Marilyn E. Weigold, "Montauk's Angels: The Women's War Relief Association at Camp Wikoff," *LIF* 48 (October 1985): 191–95.

12. Alice Ross, "Long Island Women and Benevolence: Changing Images of Women's Place, 1880–1920," in *LIW*, 114, 116.

13. Norma Cohen, "The Forebears Were Women: Three Smith Sisters," in *LIW*, 119–25. The Smith sisters lived in the Mills Pond House, now home to the Smithtown Township Arts Council.

14. Raymond A. Mohl, "Edith Terry Bremer," in *NAW*, 5:105–7.

15. Helen M. Winslow, ed., *Women's Clubs in America* (Boston: N.A. Lindsey & Company, 1922), 24:54–56.

16. Eunice Juckett Meeker, "The Ladies' Village Improvement Society: A Century of Force in East Hampton," in *LIW*, 173–79.

17. Norma White, "Civic-Minded Women: The Sayville Village Improvement Society," in *LIW*, 173–79.

18. Floris Barnett Cash, "Gender and Race Consciousness: Verina Morton-Jones Inspires a Settlement House in Suburbia," in *LIW*, 133–45. Unfortunately, the Tubman House in Hempstead did not survive into the twenty-first century. For another black social service enterprise organized by black women, see Judith A. Burgess, "The Garnet Memorial Home: An African American Fresh Air Home in Westbury, Long Island, 1895–1954," *NCHSJ* 66 (2011): 8–25.

Chapter 9. Earning a Living: Entrepreneurs, Entertainers and Scientists

1. The most extensive account is in Geoffrey K. Fleming and Amy Kasuga Folk, *Hotels and Inns of Long Island's North Fork* (Charleston, SC: The History Press, 2009).

2. The business directory listing is reproduced in Hans Henke, *Patchogue, Queen City of Long Island's South Shore: The Early Years* (n.p.: privately printed, 2003), 24–25, and re: lace mill, 62–65, particularly photographs of female workers.

3. Thirteenth Census, 1910, roll, 24/995, E.D. 17, vol. 152, microfilm, Long Island Studies Institute, Hofstra University. The manuscript census is widely used for genealogical research since it includes names of individuals, as well as much additional information. The ethnic diversity in 1910 Garden City was unusual, with immigrant women from England, Ireland, Scotland, France, Poland, Germany and the West Indies, as well as native-born women.

4. Walter E. Gosden, *Floral Park, Nassau County* (Charleston, SC: Arcadia, 2010, 41.

5. Müller, *Long Island's Lighthouses* (see ch. 4, n.18), 47, 116, 204, 206–9. See also Müller's website, www.longislandlighthouses.com, and "Keeper Biographies" on the Southold Historical Society's website. The Southold Historical Society restored and operates the Horton Point Lighthouse as a nautical museum, which is open seasonally.

6. Gosden, *Floral Park*, 8, 43; and additional information on Martin from Jeanne Petta (personal communication). The earliest of Martin's known seed catalogues dates from 1896, and apparently the last was in 1920.

7. *Home Town, Long Island* (Melville, NY: Newsday, 1999), 9; and additional information from Alan Woodruff, Bellerose village historian (personal communication).

8. Richard Evers and Val Conover, "Goldbeating on Long Island," *LIF* 46 (October 1983): 183–89.

9. Caroline Shillaber, "Christine McGaffey Frederick," in *NAW*, 4:249–50; and Janice Williams Rutherford, *Selling Mrs. Consumer: Christine Frederick and the Rise of Household Efficiency* (Athens: University of Georgia Press, 2003).

10. Nancy Bourgerie Meo, "Marjorie Merriweather Post," in *NAW*, 4:556–57. Long Island University continued its college in Brooklyn; the name of its college in Nassau County is now LIU Post.

11. William J. Johnston, "Mabel Witte Merritt: A Pioneer Woman Attorney," Farmingdale-Bethpage Historical Society's *Yeoman*, issue 3 (Early Fall 2011). Her husband, Jesse Merritt (1889–1957), was historian of the village of Farmingdale and the town of Oyster Bay and, in 1937, the first historian of Nassau County. See [Myron H. Luke], "Jesse Merritt," *NCHSJ* 18 (Summer 1957): 31–33; Myron H. Luke "Jesse Merritt," *NCHSJ* 19 (Winter 1958): 1–3; and Tributes, *NCHSJ* 19 (Winter 1958): 13–21.

12. George DeWan, "Pistol Packin' Political Pioneer," *Newsday*, February 15, 2000, A28. Shortly after her election as a justice of the peace, Stackpole secured a license for a pistol.

13. Robert F. Keeler, "Alicia Patterson and the Shape of Long Island," in *LIW*, 275; James Boylan, "Alicia Patterson," in *NAW*, 4:529–31. Harry Guggenheim donated their home to Nassau County, intact with all its furnishings. Falaise is now a historic house museum open seasonally in Sands Point Preserve.

14. Arlan R. Coolidge, "Maud Powell," in *NAW*, 3:91–92.

15. Iris M. Fanger, "Irene Castle," in *NAW*, 4:142–43. Fred Astaire and Ginger Rogers starred in the 1939 movie *The Story of Vernon and Irene Castle*.

16. Columbia Hart, OSB, "Maude Adams," in *NAW*, 4:5–7; see also the cenaclesisters.org/ronkonkoma website.

17. *New York Times*, obituary, July 10, 1979; and *Smithtown Star*, obituary, September 22, 1948, from the Smithtown Library's Long Island Room vertical files.

18. Wikipedia, "Jean Ritchie," http://en.wikipedia.org/wiki/Jean_Ritchie; *New York Times*, August 12, 2002, and November 9, 2008. See also Ritchie's memoir, *Singing Family of the Cumberland* (1955), and the documentary film *Mountain Born: The Jean Ritchie Story* (1999).

19. Janice Koch, "Barbara McClintock: An Overview of a Long Island Scientist," in *LIW*, 277–85; and Nathaniel Comfort, "Barbara McClintock," in *NAW*, 5:431–33. See also Evelyn Fox Keller, *A Feeling for the Organism: The Life and Work of Barbara McClintock* (New York: W.H. Freeman, 1983).

20. René Dubos, "Hattie Elizabeth Alexander," in *NAW*, 4:10–11.

21. Ellen S. More, Mary Steichen Calderone," in *NAW*, 5:99–101; and Natalie A. Naylor, "Mary Steichen Calderone," in *Women Educators in the United States, 1820–1993*, ed. Maxine Schwartz Seller (Westport, CT: Greenwood Press, 1994), 86–94.

22. Peter Bond and Alfred Sharff Goldhaber, "Gertrude Scharff Goldhaber," in *NAW*, 5:237–39. Alfred is one of the Goldhabers' two sons, each of whom earned doctorates in theoretical physics.

Chapter 10. Pioneering Pilots: Daring and Intrepid Airwomen

1. Blanche "Betty" Stuart Scott (1885–1970) is sometimes mentioned as the first female pilot, but her flight is not well documented. She was taking lessons in Hammondsport in upstate New York from Glenn Curtiss, who had put a device on the engine so the plane would not fly. The limiter came off, though it is uncertain whether it was the wind or if Scott deliberately removed it. Scott flew the plane a short distance ten days before Raiche's flight. Bessica Raiche certainly had the first *intentional* flight by a woman in the United States.

2. Claudia M. Oakes, *United States Women in Aviation Through World War I*, Smithsonian Studies in Air and Space, no. 2 (Washington, D.C.: Smithsonian Institution Press, 1978), 10–11 (available on the Internet); Crocker, *Mrs. Russell Sage* (see ch. 8, n.2, 1), 263; and additional information from Lygia Ionnitiu, aviation historian (personal communication).

3. That aviation field had several name changes: Hempstead Plains Field (1911–17), Hazelhurst Field (1917/18–21), Curtiss Field (1921–29) and, finally, Roosevelt Field in 1918, named for Quentin Roosevelt, Theodore and Edith Roosevelt's youngest son who was shot down in World War I over France. In the 1910s, references usually were to the fields as on the "Hempstead Plains" or "Mineola" (today's Garden City and Westbury). The airfields were

located south of Old County Road and extended to Merrick Avenue, where Fortunoffs and Roosevelt Raceway were later located.

4. In addition to Quimby and Moisant discussed in this chapter, Bernetta Miller (the fifth licensed female pilot) and Dorothy Rice Peirce (ninth) also learned to fly on Long Island. Oakes, *Women in Aviation*, 24, 27, 43.

5. Giacinta Bradley Koontz, *The Harriet Quimby Scrapbook: The Life of America's First Birdwoman (1875–1912)* (Encino, CA: Little Looper Press, 2003); Henry M. Holden, "The Life and Times of Harriet Quimby," in *LIW*, 57–64; and Koontz's website, www.harrietquimby.org.

6. Sherwood Harris, *The First to Fly: Aviation's Pioneer Days* (New York: Simon & Shuster, 1970), 247. See also Doris L. Rich, *The Magnificent Moisants: Champions of Early Flight* (Washington, D.C.: Smithsonian, 1998), 167–68.

7. Elinor Smith, *Aviatrix* (New York: Harcourt and Brace, 1981), 33.

8. Interview in *Daredevils and Dreamers*, a 1998 PBS documentary, quoted in *New York Times*, obituary, March 3, 2010. See also Smith, *Aviatrix*, 50.

9. Smith, *Aviatrix*, 8–9.

10. Ibid., 230.

11. Kathleen C. Winters, *Amelia Earhart: The Turbulent Life of an American Icon* (New York: Palgrave, Macmillan, 2010), 54–60; and "Amelia Earhart" entry in Wikipedia, http://en.wikipedia.org/wiki/Amelia_Earhart. For the family's version, see Peggie Phipps Boegner and Richard Gachot, *Halcyon Days: An American Family Through Three Generations* (New York: Old Westbury Gardens and Abrams, 1986), 192; co-author Boegner (1906–2006) was a niece of Amy Guest.

12. Despite many searches over the years in the Howland and Gardner Islands to discover the fate of the flight, even the most recent evidence found in 2012 is inconclusive.

13. See www.ninety-nines.org; and Joanne Lynn, "Women's Cradle of Aviation: Curtiss Field, Valley Stream," in *Evoking a Sense of Place*, ed. Joann P. Krieg (Interlaken, NY: Heart of the Lakes Publishing, 1988), 85–95.

14. Other early female pilots associated with Long Island in the first quarter century of flying include Laura Bromwell (1898–1921), Bessie Coleman (1892–1926), Hélène Dutrieu (1877–1961), Edna Marvel Gardner (1902–1992), Viola Gentry (1900–1988), Laura Ingalls (1901–1967), Ruth Bancroft Law (1887–1970), Bernetta A. Miller (1884–1972), Dorothy Rice Pierce (born 1892), Betty Scott (1885–1970), Mary Sims (active in early 1910s) and Louise Thaden (1905–1979). See Joanne Lynn Harvey, "First Women in Aviation," in *LIW*, 43–56.

15. Oakes, *Women in Aviation*, 2, 44.

16. For general histories of Long Island aviation, see George C. Dade and Frank Strnad, *Picture History of Aviation on Long Island, 1908–1938* (New York: Dover, 1989); Joshua Stoff, *The Aerospace Heritage of Long Island* (Interlaken, NY: Heart of the Lakes Publishing, 1989); and other books by Joshua Stoff, who is curator of the Cradle of Aviation Museum.

Chapter 11. Achieving Votes for Women

1. Statistics from David Kevin McDonald, "Organizing Womanhood: Women's Culture and the Politics of Woman Suffrage in New York State, 1865–1917," PhD dissertation, SUNY, Stony Brook, 1987, 60. Regarding Amy Post, see Wikipedia, "Amy and Isaac Post," http://en.wikipedia.org/wiki/Amy_and_isaac_post; and the Women's Rights National Historic Park website. An extensive literature exists on women's suffrage and numerous biographies of leaders. The classic account is Eleanor Flexner's *Century of Struggle: The Woman's Rights Movement in the United States* (1959; revised edition, Cambridge, MA: Harvard University Press, 1975).

2. Elizabeth Cady Stanton, *80 Years and More: Reminiscences, 1815–1897* (1898; reprint, New York: Schocken Books, 1971), 417–18, 449. Anthony visited every one of the sixty counties in the state in the petition drive. The Queens convention met in Jamaica. The campaign collected more than 332,000 signatures on petitions, but the vote in the legislature was ninety-eight in opposition and fifty-eight in favor. See also Natalie A. Naylor, "'In Deeds of Daring Rectitude': Winning Votes for Women in Nassau County and the Nation," *NCHSJ* 50 (1995): 33–34.

3. Women had secured the right to vote in country school districts in New York in 1880. Mackay resigned from the school board and departed from the suffrage movement when she left her husband and children for a man whom she married (after her divorce) in France in 1914. She did not return to New York until shortly before she died in 1930. Wilson, *Harbor Hill* (see ch. 8, n.4, 140–41); and Ellen Carol DuBois, *Harriot Stanton Blatch and the Winning of Woman Suffrage* (New Haven: Yale University Press, 1997), 107–8.

4. Sylvia D. Hoffert, *Alva Vanderbilt Belmont: Unlikely Champion of Women's Rights* (Bloomington: Indiana University Press, 2012), 76, 79; and Christopher Lasch, "Alva Erskine Smith Vanderbilt Belmont," in *NAW*, 1:126–28.

5. *Brooklyn Eagle*, March 5 and 17, 1911; and Marilyn E. Weigold, "1911 Crop of Female Farmers," *LIF* 43 (June 1980): 116–24. The farm received considerable publicity; see "Young Women Work in Overalls While Learning

to Be Farmers," *Milwaukee Sentinel*, May 28, 1911 (available online). Belmont's Brookholt house has not survived.

6. Spinzia, "Alva Smith Vanderbilt Belmont," *LIHJ* 6 (Fall 1993): 101–2. See also Hoffert, *Alva Vanderbilt Belmont*, 98, 168–69. Hoffert compiled some of "Belmont's Financial Contributions to Woman's Rights" in an appendix, 201–4. Totals to PEA, NAWSA and NWP from 1909 to 1919 were more than $400,000 (the equivalent of more than $10 million today). Belmont contributed even more to the NWP in the 1920s. Over the years, the suffrage movement included many organizations of various names, with schisms and mergers. Many of the groups cooperated, although they often differed in philosophy, strategy and tactics. The NWP had to move from the house Belmont donated. Since 1929, it has been on Constitution Avenue in what today is the Sewell-Belmont House and Museum.

7. Nora Stanton Blatch (1883–1971) graduated from Cornell in 1905 with a degree in civil engineering. She participated in suffrage activities in the 1910s and was married briefly to Lee de Forest, who objected to her following a career. She built a larger house for her father in Shoreham and spent some time in the 1910s as an architect and developer on Long Island. In 1919, she married Morgan Barney, a naval architect, and they soon moved to Connecticut. Eleanor Flexner, "Harriot Stanton Blatch," in *NAW*, 1:172–74; Terry Kay Rockefeller, "Nora Stanton Blatch Barney," in *NAW*, 4:53–55; and DuBois, *Harriot Stanton Blatch*, 171.

8. DuBois, *Harriot Stanton Blatch*, 1; Harriot Stanton Blatch and Alma Lutz, *Challenging Years: The Memoirs of Harriot Stanton Blatch* (New York: G.P. Putnam's Sons, 1940), 92, 131–36, 179–84, 189–90, 206, 257–61. Harriot's husband, William Blatch, was killed in an accident in 1915. Harriot Blatch sold her house in Shoreham in 1919 and moved to Connecticut to be near her daughter, Nora.

9. "Harriet Burton Laidlaw," in *NAW*, 2:358–60; and Naylor, "Winning Votes for Women," *NCHSJ* 50 (1995): 36–37.

10. Natalie A. Naylor, "General Rosalie Jones (1883–1978): Oyster Bay's Maverick Suffragist," OBHS's *Freeholder* 12 (Summer 2007): 3–4. See also Judith Ader Spinzia, "Women of Long Island: Mary Elizabeth Jones [and] Rosalie Gardiner Jones," *Freeholder* 11 (Spring 2007): 3–7; and Elisabeth Freeman website.

11. In the summer of 1918, Jones attended New York University and Dartmouth College. In 1919, Jones received her AB from Adelphi College, law degrees from Brooklyn Law School and Washington College of Law (later affiliated with American University) and an MA from George Washington University.

Three years later, she received a doctor of civil law degree from American University in Washington, D.C. She was admitted to the bar in New York and the District of Columbia and did pro bono work. Naylor, "General Rosalie Jones," 4–7; *Long Islander*, August 8, 1913. See also Jane Matthews, "'General' Rosalie Jones, Long Island Suffragist," *NCHSJ* 47 (1992): 24–29.

12. Sammis was elected to the New York State Assembly in 1918, see the twelfth chapter in this book. Jane Mathews, "The Woman Suffrage Movement in Suffolk County, New York: 1911–1917: A Case Study of the Tactical Differences Between Two Prominent Long Island Suffragists, Mrs. Ida Bunce Sammis and Miss Rosalie Jones," MA thesis, Adelphi University, 10–24. A copy of the thesis is available in the Adelphi and Hofstra University Libraries.

13. On Kearns, see suffragewagon.org, maintained by her granddaughter. The wagon is now owned by the New York State Museum in Albany, which exhibited it in 2010 and 2012.

14. Naylor, "Winning Votes for Women," 37–38.

15. Ibid., 38.

16. Other Long Island women involved in the suffrage movement included Lisabeth Halsey White, Mrs. Henry Medd and Mrs. E. Tiffany Dyer of Southampton; Birdsall Otis (Mrs. Frederick) Edey of Bellport; Lillian de Vere and May Duffield of Lake Ronkonkoma; Ruth Carpenter Litt of Patchogue; Louisine Waldron Elder (Mrs. Henry O.) Havemeyer of East Islip; Marjorie Merriweather Post of Brookville; Eleanor Alexander (Mrs. Theodore Jr.) Roosevelt and Katina Ely (Mrs. Charles Lewis) Tiffany of Oyster Bay; Gertrude Vanderbilt (Mrs. Harry Payne) Whitney of Old Westbury; Emeline (Mrs. Edgerton) Winthrop of Muttontown; Vira Boarman (Mrs. J. Norman) Whitehouse of Upper Brookville; Grace E. Clapp (Mrs. Frederick Stuart) Greene of Sands Point; and Mrs. Elsie R. Spellman of Rockville Centre. Those interested in learning more can consult sources cited in the notes or resources on the Internet. See also Mallory Leoniak and Jane S. Gombieski, *To Get the Vote: Woman Suffrage Leaders in Suffolk County* (Town of Brookhaven, New York, 1992).

Chapter 12. Civic and Political Activists

1. Clinton E. Metz, "Sarah Ann Baldwin Barnum: A Nineteenth-Century Achiever," *LIF* 47 (September 1984): 167; *Brooklyn Daily Eagle*, March 12, 1889, and January 4, 1893, online. A less attractive side of Barnum

was a report that she had virtually enslaved a young orphan boy she had indentured from the poor farm (*Brooklyn Daily Eagle*, March 12, 1889).

2. Metz, "Sarah Ann Baldwin Barnum," 167–73; Ruth Shackelford, "Institutional Poor Relief in Nassau County, 1899–1999," in *Nassau County: From Rural Hinterland to Suburban Metropolis*, ed. Joann P. Krieg and Natalie A. Naylor (Interlaken, NY: Empire State Books, 2000), 89, 90, n.2–3; and Richard A. Winsche, *The History of Nassau County Community Place-Names* (Interlaken, NY: Empire State Books, 1999), 49. Barnum Island is part of today's Island Park.

3. Dorothy B. Ruettgers, "Abigail Eliza Leonard: Quiet Innovator," in *LIW*, 180–84.

4. Ida Bunce outlived three husbands. Her first husband, Edgar Sammis, died in an automobile accident in 1911, and she married Dr. Alden J. Woodruff in 1921 and moved upstate. After his death in 1933, she married Reverend George E. Satchwell, a prohibitionist publisher and editor. Because of her subsequent marriages, her name is sometimes given as Ida Bunce Sammis Woodruff Satchwell. She is buried at the Huntington Rural Cemetery, where her tombstone lists her year of birth as 1868 versus 1865 in other sources. See Jane Mathews, "The Woman Suffrage Movement in Suffolk County" (see ch. 11, n.12), 82–87, 103, n.7.

5. Marcelle S. Fischler, *Great Neck: Fabled Tales & Fabulous Images* (New York: TM Design, 2003), 30–32; and Village of Saddle Rock website (history).

6. Constantine E. Theodosiou, "Genesta Strong, 'The Oleo Lady,'" *NCHSJ* 60 (2005): 22–33.

7. Arlene B. Soifer, "Energizer and Actualizer—The Nassau County League of Women Voters," in *LIW*, 194–203. In 2012, Nassau County has five local Leagues: Long Beach, Port Washington/Manhasset, Central, Southwest and East Nassau. In Suffolk County, local LWV organizations are in Huntington, Smithtown, Brookhaven, the Hamptons and Shelter Island.

8. David E. Kyvig, "Pauline Morton Sabin," *NAW*, 4:617–18. Sabin's husband died in 1933. She married Dwight Davis in 1936 and moved to Washington, D.C., where she served as director of Special Volunteer Services for the Red Cross from 1940 to 1943. She continued to summer in Southampton, where she is buried. Sabin's Bayberryland mansion was razed in 2009.

9. Ann Sandford, "Rescuing Ernestine Rose (1880–1961): Harlem Librarian and Social Activist," *LIHJ* 22, no. 2 (Summer 2011); and Ann Sandford, "The Multicultural Ideal and Social Activism of Ernetine Rose (1880–1961)," *The Bridge*, 2010, 24–27 (also available on the Bridgehampton Historical Society's website).

10. Oyster Bay Historical Society, vertical files, Derby; and curatorial files, Sagamore Hill National Historic Site. See also Betty Boyd Caroli, *The Roosevelt Women* (New York: Basic Books, 1998), 340–87.
11. Raymond E. and Judith A. Spinzia have briefly identified civic activism (including philanthropy) of many Long Island women in *Long Island's Prominent North Shore Families* and their other volumes in the series (see ch. 7, n.19).

Chapter 13. Years of Change, 1930–1980

1. Tom Morris and Bill Blyer, "The Great Storm of '38," in *Long Island* (see ch. 2, n.1), 299; and Margaret B. Perry and Patricia D. Shuttleworth, eds., *The 1938 Hurricane as We Remember It: A Collection of Memories from Westhampton Beach and Quogue* ([Quogue, NY]: Quogue Historical Society, 1988), 43.
2. Deborah G. Douglas, *United States Women in Aviation, 1940–1985* (Washington, D.C.: Smithsonian Institution Press, 1990), 7.
3. Ibid., 41–56; and www.wingsacrossamerica.us/wasp. A National WASP World War II Museum is located in Sweetwater, Texas, where the WASPs trained, and its website has information and resources on the WASPs.
4. Douglas, *Women in Aviation*, 31–41.
5. *Newsday*, obituary, April 20, 1988; Marjorie Kaufman, "Photographer 'Plucked From Oblivion,'" *New York Times*, LI section, August 28, 1994; and other clippings from the vertical files of the Smithtown Library's Long Island History collection. Frissell's photographer daughter, Sidney Stafford, collected a sample of her mother's photographs in the Toni Frissell Collection in the Library of Congress for *Toni Frissell: Photographs, 1933–1967* (New York: Doubleday, in association with the Library of Congress, 1994).
6. Since 1958, McLean's estate has been the home of the Harbor Country Day School. Richard B. Hawkins and Geoffrey Fleming, "Alice Throckmorton McLean," in Barbara F. Van Liew et al., *Head-of-the-Harbor: A Journey Through Time* (St. James, NY: Village of Head-of-the-Harbor, 2005), 162–65; Britannica online website; and Katti Gray, "From High Society to Social Service," *Newsday*, August 12, 2012.
7. Christine Kleinegger, "The Janes Who Made the Planes: Grumman in World War II," *LIHJ* 12 (Fall 1999): 1–10; an abbreviated version appeared in *LIW*, 231–35. All information on Grumman is from this source. The figure for Republic is from Bernie Bookbinder, *Long Island, People and Places, Past and Present* (New York: Harry N. Abrams/Newsday, 1983), 219.

8. The Kenyons left Long Island in 1952 for Connecticut, where they continued to fly. See Lauren Terrazzano, "Teddy Kenyon: She Tamed Grumman's Hellcats," in *Takeoff! How Long Island Inspired America to Fly* (Brentwood, NY: Newsday, 2000), 121–29.

9. The literature on suburbia is extensive. See William M. Dobriner, *Class in Suburbia* (Englewood Cliffs, NJ: Prentice Hall, 1963); Kenneth T. Jackson, *Crabgrass Frontier: The Suburbanization of the United States* (New York: Oxford University Press, 1985); Barbara M. Kelly, ed., *Long Island: The Suburban Experience* (Interlaken, NY: Heart of the Lakes, 1990); and Rosalyn Baxandall and Elizabeth Ewen, *Picture Windows: How the Suburbs Happened* (New York: Basic Books, 2000). Baxandall and Ewen interviewed many women, including African American women from Freeport, Roosevelt and Hempstead, to provide firsthand testimony about these and other Long Island communities.

10. Betty Friedan, *Life So Far* (New York: Simon and Schuster, 2000).

11. Marilyn Goldstein, "Reflections on Long Island Women," in *LIW*, 298. Komanoff (1910–2000) was the first woman on the Nassau County Board of Supervisors; she served from 1974 to 1985.

12. Linda Lane-Weber, "Significant Moments in the Evolution of the Southern Suffolk NOW Chapters," in *LIW*, 317–23. Charlotte M. Shapiro related activities of another activist organization in her article "Women on the Job: Long Island's Grassroots Action for Pay Equity," in *LIW*, 326–36.

13. Lynn, "Women's Cradle of Aviation" (see ch. 10, n.13), 85–95.

Chapter 14. Historians and Preservationists

1. Linda B. Martin and Bette S. Weidman, "Rachel Hicks, Photographer: A Woman's Conflict," *Photographer's Forum* (September 1983): 19–28. Photographer Rachel Hicks should not be confused with the Quaker preacher also named Rachel Hicks, see the chapter "Expanding the Domestic Sphere in the Nineteenth Century" in this book.

2. *Wave Hill, Portrait of an Era in Landscape Architecture: The Photographs of Mattie Edwards Hewitt*, exhibition catalogue (Bronx, NY: Wave Hill, 1983).

3. *Brooklyn Daily Eagle*, July 19, 1896, 24. Despite the reprint of Flint's book in 1967, Richard Harmond does not mention Flint in his article "Doing and Not Doing Long Island History: The Long Island Historians from Wood to Weeks," *LIHJ* 13, no. 2 (Spring 2002): 173–83, reprinted from the *Long Island Journal of History* 15 (Fall 1978).

4. The Westbury Memorial Public Library has Overton materials including correspondence, clippings and manuscripts in its local history collection in the cottage.

5. *NCHSJ* 33 no. 2, "Bernice Shultz Marshall" (1973): viii–ix. The first edition of *Colonial Hempstead* was published under her maiden name (Shultz); the second edition added the subtitle *Long Island Life Under the Dutch and English*.

6. Some of Rattray's articles and excerpts from her books are reprinted in Tom Twomey, ed., *Discovering the Past: Writings of Jeannette Edwards Rattray, 1893–1974, Relating to the History of the Town of East Hampton, Suffolk County, New York* (New York: Newmarket Press, 2001). Lucinda A. Mayo's "'One of Ours': The World of Jeannette Edwards Rattray" in *LIW*, 65–77, focused on Rattray's travels, which she wrote about in fifty years of columns for the *East Hampton Star*.

7. Edith Hay Wyckoff, *The Fabled Past* (Port Washington, NY: Kennikat Press, 1978), vii.

8. [Carl A. Starace], "Kate Wheeler Strong," *LIF* 51 (Spring 1988): 83. The *Forum* was published monthly from 1938 to 1987 and quarterly from 1988 until it suspended publication in 2004.

9. McGee also wrote several young adult novels and biographies of national figures. See "Dorothy Horton McGee, Beloved Historian, Dies," *Hicksville Illustrated News*, October 17, 2003 (online edition).

10. The Smithtown Library has Molinoff's papers on her Whitman research in its Long Island History collection.

11. Christopher Morley's writing studio, the Knothole, has been preserved in the Nassau County park that bears his name on Searingtown Road in Roslyn–North Hills, a short distance from its original location.

12. Bryant's country home, Cedarmere, is now owned by Nassau County and has been a museum site; see Friends of Cedarmere website. More recent accounts of Long Island authors include two by Hofstra professors: Joann P. Krieg, *Long Island and Literature* (1989), and Janet S. Wagner, "A Century of Authors and Literature," in *Nassau County* (see ch. 12, n.2), 300–13. See Harrison and Denne, *Hamptons Bohemia* cited in ch. 7, n.6.

13. Van Field and Mary Field, eds., *Nettie's Diary: The 1880's Diary of Nettie Ketcham* ([Moriches, NY]: Ketcham Inn Foundation, 1995). This published diary also includes a much briefer diary of Julia Hand from Brooklyn, who summered in Moriches in 1886 (when she was sixteen) and 1890, 223–44. See also ch. 4, n.17 re: journals kept by seafaring women and ch. 7, n.7 re: Annie Cooper Boyd's diaries.

14. The 1866 reprint added *Grace Barclay's Diary* to the title; both editions were edited by Sidney Barclay, which was Post's pseudonym. It was used as the

basis for a young adult book in 1996, Judith E. Greenberg and Helen Carey McKeever, eds., *Journal of a Revolutionary War Woman*. See Sarah Buck, "An Inspired Hoax: The Antebellum Reconstruction of an Eighteenth-Century Long Island Diary," *LIHJ* 7, no. 2 (Spring 1995): 191–204; and Natalie A. Naylor, "A New Incarnation of Lydia Minturn Post's "Personal Recollections" of the American Revolution: A Review Essay," *LIHJ* 9, no. 1 (Fall 1996): 109–19.

15. Harrison and Denne, *Hamptons Bohemia*, 51–53; and Frances R. Kestler, "Faith Baldwin: America's First Lady of Romantic Fiction," *LIHJ* 7 (Spring 1995): 243–52.

16. Carl A. Starace, "Recording Paumonok's Past for Fifty Years: *The Long Island Forum*," *LIF* 51 (Spring 1988): 33–34.

17. [John Allen Gable], "Mrs. Reginald P. Rose, 1906–1982," *Theodore Roosevelt Association Journal* 9 (Fall 1982): 15–16. Rose's account of the restoration of TR's home, "The Sagamore Story," 17–20, is in the same issue, reprinted from SPLIA's *Long Island Courant* 1 (October 1965): 23–36. On Rose's restoration of Rock Hall, see Hibbard, *Rock Hall* (see ch. 3, n.4), 60–72.

18. Ellen Fletcher Russell, *Roslyn Restored: The Legacy of Roger and Peggy Gerry* (Albany, NY: Mount Ida Press, 2004).

19. Catherine Ball, "In Memoriam, Barbara Van Liew," *LIHJ* 18 (Fall 2005/Spring 2006): 184; *Newsday*, July 17, 2005; and biographical information in the Barbara Van Liew Collection, Stony Brook University Library's Special Collections website. The *Long Island Domestic Architecture* booklet was reprinted from her article of the same title in the *NCHSJ* 33 (1973): 1–27.

20. Natalie A. Naylor, "In Memoriam, Alice Fiske," *LIHJ* 18 (Fall 2005/Spring 2006): 185; and www.fiskecenter.umb.edu. In 2007, a special issue of *Northeast Historical Archaeology*, vol. 6, ed. Andrew Hayes and K.H.S. Mrozowski, was devoted to "The Archaeology of Sylvester Manor." See also Gaynell Stone's two-hour documentary film, *The Sugar Connection: Holland, Barbados, Shelter Island*, Suffolk County Archaeological Association, Stony Brook, 2010; and Mac Griswold's forthcoming book, based on the Sylvester Manor archives.

21. Websites for Huntington Historican Society (history) and Suffolk County Historical Society.

Epilogue

1. Numerous books deal with changes in recent decades. Two that focus on women are Gail Collins, *When Everything Changed: The Amazing Journey of*

American Women from 1960 to the Present (Boston: Little, Brown and Company, 2009); and Sara M. Evans, *Tidal Wave: How Women Changed America at Century's End* (New York: Free Press, 2003).

2. After she moved upstate, Bredes was director of the Susan B. Anthony Center for Woman's Leadership at the University of Rochester for twelve years. See her obituaries, *Newsday*, August 19, 2011; and *New York Times*, August 22, 2011. Suffolk County named a nature preserve in Stony Brook the Nora Bredes Preserve in her honor, *Newsday*, April 3, 2012. Early in her political career, Maxine Postal wrote "Politics as a Career for Long Island Women," *LIHJ* 4 (Fall 1991): 74–78.

3. See Linda F. Burghardt, "Women in the Clergy in Nassau County: Breaking Through the Stained Glass Ceiling," in Krieg and Naylor, *Nassau County* (see ch. 12, n.2), 293–99.

4. See Charlotte M. Shapiro, "Women on the Job: Long Island's Grassroots Action for Pay Equity," in *LIW*, 326–36.

5. Cynthia J. Bogard reports on the Huntington Coalition for the Homeless in "Homeless in Huntington: Struggling Mothers and Their Care Givers," in *LIW*, 154–61; and periodic articles in *Newsday* provide updates, such as "New Face of LI's Homeless," *Newsday*, May 7, 2012, 2–3.

6. Wagner, "A Century of Authors and Literature," in Krieg and Naylor, *Nassau County*, 305–8.

7. The Dominican Sisters of Amityville have a similar program for female immigrants, see the chapter "Expanding the Domestic Sphere in the Nineteenth Century" in this book. Jennifer Gordon, the founder of the Work Project, described it in *Suburban Sweatshops: The Fight for Immigrant Rights* (Cambridge, MA: Belknap Press of Harvard University Press, 2005).

About the Author

Natalie A. Naylor was born and grew up in Peekskill, New York, in the Hudson River Valley. She received her AB at Bryn Mawr College and an MA and EdD from Columbia University (Teachers College). After being a research assistant at the National Bureau of Economic Research and a social studies teacher at Tuckahoe High School, she came to Long Island in 1968 to teach history and foundations of education at Hofstra University. In 1976, she joined Hofstra's New College, where she taught courses in American social history, including Long Island history and women's history. Professor Naylor also was director of Hofstra's Long Island Studies Institute from its founding in 1985 until she retired in 2000. She organized many conferences on Long Island history for the institute and edited or co-edited several of the institute's publications, including *Long Island Women: Activists and Innovators* (1998), *Nassau County: From Rural Hinterland to Suburban Metropolis* (2000) and *Journeys on Old Long Island: Travelers' Accounts, Contemporary Descriptions, and Residents' Reminiscences, 1744–1893* (2002). She has also published many articles on Long Island history.

Dr. Naylor has continued her interest in local history during her retirement years. She frequently speaks at historical societies and libraries and has been a consultant to several Long Island museums. Active in many historical

organizations, she has been a trustee of the Nassau County Historical Society since 1987 and editor of the *Nassau County Historical Society Journal* since 1991, and she became president of the society in 2008. She is on the board of (and is a past president of) the Friends of Rock Hall Museum, is co-president of the Long Island Studies Council and has edited the council's newsletter since 1995. She is also co-president of the Hofstra Association of Retired Professors (HARP).